Warrior, Shield, and Star

Imagery and Ideology
of Pueblo Warfare

Polly Schaafsma

*WESTERN
EDGE PRESS*

FIGURE CAPTIONS:

Page i: Sun-shield bearer with war club. This shield bearer is one of a pair that appears with other warrior figures on the Comanche Gap dike, Galisteo Basin, New Mexico. The figure is more than a meter in height.

Title page: Large white painting of stick figure warriors with small hand-held shields and clubs, Forgotten Canyon, Utah. Hand–held basketry shields would have served effectively as parrying devices against the blows from short batons or clubs in close hand–to–hand combat. These two items together probably comprised a functional set of battle gear in Pueblo III.[1] (Drawing after Castleton 1979: Fig. 9.37)

ISBN 1-889921-06-8
Library of Congress Control Number: 00 132150

Western Edge Press
126 Candelario St
Santa Fe, New Mexico 87501
505.988.7214 westernedge@santa-fe.net

Edited by Nancy Zimmerman
Designed and produced by Jim Mafchir

CONTENTS

ACKNOWLEDGEMENTS

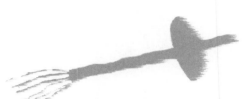

This book could not have been written without the cooperation and willing assistance of numerous persons and institutions. A volume such as this one is greatly dependent on a wealth of visual material. I am highly indebted to Brenda Dorr of the University of New Mexico Maxwell Museum of Anthropology for making available to me the Pottery Mound reproductions and slides for study and publication. Likewise, Donna Dickerson and others at the Peabody Museum at Harvard facilitated the making of reproductions of the Jeddito murals for this volume. Photographs of the Cochiti kiva mural and petroglyphs from Los Lunas were provided by the Museum of Indian Arts and Culture/Laboratory of Anthropology, Museum of New Mexico. I am also indebted to Dody Fugate and Diane Bird for their assistance. In addition, rock-art photographs were kindly furnished by David Grant Noble. Others were donated by Curt Schaafsma. Undesignated photographs were taken by the author.

I received generous cooperation from other members of the Museum of Indian Arts and Culture/Laboratory of Anthropology staff during various phases of my research, and in particular I wish to thank librarian Laura Holt for her patience and unfailing help in finding or acquiring the many references I needed.

Over the years, Carolyn and Henry Singleton have been most coopera-tive in granting me permission to visit the sites on their ranch in the Galisteo Basin, and Wesley Layman, ranch manager, has facilitated these visits. In addi-tion David Siegel was instrumental in visits to the rock art on Black Mesa.

Alan Ferg, Kelley Hays-Gilpin, Ekkehart Malotki, and Curt Schaafsma have helped clarify various specific issues and shared their ideas. Carroll L. Riley read the final text and offered valuable suggestions and corrections. Finally, the complicated task of arranging the photos, captions, and editing was expedited by Nancy Zimmerman, whose discerning eye and suggestions have greatly improved the manuscript. Any errors are my responsibility.

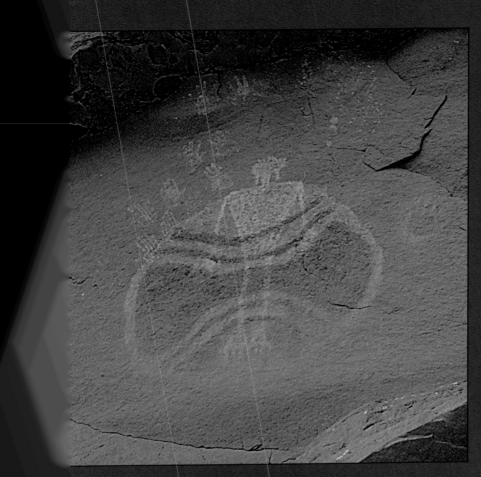

Plate 1

Thirteenth–century Pueblo shield superimposed over Basketmaker anthropomorph, lower Chinle Wash, Utah. The shield is roughly a meter in diameter. The stenciled handprint to the right is contemporaneous with the shield, while the others are Basketmaker in origin.

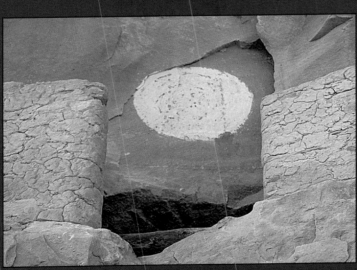

Plate 2

Shield painting at a Grand Gulch ruin behind an opening in a wall. A red handprint is painted at lower right. Two thin dotted lines in green divide the shield vertically.

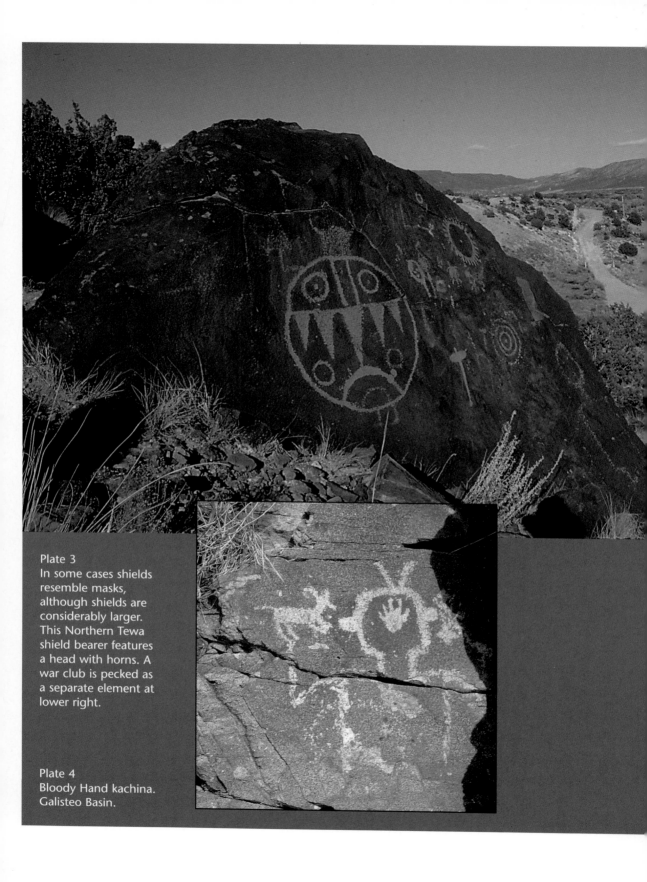

Plate 3
In some cases shields resemble masks, although shields are considerably larger. This Northern Tewa shield bearer features a head with horns. A war club is pecked as a separate element at lower right.

Plate 4
Bloody Hand kachina. Galisteo Basin.

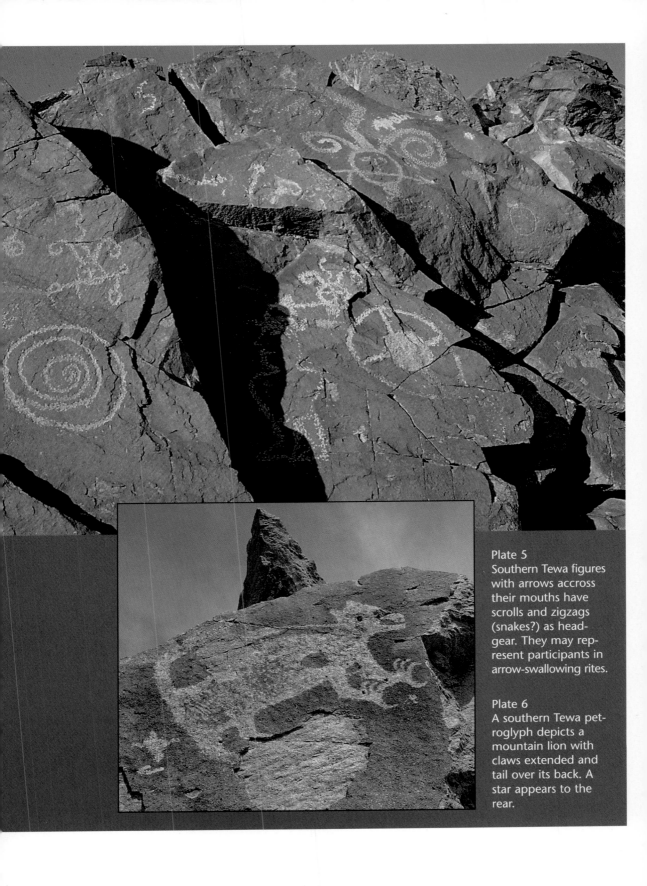

Plate 5
Southern Tewa figures with arrows accross their mouths have scrolls and zigzags (snakes?) as headgear. They may represent participants in arrow-swallowing rites.

Plate 6
A southern Tewa petroglyph depicts a mountain lion with claws extended and tail over its back. A star appears to the rear.

Plate 7
Pottery Mound land-
scape, looking west,
Puerco River Valley,
New Mexico.
*(Photograph courtesy
of the University of New
Mexico—Albuquerque,
Maxwell Museum of
Anthropology.)*

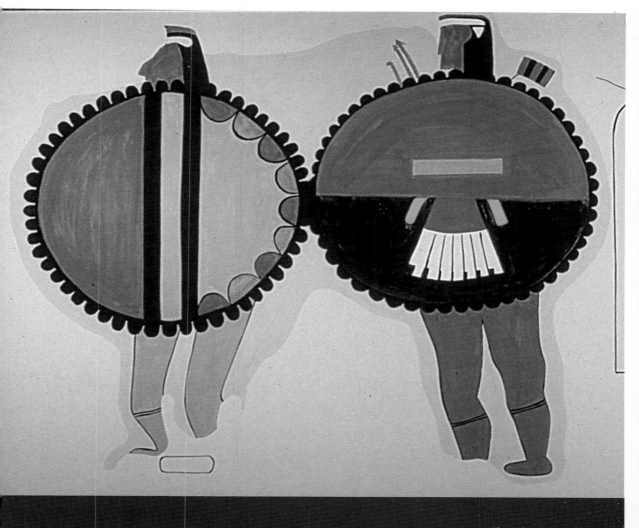

Plate 8
 Shield bearers,
Pottery Mound, Kiva
2, layer 3, west wall
(*Photograph courtesy
of the University of New
Mexico—Albuquerque,
Maxwell Museum of
Anthropology.*)

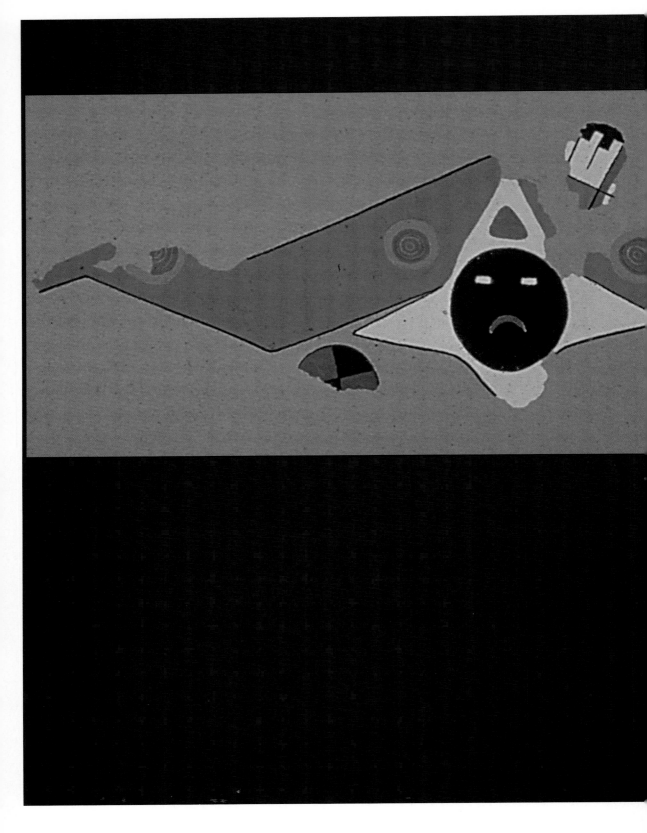

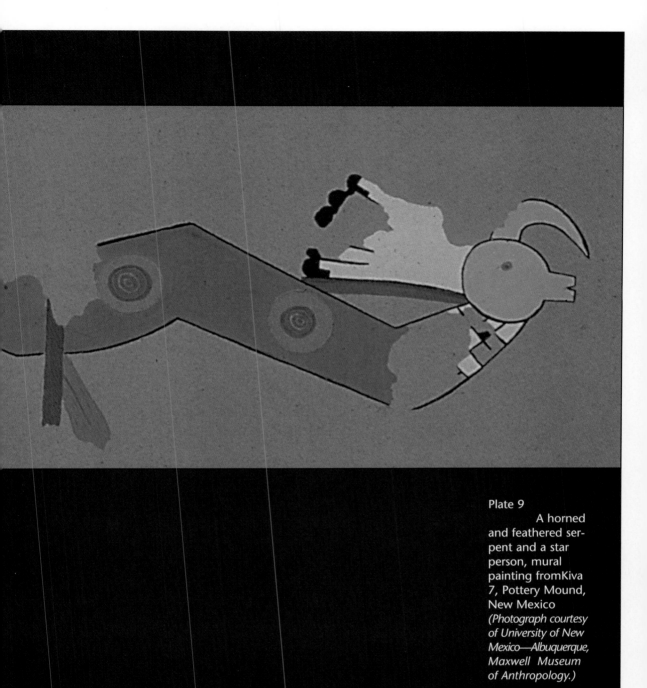

Plate 9
A horned and feathered serpent and a star person, mural painting fromKiva 7, Pottery Mound, New Mexico *(Photograph courtesy of University of New Mexico—Albuquerque, Maxwell Museum of Anthropology.)*

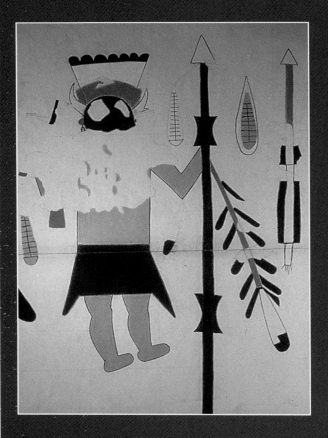

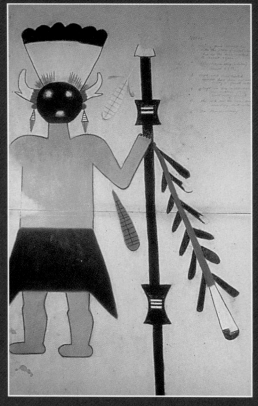

Plate 10

At Pottery Mound, Kiva 9, layer 2, two black-faced figures with curved, antelope-like horns hold tall spears and wear crowns of eagle feathers. More spears and feathers occupy the field in between. These and some of the other black- or dark-faced ritual participants may be masked or their faces may be painted. The faces of some are reminiscent of those on stars (see Figure 26). *(Photographs courtesy of University of New Mexico—Albuquerque, Maxwell Museum of Anthropology.)*

PREFACE

In the winter of 1997 I decided to take a look at some rock-art images that had been nagging me for some time—the shield paintings in the rock shelters of the Colorado Plateau. I had been wondering how their designs compared with those on later Pueblo shields pictured in rock art made after these cliff dwellings were abandoned. All together, what information might these large and imposing images encode about warfare in the Southwest among a Pueblo people traditionally regarded as peaceful? If I were to examine these images together as a class of figures, I thought, this might make a good subject for an article. It was soon apparent, however, that there was so much material here that the "article" was becoming way out of hand, and that I what I really had was a book. Thus a winter project extended itself into a study lasting a couple of years.

I was excited to discover that the subject of shields and shield bearers, like a fiber in Spider Woman's web, was inextricably and meaningfully linked within the framework of warfare to many other images—other warriors, gods, kachinas, stars, birds, and animals. The symbolism of Pueblo strife as seen in rock art and kiva murals played a surprisingly major role and was woven into the unified fabric of the Pueblo world view.

Traditionally, Pueblo warfare has been understood in terms of climatic factors, economic stress, population growth, and the resulting social adaptations. Although these important factors are given general review, my intent in this volume is to supplement these considerations by examining the art and the symbolism it holds for Pueblo ideas behind conflict and warfare. It is apparent that the rationale for hostilities was grounded in cosmology and religion, and in typically Pueblo fashion, the fruits of battle were tied to rain-making and fertility in one continuous text.

Knowledge of past ideas is imperative if one is to understand prehistoric cultures and map past behavior. As far as warfare goes, many scholars have tended to carry Western explanatory baggage to the battlefront of scholarly debate, thereby overlaying Native motivations and practices with Western models. The imagery preserved in rock art and kiva murals provides a native "voice," as it were, that, one hopes, to some degree mitigates the tendency

toward ethnocentricity in the silent context of prehistory. Yet even with the substantial aid of ethnographic texts, so useful when applied to this rich body of visual material, one acknowledges that the archaeological record is fragmentary, that access to its meaning is impeded by time and changes in Pueblo culture itself. Thus, at best, the interpretations presented here represent only an imperfect and partially understood glimpse of warfare ideology of the Pueblo past.

This discussion provides one of many possible answers to the question of why we study rock art. Recording, describing, and classifying are necessary steps in the early stages of any discipline, or whenever new data are found. These steps, however, are not an end in themselves. It is one's hope that such preliminary work will eventually cut a path granting access—however variable it may be—to ideas, religion, and cosmologies of prehistory.

Now, neglecting your children,
Neglecting your wives,
Yonder into the country of the enemy
You have made your road go forth.
Perhaps one of the enemy,
Even one who thought himself virile,
Under a shower of arrows,
A shower of war clubs,
With bloody head,
One of the enemy,
Reached the end of his life.
Our father,
Beast bow priests.
Took from the enemy,
His water-filled covering.
Now you will tell us of that,
And knowing that we shall live.
Is it not so?

—Ritual address,
Zuni scalp chief to returning war party[1]

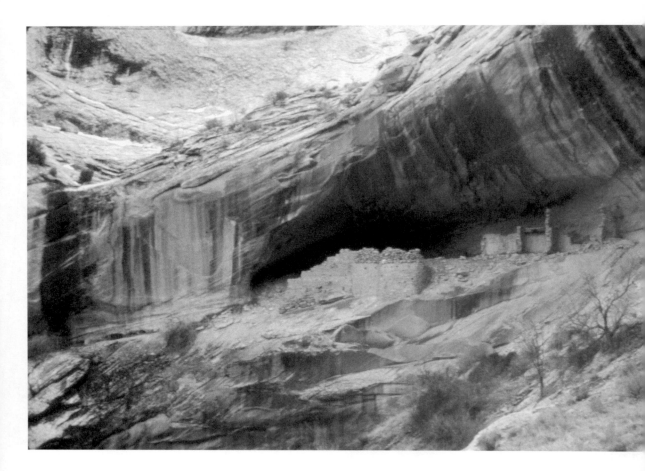

Fig. 1.1
 Cliff ruin north of
the San Juan River,
southeastern Utah

INTRODUCTION

Conflict and warfare were endemic among the ancestral Pueblo people of the Southwest. If archaeological evidence for social strife and aggression is occasionally ambiguous, Pueblo hostilities are, nevertheless, well documented in the early historic accounts of the first Spaniards in the region.[1] Prehistoric warfare as a topic of considerable interest has been subject to extensive recent review by various archaeologists.[2] "Warfare" as a term used in this volume with regard to the Pueblos should be understood in its broadest sense. Although "warfare" is used to refer to social conflict between villages or outside ethnic groups, the word does not imply standing armies or even encounters between all able-bodied men of opposing towns, and there is no indication that hostile engagements were perpetrated for the purpose of gaining territory or for the domination or elimination of other villages. Fighting often took place on a limited scale between small numbers of individuals and was frequently instigated by feuds, for purposes of revenge, or in the context of raids.

Part of the discussion here addresses an early notion, promulgated by Ruth Benedict in *Patterns of Culture* (1934), of the Pueblos as an Apollonian "civilization," within which conflict was avoided and abhorred. Indeed: "Benedict's image of the Pueblos as peaceful people was and remains to a great extent the prevailing view in the ethnographic and popular literature on the Southwest, and this image has some impact on archaeological interpretations as well."[3] In spite of a wealth of contrary evidence, as recently as 1989 the following comment was made by Arthur Rohn:[4] "Despite the broad range and great quantities of Pueblo/Anasazi pictorial art on structural walls, on rock surfaces, and on ceramic vessels, it shows absolutely no traces of warfare or even hostility toward human beings. Scenes of battle are common in the art of the Near East, of ancient China, of pre-Columbian Peru, of Mayaland, and of Central Mexico. These same art styles also frequently depict men in warrior garb with weapons. Nothing even remotely similar has been found in Puebloan art." This volume provides a response to this misconception.

Traditional archaeological evidence for conflict and violence is present in the remains of the earliest Anasazi populations in the Four Corners region, the San Juan Basketmakers. This evidence includes skeletal material with broken or

smashed bones, projectile points embedded in bones, mummies that show evidence of slashing, and the location of sites in defensive locations.[5] Flayed head skins (face included), transformed into fetishes, from archaeological contexts in the Marsh Pass area in Arizona and near Moab, Utah, are also pictured in Basketmaker rock art.[6] Archaeological evidence for violence continues sporadically throughout later periods among the Anasazi on the Colorado Plateau in the form of cannibalism.[7] Site clusters with cannibalism in evidence begin around A.D. 900, although the average date for this material falls between A.D. 1100 and 1129. Social conflict during this period, however, does not seem to have resulted in any recognizable expression in the rock art. Early palisade structures and slightly later towers and tower kivas from the late 1000s and early 1100s are interpreted as defensive by some archaeologists,[8] although Rohn[9] presents convincing evidence that towers may have served ceremonial functions.

Following this period, archaeological evidence for social stress and conflict in the Kayenta Anasazi region in the thirteenth century has been considered at length by Jonathan Haas and Winifred Creamer.[10] Their research has led to the hypothesis that social aggression took place between Anasazi groups, although Steadman Upham and Paul Reed[11] urge further investigation. That the entire region was abandoned by A.D. 1300 confirms the interpretation that serious problems existed for these long-term residents of the region (Fig.1.1).

While Pueblo social strife in the Rio Grande Valley is cited in historical documents, the evidence indicates that conflicts on a sporadic basis occurred throughout the preceding Classic period (ca. A.D. 1325–1600),[12] both between Pueblos as well as in the form of raids by outsiders such as the Plains Teyas and Apacheans. After examining in detail the evidence for conflict during this period in the Western Pueblos, E. Charles Adams concludes that the archaeological record is "remarkably mute" on this subject.[13] For the most part the evidence cited as indications of warfare throughout the Pueblo realm is indirect, leaving few means by which to conclude that fighting actually occurred. Even in the well-documented case of the destruction of Awatovi in 1700 or 1701, the resulting burials were carried out elsewhere, and the remaining archaeological record bears little evidence of this relatively recent historic disaster.

In the face of the ambiguity in the traditional archaeological evidence are the rock-art images fixed in the landscape and murals painted on kiva walls within the remains of the pueblos themselves. What is represented in these often detailed graphic records constitutes a rich source of evidence for prehistoric Pueblo conflict. This visual display, however, has archaeological value not as an historical document of militant events but as a record of the ideology of warfare—a set of beliefs concerning warfare and conflict and the relationship of these activities to the cosmos and Pueblo religion.

That religion and warfare are separate and antithetical enterprises may be a contemporary prejudice. Commonly the two are inextricably linked, a synthesis to be expected. As pointed out by R. Brian Ferguson,[14] war is a collec-

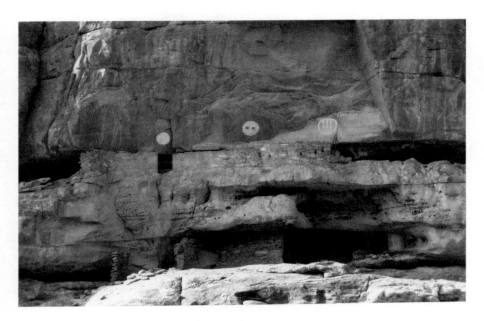

Fig. 1.2
Three large white circles painted above the walled ledge of a cliff dwelling in the Grand Gulch drainage, Utah. The circles are believed to represent shields and are approximately a meter in diameter.

tive activity that involves group solidarity and survival, and it repeatedly poses "the question of meaning," as participants confront hazardous unknowns and risks. In Ferguson's words: "War is a virtual magico–religious magnet." Dangers of combat are dealt with through rituals that commonly are enacted before, during, and following a battle, and supernatural means are employed to confuse the enemy. In the Pueblo case, as elsewhere, conflict is written into the workings of the cosmos; elements from the natural world are infused with supernatural significance and powers to ensure success in warfare, and a portion of the reward of winning is the power to maintain a balance with nature.

The shields and shield bearers associated with the Kayenta sites confirm the notion that these Anasazi were dealing with hostilities and, in addition, were possibly using shields as a magical defense strategy (Fig 1.2). With regard to the period after A.D. 1300, the large number of warriors as well as shields portrayed in both the rock art and kiva murals suggest increased militarism, and are testimony to the presence of a vastly more complicated war-related ideological framework (Fig. 1.3). The overwhelming bulk of the imagery falls within the Pueblo IV time period, or sometime after A.D. 1300 and before 1600. This late Pueblo imagery is amenable to interpretation via ethnographic information that in many cases elucidates its meaning.

Through this method, the metaphors of war during the Pueblo IV period may be approached and often, to a large degree, understood. In addition to shields and warriors, this imagery incorporates symbols from the natural world—the sun, stars, and selected birds and animals that have been transformed into protectors, supernaturally empowered entities that aided the Pueblos in their military endeavors. Indeed, as Matthew W. Stirling[15] noted

during his research at Acoma, "They paint anything they want to get power from." Multivalent and often ambiguous, the symbols of war in Pueblo art embody the complexity of the dynamics and structure of Pueblo religion and world view. Through an analysis of the art, supplemented by a substantial body of ethnographic material, a pattern of duality emerges that links the cults of war with the economic powers necessary for success in the agricultural realm. This rich and often complex iconography of warfare before Spanish contact is the primary subject of this volume.

The visual data gathered for this study include that from my own extensive collection of rock-art slides, as well as from the numerous published sources cited. Kiva murals are also available from both unpublished and published works, and these, like the rock art, have been reviewed with the explicit purpose of examining the imagery as it pertains to warfare. Not only are individual images taken into consideration, but the various conflations and spatial associations that take place are significant to approaching some understanding of the symbolism and metaphors of the past. Although Pueblo IV rock art and kiva murals are highly amenable to interpretation using ethnographic information, certain caveats are in order.

At best, the imagery from Pueblo antiquity is but a mute, fragmentary record of knowledge and intellectual constructs that at one time were fully integrated and expressed in Pueblo thought by means of myths, stories, ritual dramas, and poetry. Symbols and metaphors are inherently ambiguous and multivocal in their meaning. While this makes them more powerful in their impact on the informed native viewer, it also may pose problems of interpretation for others. Thus, which of several aspects of a cluster of meanings is most appropriate for the interpretation of any given icon, as intended by its maker, is not necessarily clear to the outsider several centuries later. Also, connotations current at the time that the art was made may have been lost or changed to some degree. As a result, it should be kept in mind that the data and interpretations presented here represent an interpretive attempt that necessarily suffers from cultural and temporal barriers.

Pueblo warfare as an ongoing institution was severely curtailed in late historic times, and in 1944 Mischa Titiev[16] noted that he had a great deal of difficulty securing material on Hopi warfare. Fortunately, however, many war practices and related rituals were documented at the turn of the century in the Western Pueblos by a number of investigators, among them Frank H. Cushing,[17] George A. Dorsey and Henry R. Voth,[18] Jesse Walter Fewkes,[19] Alexander M. Stephen,[20] Matilda Coxe Stevenson[21] and Henry R. Voth.[22] By this time, however, war societies had been greatly reduced in scope in the Rio Grande Valley. Also, a time span of approximately 250 to 500 years exists between the making of the images found in archaeological contexts and the material collected by ethnographers at the end of the nineteenth and beginning of the twentieth centuries.

During this time, an assault on traditional Pueblo life had taken place as the Spanish conquered the area and forced Christianity on the Indians. Those of the Rio Grande Valley were the recipients of the worst atrocities and bore the brunt of the efforts toward conversion, while disease and hostilities greatly reduced the Pueblo population. Out of the 60 to more than 100 Pueblo villages existing at the time of the Conquest, only 19, not including the Hopis, remain today.[23] Cultural changes affected by these traumas would have an inevitable effect on Pueblo religion. The fact that, in spite of all of this, there is such a good "fit" between the prehistoric images and information available in the ethnographic record is testimony to the endurance, tenacity, stability, and strength of Pueblo traditions. Pueblo myths, narratives, aspects of social organization, ceremony, and ritual still hold information pertinent to understanding the art of recent prehistory. Nevertheless, it is inevitable that changes occur, and these changes account for some of the difficulties that are encountered in interpretation.

In today's Pueblos, nevertheless, warrior societies and their officers still function, and some of the more traditional ritual practices in this connection are still carried out. The accommodations that Pueblo war societies have made to the contemporary world and the extension of this ideology into society at large is the subject of the final chapter. The quest of the Zuni to retrieve their stolen war gods provides a dramatic example of how this aspect of the Pueblo world has penetrated the consciousness of the dominant culture.[24] The subject of this volume is not a relic of the past, but something that continues into the contemporary world.

Fig. 1.3
Kiva mural from Pottery Mound, New Mexico. A feathered sun shield is superimposed by a rattlesnake person. Mountain lions emerge on either side, Kiva 8, layer 5. *(Photograph courtesy of University of New Mexico— Albuquerque, Maxwell Museum of Anthropology.)*

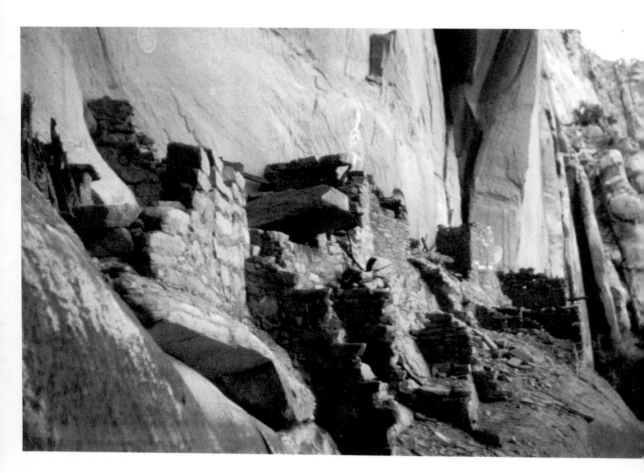

Fig. 2.1
 View of Bat
Woman House with
shield paintings, Tsegi
Canyon drainage,
Arizona. *(Photograph
by Curtis F.
Schaafsma.)*

CHAPTER II:

SHIELDS and MEANING in ANCESTRAL PUEBLO AND FREMONT ROCK ART on the COLORADO PLATEAU (A.D. 1250 to ca.1350)

Prehistoric Pueblo iconography directly related to warfare first appears in a limited form in the rock art of the Kayenta Anasazi around A.D. 1250. In this region, shields and shield bearers are painted on the walls of rock shelters in association with defensible cliff dwellings (Fig. 2.1), and less often with storage units, dating between A.D. 1250 and 1300.[1] The distribution of these paintings, largely in the San Juan drainage, encompasses the region between Cedar Mesa in southern Utah and Navajo Canyon in Arizona, through the Tsegi Canyon drainage and east to the Chinle drainage (Figs. 2.2 and 2.3). With the exception of an occasional weapon, other implements of war and conflict or symbols pertaining to warfare are lacking.

Large circular paintings representing shields more often than not lack further attributes. There is a handful, however, to which pairs of legs have been added, and even more rarely there are heads as well. These supplementary details are valuable clues that identify these paintings as large body shields.

Material analogues have been found in archaeological contexts in the form of basketry shields. These shields, massively constructed with a three-rod foundation, are known only from the Pueblo III period (A.D. 1100–1300). One derives from Mesa Verde, another from a Mesa Verde cultural context at Aztec Ruin, and a third from Canyon de Chelly.[2] Only the last was excavated from a district in which the paintings also occur. The shield from Aztec was painted in a concentric pattern; the center coils were stained with concentric bands of green-blue, and these were surrounded by a band of coils stained red. An overlay of pitch spangled with selenite covered the outer coils.[3] The overall design resembles the white rock-art shields painted in concentric circle patterns, and these, too, commonly have a solid central circle. The shield found in Mummy Cave in Canyon de Chelly was painted with a zoomorphic figure with a circular body and froglike limbs.[4] Life forms occur rarely in the rock art examples.

The Anasazi Rock-Art Shields

This discussion considers 36 shields and shield-bearing warriors of indisputable Anasazi origin from well within Anasazi boundaries. Shields alone are

Table 1 Chronological subdivisions of Pueblo Culture	
	Pueblo V Historic Period
1600	
	Pueblo IV Rio Grande Classic Period
1300	
	Pueblo III
1100	
	Pueblo II
900	
	Pueblo I
700	
	Basketmaker III
400	
A.D.	**Basketmaker II**
B.C.	

Fig. 2.2
 Map of the Four
Corners region

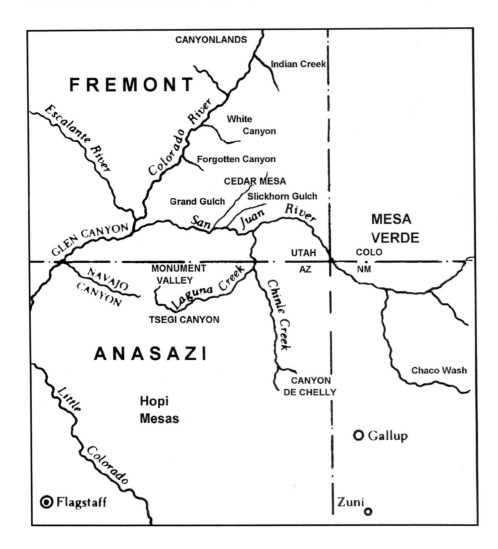

more common than shield bearers. The large round shields, painted in white, are placed in highly visible locations, often on the right-hand side of the rock shelter above the houses. According to Sally J. Cole,[5] this type of painting also is found alongside storage units in the Cedar Mesa region. All but two out of 36 are circular; the exceptions are slightly off-round and truncated at the top. The large shields commonly measure approximately a meter in diameter, and the figure with head and feet, popularly known as Bat Woman, from which Bat Woman House in the Tsegi is named, is well over a meter and a half in overall height (Fig. 5.1).

In this group of 36, 26 shields lack anthropomorphic attributes. There are eight additional shield images at a single site in Slickhorn Gulch, Utah,[6] each with a different interior design. Six shield bearers with body shields are painted at three separate sites in this sample. These shield bearers are static fig-

ures with short, straight legs, and the feet face in one direction. Only three of these have heads. In one rare example, a shield is centered over a much earlier (ca. 200 B.C.–A.D. 400) Basketmaker anthropomorph in such a way as to incorporate the earlier figure, the head of which rests above the top of the shield (Plate 1).

Finally, there are four examples, all in Utah, of Anasazi figures with hand-held shields. At Defiance House in Forgotten Canyon, an eastern tributary of the Colorado River, there is a rare scene of three stick figures in combative poses holding small shields and clubs in their hands (title page). Another hand-held shield was recorded from the San Juan River below Oljeto by the Rainbow Bridge–Monument Valley expedition.[7] Hand-held shields are more common in Utah, especially in the Anasazi/Fremont border zone, where they are often pictured in the hands of broad-shouldered Fremont-type anthropomorphs wearing horned or antlered headdresses (Fig 2.5). Although most of the Anasazi shields discussed above are painted in white, the interior patterning of four of these has been embellished with designs in red and yellow.

Not included in this discussion are two petroglyph shields from Canyon de Chelly recorded by Campbell Grant as Puebloan.[8] Both because of their location in Canyon de Chelly, where Navajo rock art also abounds, and because they are petroglyphs with unusual designs (two are shown pierced with projectiles and one of these has a zigzag pattern on the inside edge, both elements more commonly found in later Pueblo art), the possibility must be considered that they may be of much later Navajo manufacture. In addition, Cole[9] describes three shield bearers, with legs and feet only, incised on a wall of Kiva K in Cliff Palace on Mesa Verde. These unusual shields have a high, horizontal dividing line from which hang lines with trifurcated ends, like birds' feet. Although there is little to argue against these being Anasazi, the lack of comparable shield designs in the rock art puts the origin of these in question, and the possibility of Ute origins cannot be discounted.

SHIELD DESIGNS

None of the thirteenth-century Anasazi shields from the Colorado Plateau has feathers or other exterior edging, although interior designs are characteristic and notably varied (Fig. 2.4). Only the shield bearers from Poncho House in Chinle Wash and two small hand-held shields from Defiance House lack interior patterns.

The designs on a large number of shields have a central focus. Several shields have a very small, solid, central circle, and concentric circle designs appear to be an elaboration on this basic scheme. The concentric circle is the most oft-repeated shield pattern, with concentric circle shields occurring in high numbers in the Tsegi Canyon vicinity and in Canyon de Chelly (Fig. 2.6). Variants on this type include shields with concentric arcs, halved solid

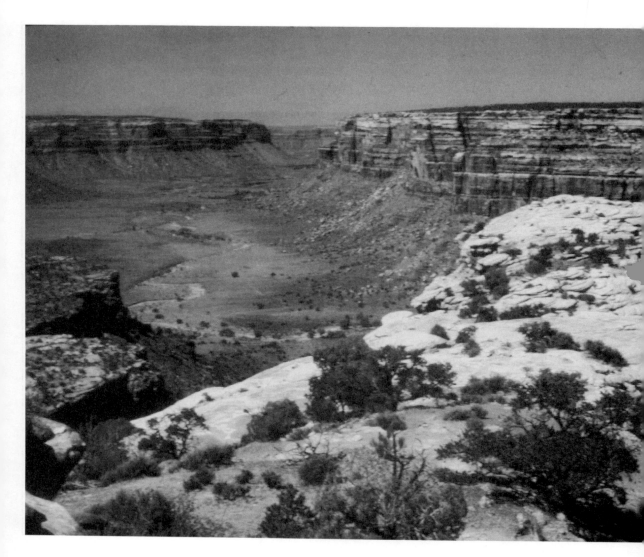

Fig. 2.3
 John's Canyon,
Cedar Mesa, Utah.

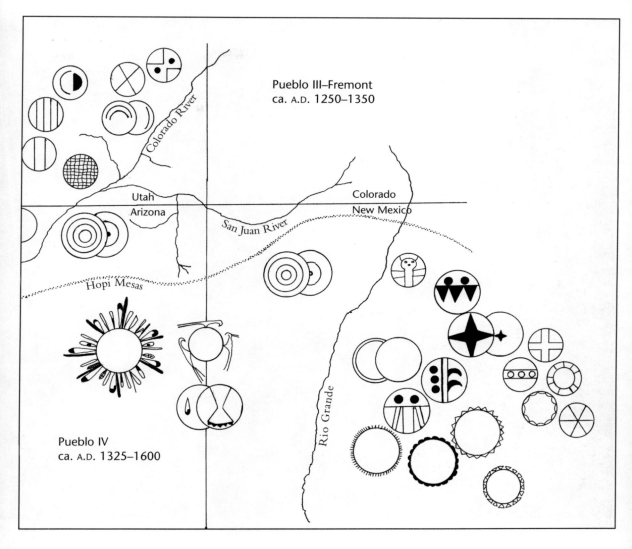

Pueblo III–Fremont
ca. A.D. 1250–1350

Utah
Arizona

Colorado
New Mexico

Hopi Mesas

Pueblo IV
ca. A.D. 1325–1600

Fig. 2.4
Chart of the Four Corners region and upper Rio Grande valley of New Mexico showing the geographic distribution of shield designs in Pueblo art before and after ca. A.D. 1300. This information was obtained from 85 Colorado Plateau shields and more than 225 Pueblo shields dating after A.D. 1325. Shield designs illustrated may be simplified and schematic, and design motifs may be found in combination, not shown here. Except for the temporal and geographic divisions indicated by dotted line, shield placement on the map is somewhat arbitrary. Feathered sun shields, for example, occur both in the Rio Grande Valley and at Hopi. Relative frequencies of occurrence of selected repeated motifs are indicated by the size of the shield.

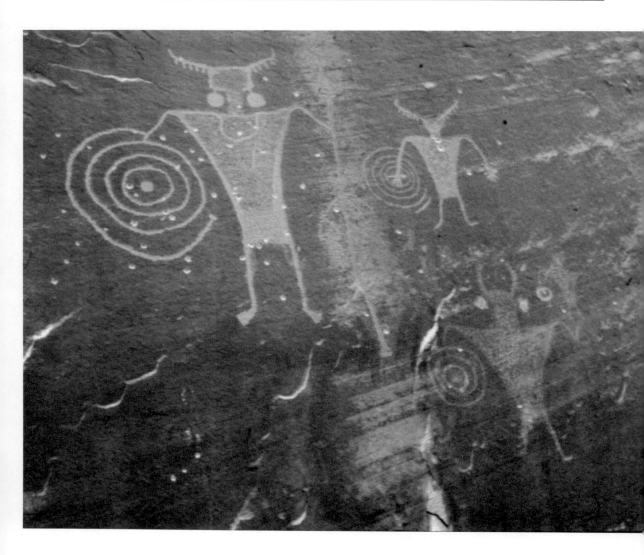

Fig. 2.5
Fremont figures
with large earbobs
and "fringed" horns
or possibly antlers
holding concentric
circle shields near
Moab, Utah.

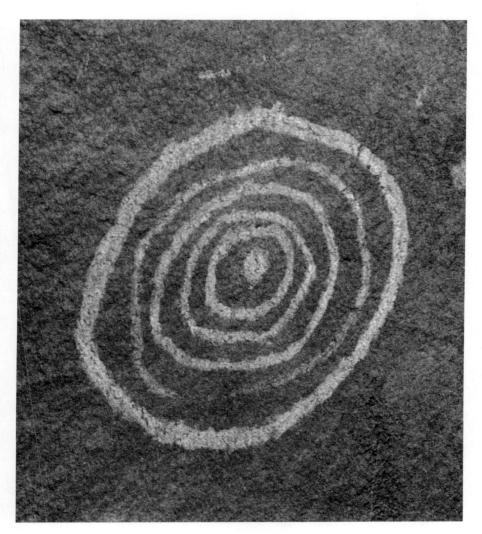

Fig. 2.6
Large concentric circles in white, Bat Woman House, Tsegi Canyon drainage, Arizona. *(Photograph by Curtis F. Schaafsma.)*

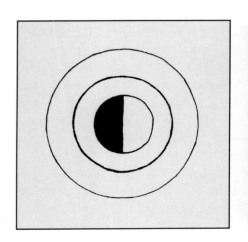

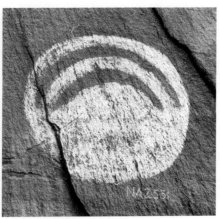

Fig. 2.7
Concentric circle shield with halved central circle, Marsh Pass, Arizona. *(Redrawn from Wormington 1955: Fig. 65k.)*

Fig. 2.8
Large shield, Bat Woman House, Tsegi Canyon, Arizona. *(Photograph by Curtis F. Schaafsma.)*

Fig. 2.9

Shield bearer in Lower Chinle Wash, southeastern Utah. The central radiating design in the shield resembles a flower or star. Handprints are stamped to the lower left of the shield.

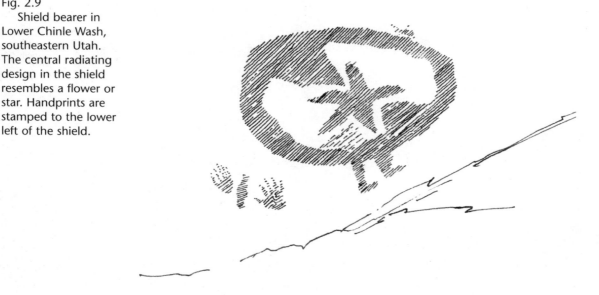

central circles, and other concentric patterns (Figs. 2.6, 2.7, and 2.8). Some shields are quartered diagonally like pies, with the dividing lines crossing in the center (Fig. 2.4). An unusual shield from the lower Chinle Wash has a five-pointed motif radiating from the center (Fig. 2.9).

Vertical lines and bands are yet another approach to dividing the circular field (Fig. chart). Several vertically patterned shields are recorded from Navajo Canyon and Jail House ruin in Grand Gulch, but all are individual in concept[10] (Plate 2 and Fig. 1.2).

There are, in addition, a number of highly distinctive shields centrally divided horizontally. The Tsegi Canyon Bat Woman previously mentioned (Fig.5.1) has a shield that combines a horizontally divided field with concentric arcs above and a downward pointing triangle below. A similar rendition of the arc pattern occurs close by, probably painted by the same individual (Fig. 2.8) On the lower Chinle, the shield superimposed over a Basketmaker anthropomorph is divided horizontally by lines that narrow toward the center above and below a centrally contracting red band in a manner that resembles the stitching on a baseball (Plate 1). Thus the popular name Baseball Man has been coined for this painted complex.

Life forms functioning as shield designs, such as the negative stick–figure anthropomorph on the shield at Betatakin in Tsegi Canyon (Fig. 2.10), are exceedingly rare. In addition, there is a large white circle, or shield, with a central "face" at Turkey Cave, also in Tsegi Canyon. Cole[11] compares the Betatakin painting with the image on the Mummy Cave basketry shield. Although both lack tails, the basketry painting is considerably more lizardlike, and different symbolism may be involved (see pp. 25–26).

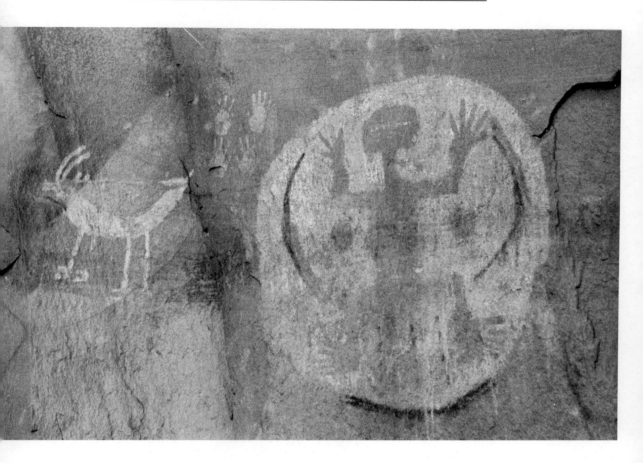

Handprints are associated with several shields (Figs. 2.8, 2.9, 2.10). In Jail House ruin, a red left handprint is stamped or painted at the lower right of the shield opposite the doorway in the wall that encloses the high ledge above several rooms. This print is partially superimposed on the shield, indicating that it was made after the shield painting was completed, possibly immediately after (Plate 2).

The only weapons pictured are the clubs in the right hands of the figures at Defiance House (title page). Headgear of the few Anasazi shield bearers is minimal. A pair of short lines projects from the head of one of the shield bearers at Poncho House, but more distinctive are the two simple triangular points on Bat Woman's head. A similar headdress also appears on a shield bearer from Indian Creek, Utah, in the Fremont/Anasazi fringe.

Additional Fremont/Anasazi Shields and Shield Bearers in Southeastern Utah Sites in the Colorado River Drainage

Shields and shield bearers in the Canyonlands region of the Colorado River drainage of southeastern Utah are not as consistently found in association with cliff dwellings as they are to the south,[12] but these figures occur in

Fig. 2.10
Large shield painting, Betatakin, Tsegi Canyon, Arizona. Painted as a negative design on the face of the shield, the anthropomorphic stick figure is flanked by two yellow disks. Arcs in red and yellow occur on either side. Four handprints are stamped at the upper left, beyond which is a painting of a bighorn sheep. *(Photograph by Curtis F. Schaafsma.)*

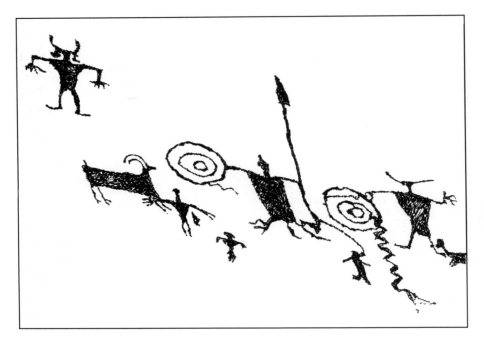

Fig. 2.11
Petroglyph figures holding concentric circle shields and a spear near Moab, Utah. The more dynamic Fremont type anthropomorphs with shields in the Colorado River drainage are often shown with weapons.

significantly greater numbers in this northern frontier zone that borders the Fremont area. There are numerous scattered petroglyphs and rock paintings of solitary shields and shield bearers with body or hand-held shields.[13] Although in many cases shield patterns tend to be more complicated and innovative, manifesting greater dynamism, the designs on many of these shields are like those in the unequivocally Anasazi sites in the San Juan drainage (Fig. 2.4). Concentric circle patterns are common (Figs. 2.11 and 2.12), as are shields with one or more vertical bands (Fig. 2.13).[14] Other shields are quartered by pie-shaped divisions embellished with small circles.

There are also individually distinctive designs, such as the apparent rain-cloud motif from Canyonlands[15] and the famous white, red, and blue-gray All-American Man. Painted near an earlier Anasazi masonry structure in Canyonlands National Park (see p. 22), the latter has an unusual shield pattern consisting of a broad central horizontal band, below which further bands and striping continue to divide the field both horizontally and vertically.[16] In Indian Creek, a previously mentioned shield bearer wearing a cap with two points sports a body shield with a reticulate design.[17] Elsewhere in Utah there is an occasional shield bordered by short radiating lines. Some of these appear to be Ute in origin, but others are Fremont.

In this northern border region, figures may display ethnic distinctions based on the kinds of headgear they wear as well as body shape (Fig. 2.5). Although the Fremont culture area is predominantly west of the Colorado River, Fremont anthropomorphic figure types occur in White Canyon and Indian Creek, thereby suggesting a Fremont presence east of the Colorado

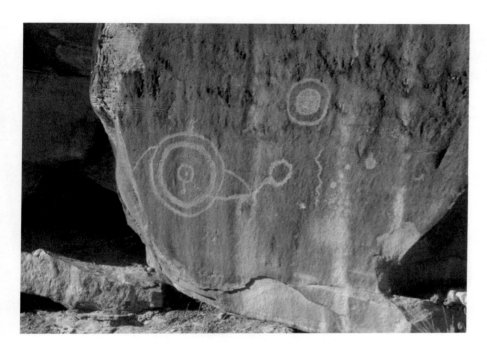

Fig. 2.12
Petroglyph shields with concentric patterns, south of Moab.

River. From White Canyon, near Indian Creek's junction with the Colorado River, an impressive array of more than 20 shields and shield bearers was painted and carved in association with a cliff structure that was highly defensive, both in terms of architectural design and location (Figs. 2.13, 2.14, and 2.15).

Fremont-type broad-shouldered human figures lacking shields are also present in the rock art. This site, designated Site 2 when first described and illustrated by Julian Steward,[18] is now under Lake Powell. Situated in the hot lower elevations of the canyon system, this location must have been less than desirable for agriculturalists. Mesa Verde ceramics found in association were classified by Steward as Pueblo II or early Pueblo III (i.e., ca. late eleventh century to early thirteenth century). Six of the shield bearers, however, have either horned headgear or antennae-like projections, and others wear earbobs as well, all costume details that are characteristic of Fremont anthropomorphs. The remaining shield bearers are not inconsistent with Anasazi representations but, in fact, lack clear-cut clues as to their ethnic affiliation. The shield bearers are unusual in that most were pecked, incised and/or abraded. All are rather static and, for the most part, stand with legs parallel. Several shields, however, have zigzag patterns and are more dynamic and complicated than the more southern examples away from the border region. Two paired shields painted in white (Fig. 2.15) have red handprints stamped in their centers. Additional shields pictured in Canyonlands and in the Colorado River drainage sites on the northern Anasazi frontier occur in contexts of broad-shouldered Fremont-style anthropomorphs.[19]

Fig. 2.13
Two petroglyph panels of shield bearers, Site 2, mouth of White Canyon, Utah. Shields at this site are typically about a meter in diameter. Projections from the edges of the shields may represent weapons. *(Steward 1941: Figs. 72a and 73a.)*

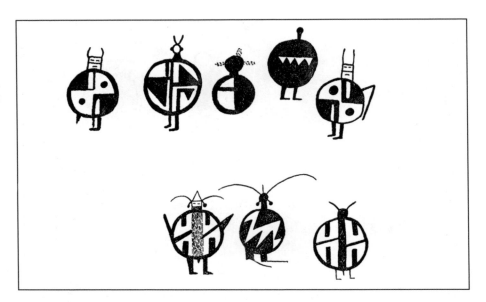

Near the Colorado River, some distance below the mouth of White Canyon in Davis Gulch of the lower Escalante, is another major focus of shield bearers comparable in number to Site 2. In Davis Gulch the work appears to be that of a single painter. Here, hand-held shields are borne by Fremont-style anthropomorphs, some of which wear horns or centrally placed feathers (Fig. 2.16). The shields may be held in either hand. The layouts of these shields deviate widely from the Anasazi norm described above, and several are apparently unique to this scene, suggesting that the painter was not under any particular social constraints in his choice of designs. Among these designs are overall patterns that include a reticulate pattern and a field of painted rows of dots and/or stripes and various combinations thereof that divide the field vertically. Another shield is covered with nested chevrons. Two interlocking scrolls comprise the pattern of one shield, a dynamic variant with a central focus. Single large positive and negative equilinear crosses embellish two others. In another example, a single wide negative chevron creates an asymmetrical design field.

Only two of the patterns of these shields bear any similarity to the Anasazi work reviewed here. These include the shield quartered in pie fashion, and the negative horned Fremont-style anthropomorph on another. This negative image is reminiscent in concept, but not in form, of the stick figure on the Betatakin shield.

In conclusion, rock art with warfare themes is more complex and vigorous in sites along the Anasazi/Fremont border zone than it is in adjacent Anasazi sites to the south, situated largely in the San Juan drainage. These latter by comparison seem to be in some ways peripheral to the shields in the Colorado drainage. Shields and especially shield bearers and hand-held shields

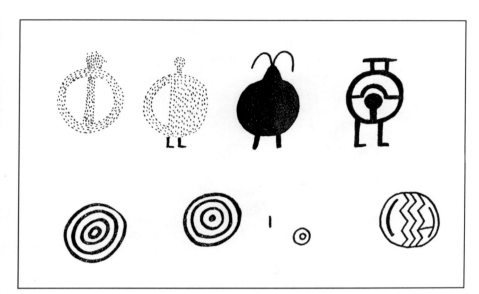

Fig. 2.14
Individual petroglyphs of shields and shield bearers from Site 2, White Canyon. *(Steward 1941: Fig. 72 b–e, 73c and Fig. 74.)*

are more numerous along the Anasazi/Fremont frontier. At the same time, shield designs indicate that a single tradition of shield images was operative throughout the entire region. All of the basic layouts discerned for the strictly Anasazi shields are present in the northern area, indicating a cultural continuity among all of them, although those bordering the Fremont territory manifest greater diversity and more dynamic patterning.

These observations suggest that conflict and hostilities on the Colorado Plateau, possibly involving late Anasazi and certainly Fremont populations, were intensified along this ethnic boundary. This raises the question of contemporaneity and, if this is the case, whether hostilities existed between these ethnic groups or whether both were responding in kind to an outside enemy. Elsewhere in Utah, rock art indicates that conflict may have been endemic to the Fremont population as a whole over several centuries, since in addition to shields, large knives and trophy heads (or head skins) appear in the hands of Classic Vernal-style Fremont anthropomorphs dating between the seventh and tenth centuries.[20]

Assigning archaeological remains in the frontier zone along the Colorado River drainage to either the Anasazi or Fremont can be problematic. Phil R. Geib[21] offers an excellent and lengthy discussion of the issues involving the recognition of cultural boundaries and ethnicity, temporal variables, and sequential occupations. Nevertheless, a Fremont cultural identity is well established for tapered-bodied anthropomorphs often portrayed with large heads without necks. Further, these figures wear horns, antlers and/or hairbobs, yokes or necklaces, and they may carry hand-held shields. This type of anthropomorph is found throughout the Fremont area of Utah and is lacking among the Anasazi.

21

As we have seen, however, Fremont-type human figures were frequently painted or pecked near Anasazi-type structures. Pottery and masonry storage units in this region, and especially in Canyonlands, are Anasazi in character. Based on ceramic cross–dating, the structure at the All-American Man dates between A.D. 1075 and 1150.[22] As evidence points to the abandonment of the region by the Anasazi between A.D. 1260 and 1290, this cultural assignment poses no problems. Radiocarbon dates on the paint from the associated shield bearer, however, fell between A.D. 1220–1281 and A.D. 1297–1421,[23] dates that are thought to better conform to dates of A.D. 1272–1379 obtained from Fremont-style rock paintings in Glen Canyon.[24] These relatively late dates led Phil Geib and Helen Fairley to speculate that this and other Fremont-like rock art was created by scattered Fremont populations temporarily occupying abandoned Anasazi sites in the region.[25] In this scenario, the Anasazi would not have been involved in the latest hostilities that led to the demise of the Fremont. Clearly, more studies of this type are needed to help resolve the problems of ethnic relationships and conflict in this area.

Site 2 in White Canyon exemplifies the problems inherent in the archaeology of this region. Clearly, most if not all of the shield bearers at this site have their origins in the Fremont tradition. What this signifies in terms of what transpired at this defensively situated Anasazi habitation site is unclear. Who was the enemy? Did both Anasazi and Fremont groups occupy this site simultaneously in the twelfth or early thirteenth century in the face of a common threat? Or did Fremont peoples, soon to disappear but still occupying the area after the Anasazi had left, find this site a good refuge from threats from a third cultural group or possibly other Fremont contingents? Lacking dates and other information from both the rock art and other cultural remains flooded by Glen Canyon Dam, these questions are probably unanswerable in terms of this particular site. Site 2 does generate questions, however, the answers for which can be sought elsewhere.

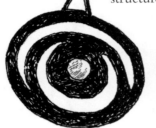

Fig. 2.15
Pair of shields painted in white with red handprints stamped in the center, Site 2, White Canyon.
(After Steward 1941: Pl. 52d.)

Interpretation and Function: Social Symbolism or Defensive Magic?

In the Kayenta Anasazi heartland, the shield motif alone was favored over those with anthropomorphic additions. The essentialness of these paintings in sites in southern Utah and northern Arizona contributes to their emblematic quality and led to the earlier suggestion that these shield designs might have socio-religious implications.[26] These visual devices associated with defensible cliff dwellings could have served as a statements of group identity and solidarity

in a social context characterized by sporadic warfare, although their meaning as social symbols as such is hard to confirm.

A number of archaeologists proposed early on that tower structures, loopholes, and other apparently defensive architectural features represent in-fighting among Anasazi communities.[27] The question of inter-Pueblo strife has been explored recently in the Tsegi drainage by Haas and Creamer,[28] who found evidence indicating that the Anasazi of the region after A.D. 1250 were divided against each other, drawing social boundaries and forming group alliances (see Chapter V). Allied population units maintained a physical sepa-ration or distance from one another, and villages were defensively located. Furthermore, they cite evidence that affiliated pueblos were situated in a line of sight so that they could communicate in the event of an emergency. It remains to be shown whether the shield paintings within the domain of an identifiable allied archaeological unit display symbolism distinct from that in other, socially discrete, territories. If this could be demonstrated, symbolic unity would argue that the shield designs were indeed indicators of social cohesion and consolidated group strength. To date, the field work necessary to verify this theory has not been undertaken, although the fact that shield designs in historic times are said to incorporate "some measure" of village identity[29] lends support to this notion.

Also open for consideration is the possibility that around the end of the thirteenth century the Anasazi and other longtime Plateau residents, like the Fremont, were harassed by nomadic outsiders—encroaching Shoshonean, or proto-Ute, Numic populations pushing in from the north and west out of the Great Basin.[30] In either situation—conflict between Anasazi farmers them-selves or outside harassment—the shield paintings could have signaled con-solidated group identity and power.

The meaning that the shield designs as such held for the Anasazi is not at all clear. Seemingly generic, concentric circle shields or shields with a cen-tral dot have a broad distribution throughout the Colorado Plateau, and while fewer in number, shields with vertical lines and bands or diagonal quartering also are widely dispersed. A clan, by definition, would not have been limited to a single community, and one would expect that a given clan symbol would have been repeated in numerous sites throughout a region. Many of the most distinctive shield designs, however, occur as single examples, but whether there was any correlation between design and a community seems unlikely in many cases. It is difficult, for example, to reconcile the many individualistic shield patterns at Davis Gulch, presumably painted by a single person, with social hypothesis. Likewise, shield designs elsewhere within a single site are widely variable.

Overall, a review of the various shield motifs and their distribution does not appear to support a social affiliation related to design, at least one that can be determined easily. Being largely abstract, they do not correspond to con-temporary clan symbols among the Hopi, which are largely representational

and are also widely repeated,[31] Although one might argue that changes in ideology and corresponding iconography over the last 700 years might account for such discrepancies. The only shield in the sample with a representational design was given a tentative interpretation by the Hopi elders who accompanied me to Betatakin in 1966. They debated whether this figure might represent Masau, the male Hopi god who is the owner of the earth surface, a major fertility power, and in charge of fire and the passages to the Underworld.[32] Masau also has an important role in warfare (see Chapter IV). The elders based their interpretation primarily on the fact that the head of the figure is undecorated and thus could be a skull, and because of the presence of the red and yellow flanking arcs that suggest fire, an element that Masau controls. This likeness suggested to them that this was a Fire Clan symbol, although they were by no means certain about this. The skull-like appearance of the central face in the shield at Turkey Cave also looks like Masau. An alternative interpretation of the Betatakin painting is offered below.

Location, size, and general visibility may be the more important attributes for determining the function of these shield paintings. A strong case can be made that they served as magical protective elements, an interpretation that is supported by ample ethnographic evidence. As previously mentioned, these large white shields, many nearly a meter in diameter, for the most part tend to be located above the houses of defensible cliff dwellings or storage units, where they can be seen from a distance. Being white in color, they stand out against the tan cliffs on which they are painted. The very fact that they are shields denotes the vocabulary of defense. Ethnographically shields were regarded as being considerably more than merely functional protective devices. They also were imbued with a spiritual dimension, and their designs

were viewed as having power to provide protection. Just as the shield and its design empowered and protected its wearer,[33] it is likely that images of shields and the designs featured on them similarly would have transmitted their protective powers to the vicinity in which they were painted. Following this line of thought, as statements of supernatural protection they may have signaled warnings to outsiders. If they also conveyed implications of social identification, this would not have contradicted their magical defensive function, but may easily have contributed to it. More research, however, is needed on the potential social implications that the shield designs have to offer.

INTERPRETIVE IMPLICATIONS OF THE BETATAKIN SHIELD AND BASEBALL MAN

In the vicinity of Petrified Forest in the Little Colorado River region, Patricia McCreery and Ekkehart Malotki[34] have found repeated examples of stick-figure anthropomorphs flanked by a pair of disks. These petroglyphs closely resemble the Betatakin shield design. Although there is no clue as to the actual meaning of the disks, they suggest that these solid circles may signify the figure's particular identity. The figure in question is female, and in several instances animals and flute players are pecked in smaller scale nearby. The Betatakin figure also appears to be female, and a large painting of a mountain sheep is located to the upper left. Its female gender argues against its interpretation as Masau (Fig. 2.10).

McCreery and Malotki propose that the Little Colorado examples are representations of a figure generally designated among contemporary Pueblos as Tiikuywuuti, or Tuwapongtumasi, Child-Water Woman or the Mother of

Game. "The figure is consistently depicted as female, and in four instances is associated with animals and symbols of the hunt. Her unvarying posture, arms raised and bent at the elbow, legs extended to each side and bent at the knee, gives her a rigidly formal mien."[35] How a figure related to the hunt and fertility finds itself located on a purportedly defensive shield motif at Betatakin is not clear until one learns that she also is a dreaded figure that makes men freeze in terror.[36] Elsie Clews Parsons[37] equates Tiikuywuuti with the sister of Masau, and notes that she was prayed to in time of war. McCreery and Malotki[38] add that Tiikuywuuti is also known as Child-Sticking-Out-Woman, who died in childbirth (her offspring later were discovered to be infant game animals), and she wanders as a ghost and wails.[39] She is perceived as a beautiful woman who wears a "hideous mask of bones" so no one can discern her true appearance. Chakwaina (also Tsakwaina or Chakwena) Mana seems to be a modern kachina manifestation of some of the concepts that Tiikuywuuti embodies, Chakwaina Mana herself being a warrior as well as the Mother, Keeper, or Owner of all the Game Animals, and a patron of childbirth. A ritual enactment of this relationship between warriors and childbirth at Hopi takes place during the *kaletaka*, or real warrior initiation, that ends with a visit by the warrior initiate to the shrine of Talautumsi, a similar Hopi goddess of childbirth.[40]

This contemporary Hopi interpretation of Tiikuywuuti is strikingly similar to a description of the Aztec deity Cihuacoatl, an earth-mother goddess, patroness of the *cihuateo*, the wailing spirits of women who died in childbirth and who shared their afterlife with warriors. Like Tiikuywuuti, Cihuacoatl herself was perceived as a well-dressed woman with a skeletal jaw, a figure of evil omen who, among other things, demanded war and sacrificial victims.[41] The wandering wailing woman is a Mexican element that has taken several forms in Mexican oral tradition and comes down to us today as La Llorona. Assuming that the Betatakin figure derives from such an ideological complex, her appearance on a shield is appropriate.

The shield painting popularly known as Baseball Man (Plate 1) also merits special consideration in this discussion. This quite elaborate bicolored shield is situated low on a cliff face adjacent to Anasazi habitation remains. On an inaccessible ledge above is a series of small rooms, many of which may have functioned primarily as storage facilities. Not only is the red and white design unusual among shield motifs but, more importantly, it was superimposed over a Basketmaker II anthropomorph, painted in a creamy white some 800 years or more earlier, probably between ca. 200 B.C. and A.D. 450. In essence, the Pueblo occupants of this site turned the Basketmaker figure into a shield bearer. The carefully centered shield on top of the Basketmaker figure incorporates the older image visually, and within the current hypothesis of defensive magic I suggest that this merging of images served to incorporate the perceived power of the ancestral figure, adding to the protective function of

the design. Other examples of this kind of superimposed relationship are found in Canyon de Chelly in the upper Chinle drainage.

In neither Baseball Man nor the Betatakin painting is there any implication that the designs signify broader social relationships, and both paintings support the hypothesis that these designs may have functioned as protective power symbols.

Anasazi warfare iconography before ca. A.D. 1300 on the Colorado Plateau is very circumscribed in scope, being limited almost entirely to shields and, to some degree, the designs they bear. These shields are, nevertheless, material indications of conflict and strife in the thirteenth century, evidence for which is supplemented by other archaeological data, to be considered further in Chapter V. Response to conflict has an ideological dimension that is expressed in the imagery as well as in the location, or placement, of the rock art.

As we have seen, the distribution of this Anasazi iconography articulates spatially with Fremont rock art in southern Utah in which shields and shield bearers appear in even greater numbers. In this northern zone there is often difficulty separating Fremont and Anasazi archaeological remains, although ethnicity in the art seems to be identifiable on the basis of body form and accessories. It is likely that a more or less common shield iconography, underwritten by a common ideology, grew out of a regional response to a situation in which conflict played an ongoing role. As reviewed previously, whether this conflict was endemic or involved outside marauders is a matter of current debate.

Whatever the cause, the Fremont as an identifiable cultural configuration in the archaeological record vanished around the fourteenth century, and the Anasazi to the south abandoned the adjoining regions by the end of the thirteenth. Interestingly, warfare and its symbolic expression in the graphic arts did not cease, but it became vastly more complex.

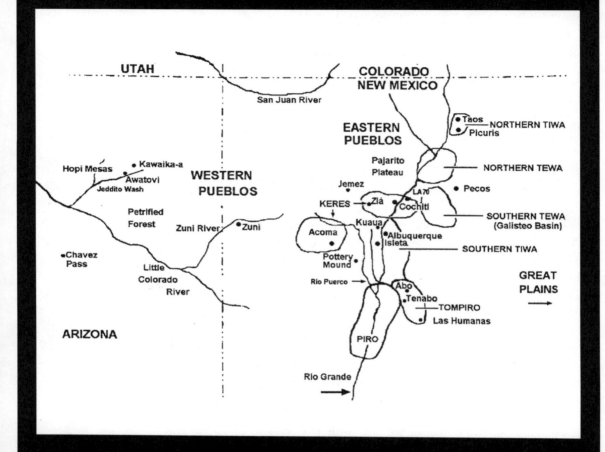

Fig. 3.1
Map of the Pueblo world showing ethnographic linguistic regions, contemporary Pueblo villages, and various archaeological sites dating after ca. A.D. 1300.

WAR ICONOGRAPHY IN ROCK ART AND KIVA PAINTINGS, ca. A.D. 1325–1600

Shortly after ancestral Pueblo people departed the San Juan drainage and adjacent parts of the Colorado Plateau around A.D. 1300, their rock art and kiva murals displayed a new iconography that included kachinas as well as complex symbolism and metaphors pertaining to warfare. These are visual statements of a much-changed underlying ideological dimension incorporating ideas not found in the earlier Puebloan imagery. Many aspects of this symbolic structure dating back to the fourteenth century have persisted in Pueblo culture to the current day. The focus of this symbolic complex is some 300 miles or more to the southeast of the Colorado Plateau in the Rio Grande Valley (Fig. 3.1). Here, early to middle Classic period kiva murals at Pottery Mound, a pueblo site on the Rio Puerco south of Albuquerque, New Mexico, also incorporate this new world of symbols and visual expression.

Geographically closer to the Kayenta and the thirteenth-century shields are the kiva murals in the Jeddito drainage on the Hopi Mesas in northeastern Arizona. These, too, however, break with past traditions to the same degree as the art in the Rio Grande. Throughout the Pueblo world in the fourteenth century, this art, with its prominent warfare and kachina iconography, developed in the context of new environmental settings and in response to different internal and external social environments that included the construction of significantly larger towns and different outside contacts.

Following the Anasazi abandonment of the San Juan drainage and neighboring areas of the northern Colorado Plateau by the end of the thirteenth century, Pueblo populations increased in the Little Colorado region and along the Rio Grande and its tributaries. This demographic shift was accompanied by the growth of unprecedentedly large, aggregated, multi-storied pueblos, a building trend that began in the late 1200s. Towns sometimes consisted of as many as 1,000 or 2,000 ground-floor rooms enclosing several spacious plazas. Simultaneously, major changes in ceramic techniques and designs accompanied new developments in other media, notably the rock art and kiva murals.

The complex of images of the late prehistoric rock art in what is now New Mexico is designated as the Rio Grande style.[1] In the Little Colorado

River region, McCreery and Malotki[2] describe a related but somewhat less complex petroglyph style with fewer discrete elements. They refer to this Little Colorado River rock art as the Palavayu PIV style to distinguish it from the Rio Grande rock art from which it differs in several respects.[3]

Although war iconography in rock art made ca. A.D. 1325–1600 is found throughout the Pueblo landscape, from the Little Colorado River drainage to the Rio Grande valley and neighboring regions to the east, it is most highly developed in the Rio Grande style of the Eastern Pueblos. Within this vital new art movement, iconography related to warfare not only vastly increased but was highly diversified, and a wide range of new images is pictured in the Rio Grande valley rock art in the fourteenth and fifteenth centuries. In Pueblo art after A.D. 1300, shields and shield bearers continue to be represented but they are pictured more frequently, and shield bearers are often vigorous, active figures. Further, the elements on the shields themselves take on new forms and meanings (Fig. 3.2).

Beyond the shield and shield bearer, the war-related repertoire of the rock art of the Eastern Pueblos is expanded to include weapons, deities with warrior capacities, a variety of warrior kachinas (kachinas being rain-bringing supernatural intermediaries between the Pueblo people and their deities), and human warriors with weapons but lacking shields (Fig. 3.3). Also found is a wealth of new symbols and graphic metaphors that include stars and animal war patrons such as bears, mountain lions, eagles, and possibly owls.

In contrast, among the Western Pueblos at this time rock art as a communicative art form was much less developed. Shields and shield bearers are present but in fewer numbers, stars are extremely rare, and other war-related symbols, including certain bird images, are limited in number and diversity. For the most part, in the rock art of the Western Pueblo region, animals with multi-symbolic referents, such as bears and mountain lions, lack association with other iconography that would link them to the war complex.

Kiva painting throughout the Pueblo domain changed from an earlier format, in which isolated, small, simple life forms painted in a single color floated against empty space and simple geometric patterns enhanced architectural design, to large polychrome paintings, dynamic compositions, and integrated visual statements that encompassed entire walls. Beginning in the fourteenth century, the large majority of the painted kivas were rectangular. In the Rio Grande valley, all four walls were often painted. Symbols of warfare played a large role in the kiva paintings at Pottery Mound in the Rio Grande valley and in the Jeddito drainage at Hopi, where it is assumed that the war imagery was a backdrop to, as well as an integral part of, the rituals enacted in these closed settings. Some murals depict complex ceremonial scenes with numerous human and animal participants (Plate 11). In contrast, in the rock art, relationships between figures are less extensive; an image

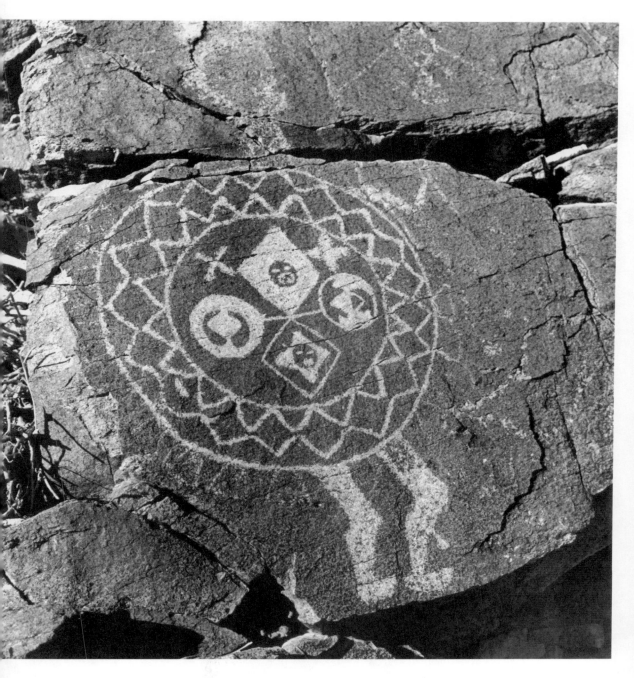

Fig. 3.2
Galisteo Basin shield bearer, Southern Tewa. Serrations are believed to represent the sun's rays, and star motifs are featured on the interior of the shield. The flat feathers surrounding the circumference resemble turkey feathers. A bird with outstretched wings is visible at upper right. *(Photograph by David Grant Noble.)*

Fig. 3.3
This warrior in profile view with spear and eagle–feather head-dress stands more than a meter tall. A narrow band is tied around one knee. Southern Tewa, Galisteo Basin.

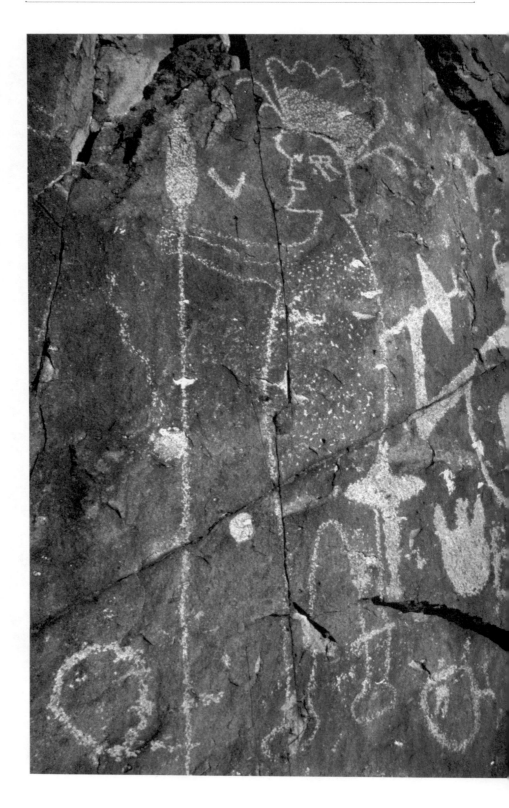

may stand as an isolated statement, or two or three figures may constitute a meaningful group.

ROCK ART: IMAGES OF WAR

During the Classic period among the Eastern Pueblos, many more rock paintings and petroglyphs were created than formerly, with the images at many locations numbering in the thousands. As the production of rock art and kiva murals increased, they became important vehicles for the communication of ideas and social and religious values, although the function of rock-art imagery in its landscape contexts would have differed from that of the kiva murals.

In addition to the iconographic and stylistic shifts that occurred after the end of the thirteenth century, the kinds of topographic situations in which rock art was made become more diversified. As described in Chapter II, during the late thirteenth century Pueblo rock art related to warfare was made almost exclusively in rock shelters harboring defensive cliff dwellings. However, with one possible exception at Cliff Palace, no imagery related to war has been identified from the kivas inside these dwellings. After ca. A.D. 1325, war-related figures along with other rock-art motifs were displayed both on rocks near villages and in the open country some distance away, so that they became a part of the Pueblo terrain and definition of Pueblo space (Figs. 3.4 and 3.5). The locations chosen to make images related to war and warlike rituals may in themselves have taken on symbolic dimensions, an issue to be considered later on.

Rock-Art Shields and Shield Bearers

The many shields and shield bearers present in this rock art are the most compelling elements among the plethora of other war-related images. The circular shield as an element in its own right outnumbers shield bearers in most regions. Although shield bearers are represented in a wide range of sizes in the rock art, shields and shield-bearing warriors wearing body shields continue to be featured on a large scale, a factor that denotes the importance of these figures.

Small hand-held shields are extremely rare. There is only one questionable example in the rock art examined here. In the kiva paintings, on the other hand, there is one hand-held shield in the Jeddito murals, carried by a figure engaged in combat, and one or two others at Pottery Mound. Of these, one is large enough to be described as a body shield, although it is not so positioned in the painting (Plate 12).

Shields and war iconography are especially prevalent in late prehistoric rock art in the Northern and Southern Tewa linguistic provinces of the early historic era. The Southern Tewa are also sometimes referred to as the Tano. (Note: Although Pueblo linguistic provinces are delineated on the basis of

Fig. 3.4
View of the Galisteo Basin with the Comanche Gap volcanic dike visible in the distance.

information from the early historic period, it is assumed that the complex linguistic divisions extended back into late prehistory.) Historically, the Tewa elaborated war themes more than did other Pueblos, and the rock art indicates that this emphasis had roots in the late prehistoric period. In the Galisteo Basin of the Southern Tewa region, shield designs and the technical excellence of their rendering reach aesthetic heights, and warriors with and without shields and subsidiary war images are represented in their greatest diversity and complexity of forms. Their often fine execution indicates that a considerable investment of time was involved in their production. This, combined with their complexity, indicates that these figures reflect the outstanding importance of warfare in this region.

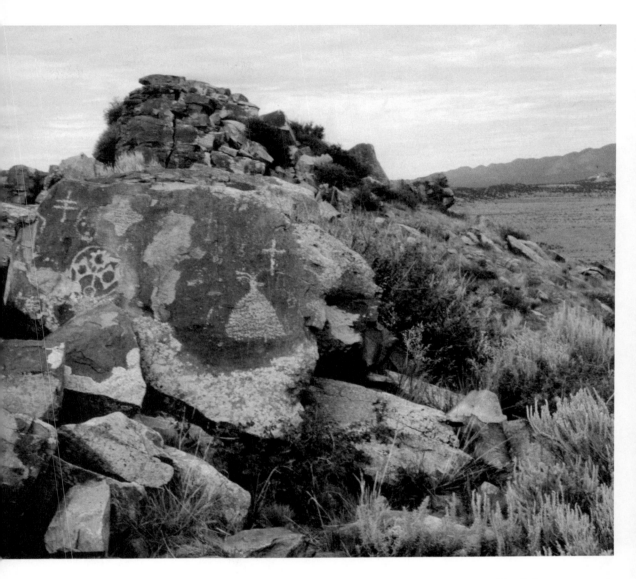

Sometime after A.D. 1300, shield designs take on a variety of new forms notable for their creative elaboration. Classic-period shields in the Rio Grande valley rock art and elsewhere exhibit a much wider range of decoration than do shields on the northern Colorado Plateau. Although plain shields and shield designs based on concentric circles are popular and are found in about equal numbers, many of the later designs exhibit innovative variability and individuality. Even the commonly occurring four-pointed star, for example, is utilized as a shield design in a variety of ways (Figs. 3.5 and 3.10).

In contrast with the earlier painted shields on the Colorado Plateau, the Classic-period rock-art shields most commonly occur as petroglyphs. Only a

Fig. 3.5
Comanche Gap dike with dragonfly, shield, star, and Shalako kachina pecked along the crest. The Christian cross is a recent addition.

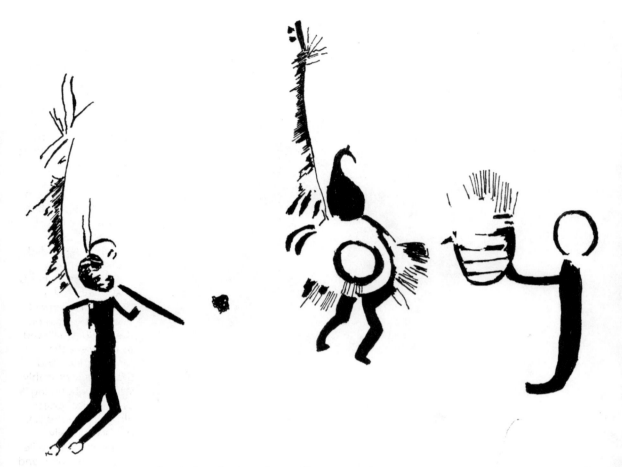

Fig. 3.6
In this Piro painting, small red figures only a few inches tall, including a shield bearer and a fluteplayer, carry elaborately feathered staffs. The seated figure holds out toward the shield bearer a mask with horizontal facial striping and tall feathers

few painted examples are known, and among these only one, a shield bearer, is rendered on a large scale. Shield bearers are most frequently portrayed in profile as dynamic, advancing figures wielding weapons. Within the imagery considered here, there are at least 28 petroglyphs of shield bearers with weapons in their hands or protruding from behind the shields. In addition, long staffs believed to be ceremonial in function are carried by shield bearers pictured in Piro rock art (Fig. 3.6).

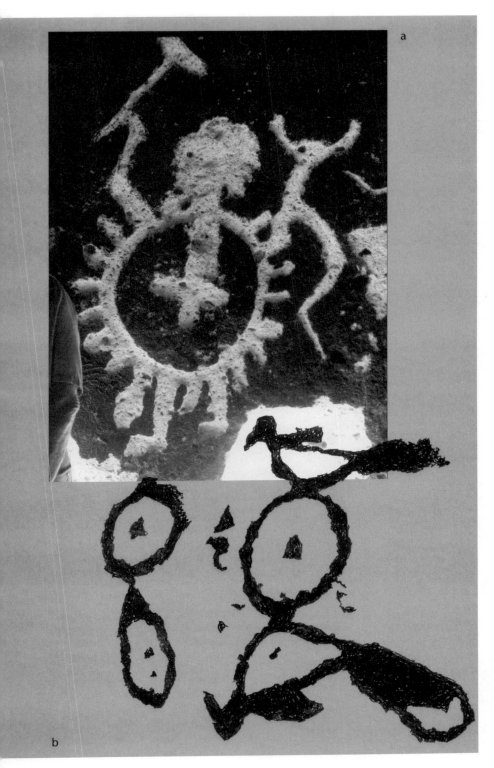

Fig. 3.7, a–d

The later shields often have a variety of elements around their peripheries. Radiating features suggesting the sun commonly take the form of ticks, serrations, or long feathers (see p. i and Fig. 1.3).

(a) This Northern Tewa sun-shield bearer inside a smoke-blackened cavate room in Mortandad Canyon on the Pajarito Plateau holds a war club and a two-horned serpent. The simple cross on the shield is believed to represent the Morning Star, and the serpent probably stands for lightning as a magical projectile (see Chapter IV). (b) Occasionally entire birds in profile may be attached, and macaws, jays, and magpies are suggested by the form and/or coloration of the birds. Shields with birds are most commonly encountered in the detailed paintings of the Jeddito kiva murals, although there are a few examples, as pictured here from Petroglyph National Monument, in the rock art of the Rio Grande valley.

(c) Flat-ended turkey feathers project from shield rims in some examples, as seen on the Northern Tewa shield bearer, also from the Pajarito Plateau, who wears a pointed, netted War God cap. (d) Other shields have scalloped edges, like this Southern Tiwa shield with an avian motif at Petroglyph National Monument in Albuquerque. Lunettes and serrations may also occur along the inside periphery.

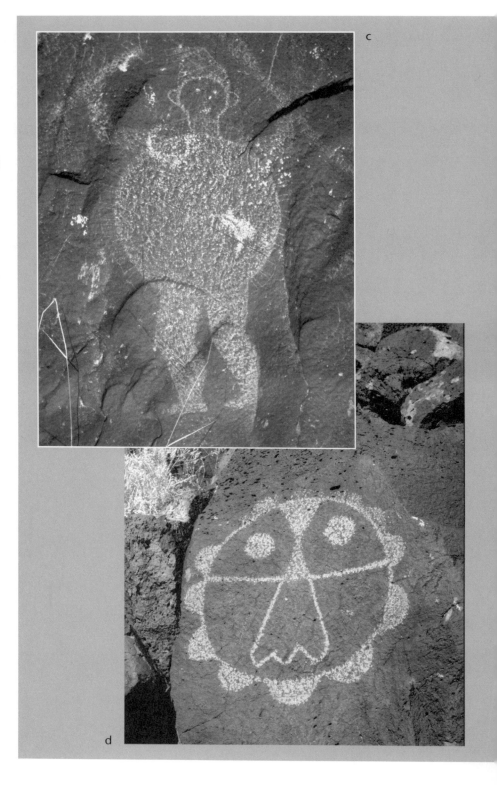

c

d

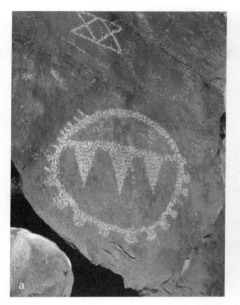

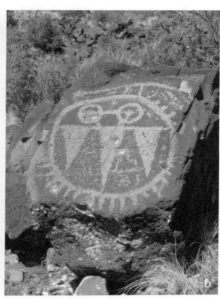

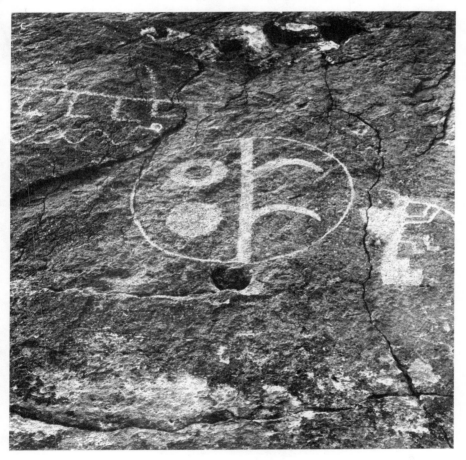

Fig. 3.8, a–f

There are several distinctively Pueblo IV shield designs or layouts. A line or band commonly divides the shield horizontally above the center point. In a number of examples, large pendant triangles are suspended from this line. The space above may be empty, contain one or two circles, or, less often, contain small crosses that probably represent stars. These are especially prevalent in the Northern Tewa region.

(a) This Northern Tewa shield is divided horizontally, with pendant triangles dominating the lower two-thirds of the design. There are two stars in the upper part of the shield. The two hour-glass motifs above the shield denote scalp-knots. These may be newer additions. (b) A Northern Tewa shield in the upper Rio Grande valley displays pendant triangles and radiating lines around the circumference. A projectile is shown over the top of the shield. Another frequently encountered pattern is a shield vertically divided by a line or band with curved motifs attached to the vertical element, while a vertical sequence of two or more circles is found in the opposite side. Vertical bands may also lack.

39

the hooked elements. (c) This Keres or Southern Tewa shield is vertically divided and has circles and bands with the curved elements attached. The flute player seated on the cloud terrace is clearly associated with the shield, uniting the concepts of war and fertility. *(Photograph by Curtis F. Schaafsma.)* (d) Another Southern Tewa shield in the Galisteo Basin is adorned with curved elements and circles. A star, birds, snakes, and hands occur nearby. (e) This Southern Tewa shield bearer in the Galisteo Basin provides a variant on the above shields. Double arcs are shown on the inside perimeter of the left side. (f) Shield and other petroglyphs, Jemez region.

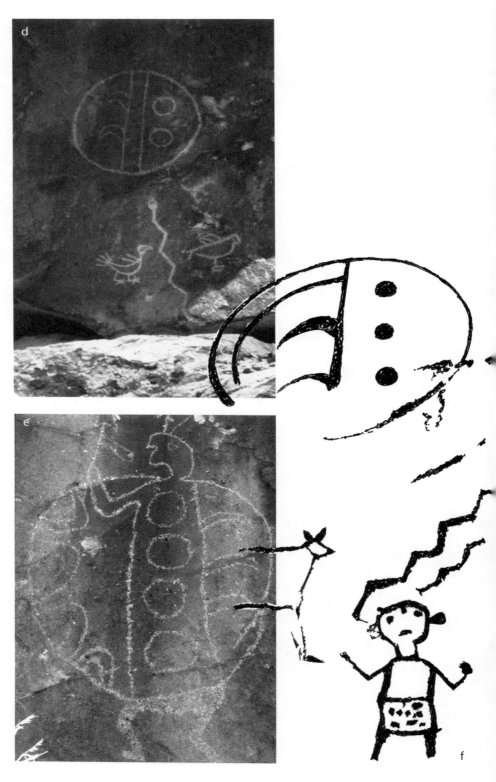

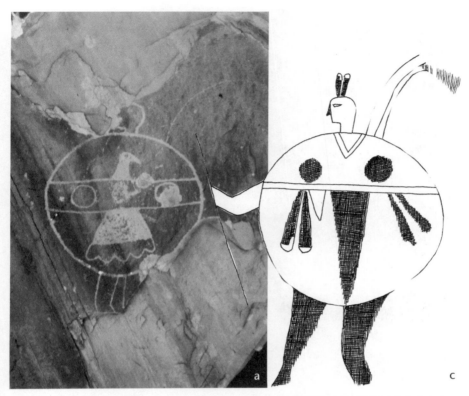

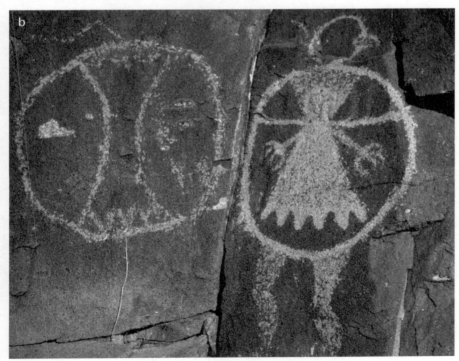

Fig. 3.9, a–c

Related to the sun shields are shields with eagle-like motifs. These are common in the central Rio Grande region, and avian elements are combined with shields in a variety of creative ways.

(a) On this Southern Tewa shield the whole bird is represented. (b) On this pair of Southern Tewa shields the bird is symbolized by a stylized torso and/or tail and talons. The shield bearer (right) is actually portrayed with a bird's head. (c) Occasionally single eagle feathers are shown attached to the face of the shield. In this example, carved and abraded on sandstone in the Galisteo Basin, a one-step pattern at the tip of the feather denotes the black-tipped tail feather of a young eagle. The design on the shield also includes a large triangular element.

Other avian motifs in connection with shields, as mentioned previously, include feathered edging or birds attached to the rim.

41

Fig. 3.10

The four-pointed star is a characteristic element on Classic period shields in the Rio Grande drainage, as seen on these Southern Tewa shields from the Galisteo Basin. Typically this star has an expanded center and tapering points. The star may fill the design field, or it may be simply a smaller element in the center, as in this other example. There are also instances in which several stars and/or equilinear crosses representing stars are placed together on the face of the shield. The serrations around the circumference are believed to indicate the sun's rays.

Stars do not play a major role in the Colorado Plateau iconography. Although two shields among the Davis Gulch paintings had equilinear crosses (see Fig. 2.16), without any further information, it is not known what these crosses stood for in this cultural context. In Rio Grande–style rock art and in the kiva murals, however, these simple crosses occur repeatedly and clearly represent stars (see Chapter V).

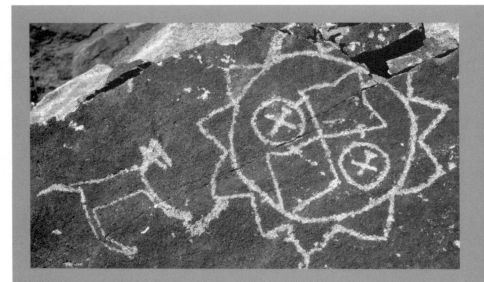

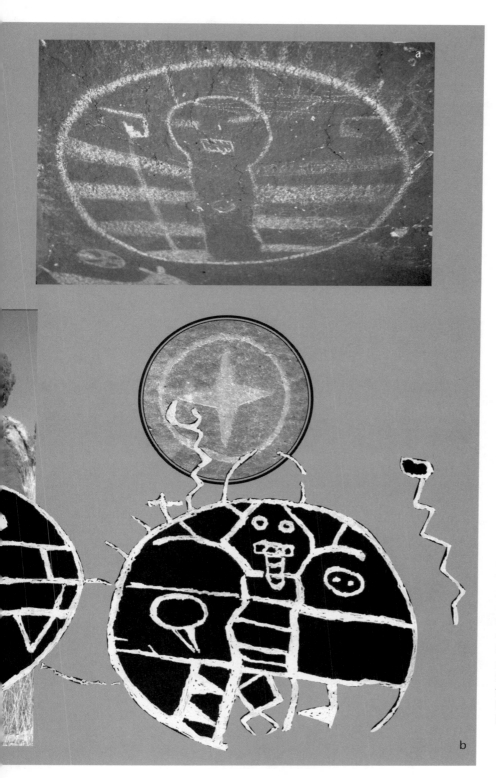

Fig. 3.11, a–b

Life forms, including anthropomorphic figures, are slightly more commonly represented on Pueblo IV shields than on shields from the thirteenth century. For the most part, humanlike elements are shown as a head and face above a straight, appendageless body. Several heads have horns and a rectangular mouth with teeth that create a fearsome aspect.

Serrations or triangular elements on the outer edges or within the interior of several of the shields on which these anthropomorphs occur suggest that the beings on the face of the shields represent the sun or closely related supernatural entities (see Chapter IV). (a) For example, this Northern Tewa anthropomorphic figure with teeth displays rayed elements and peripheral serrations that suggest that this is a sun shield. Stepped elements flanking the figure indicate clouds. (b) In these Northern Tewa paired shields the horns of the anthropomorphic figure on the right-hand shield extend beyond its periphery.

Fig. 3.12
There is a small number of very large shieldlike circles (over a meter in diameter) filled with miscellaneous motifs rather informally arranged.[2] Some have heads attached at the top, and two have short "arms." The most elaborate of these "shields" is at Comanche Gap in the Galisteo Basin, where one occurs in the context of war-related iconography. Elements inside include a human figure, bear and badger tracks, eagle talons, snakes, handprints, circles, stars, and a war club. There are also two series of arcs inscribed along the inside circumference. The symbolic significance of these large circles in general is unclear, and how closely they relate to warfare is uncertain, although context and several elements in the Comanche Gap example do suggest war affiliations. Contemporary Northern Tewa tend to view these complex circles as representations of the Tewa world and everything in it.

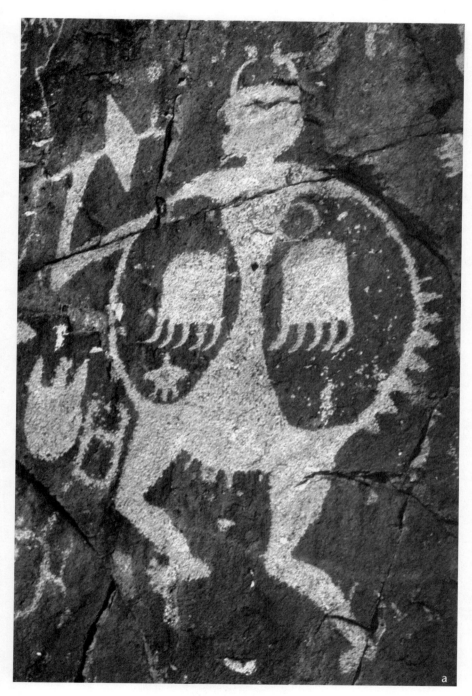

Figs. 3.13, a–d
In the more complete renditions, the animated shield bearer of Pueblo IV may be shown with legs bent, full-fledged calves, and well-defined feet. Even frontal figures are usually shown with facial features and arms, and they may hold weapons in their hands.

(a) This horned shield bearer holding a bipointed war club is one of a pair (see page i) at Comanche Gap in the Galisteo Basin. Bear-paw prints and a small star with talons decorate his shield. (b) Another Southern Tewa shield bearer carries a war club and projectile. (c) A third carries a quiver of arrows and holds a projectile in one hand, a bow in the other. He appears to be yelling, and a star fills the design field of the shield. (d) A frontal Piro shield bearer with horns and a toothed mouth is portrayed with weapons projecting beyond the shield. The equilinear crosses are thought to represent stars.

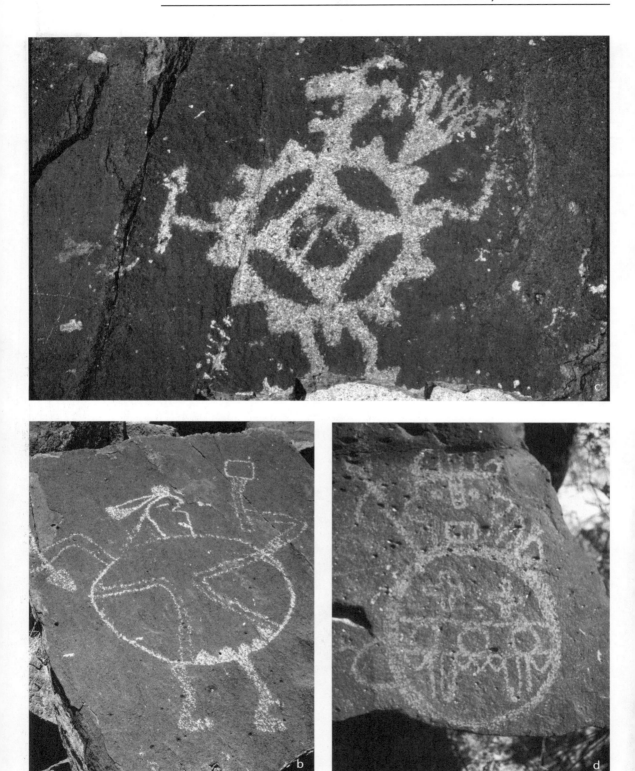

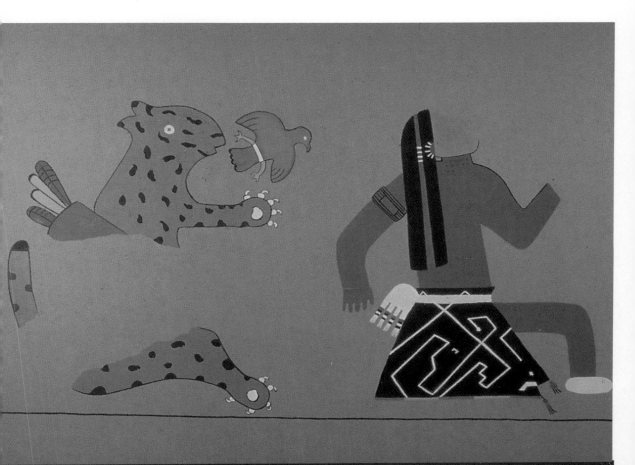

Plate 11
Pottery Mound mural with seated feline and human Kiva 6, layer 1. *(Photograph courtesy of the University of New Mexico— Albuquerque, Maxwell Museum of Anthropology.)*

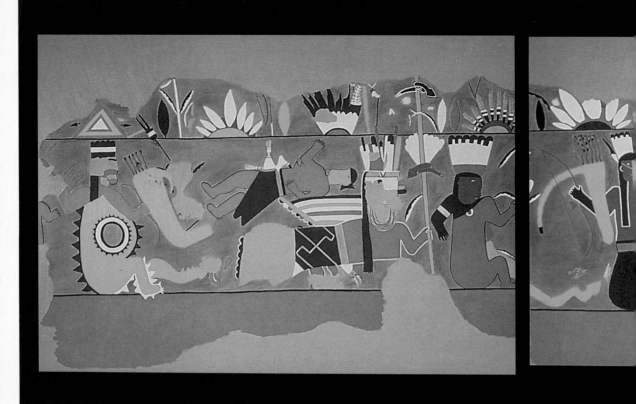

Plate 12

Layer 1 in Kiva 2 is painted with a complex ceremonial scene that encompasses all four walls[4] It appears to be an indoor scene, probably within a kiva. The south wall, extending to the southern portion of the west wall,[15] shows standing and seated participants, diversely attired, involved in what is apparently a war ritual. The group is led by the two warriors wearing differing pointed caps. The lead warrior has a black face, wears a pointed cap crossed with hatching, and holds a shield with a bold equilinear cross in one hand and a staff in the other. Small arrow points are pictured near the lower edge of his hat. The second warrior, with a Dick Tracy profile, holds a bow and feathered staff. He wears a large snake "belt" and has a kind of skullcap with a short apical projection and a feather fan. The ethnographic record provides ample evidence that this kind of headgear belongs to the War Gods, who apparently are impersonated here, leading the group. In front of the War Gods are three small, much simpler, seemingly incomplete personages, one of whom is winged. Behind the War God impersonators is a series of seated figures variously attired and wearing a variety of tall feathered headdress. They carry quivers filled with arrows and bows. Some hold staffs. A third warrior with a war club follows behind the War Gods.

Next, moving to the left, is a front-facing bilaterally colored person holding a mountain lion skin quiver, bow, and possibly a small shield.

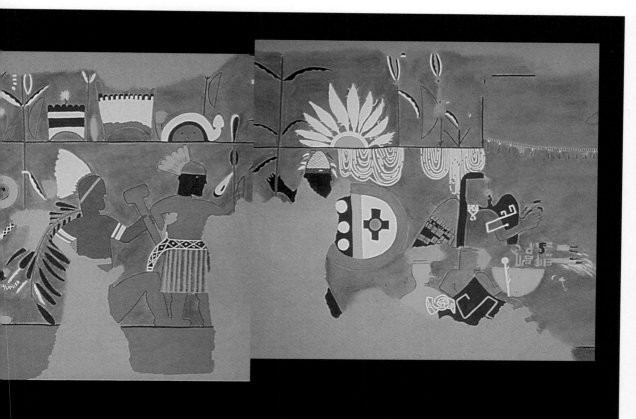

The figure appears to have an asymmetrical hair arrangement—one side hangs loose while the other is done up. There is a diagonal line across the face. The next figure to the left wears a towering eagle-feather headdress. The diagonal line of the garment suggests female attire, although this is not clear. The conflated figure of a masked bird/human follows and holds a feathered staff around which rattlesnakes are wrapped. Above the striped wing of this composite being floats the horizontal

figure of a woman. At the far left, the last (preserved) member of this group is edged with triangular serrations, and a circle, similarly rimmed, is painted in the middle of his paunchy midsection. This impersonator also holds a bow and quiver filled with arrows.

Above this entourage is a line, apparently representing a shelf, upon which rest various headdresses with radiating feathers. Bows and arrows are pictured in between. Worthy of special note is a triangular

element, presumably representing a headpiece, from which projectile points radiate. Eagle and red hawk feathers are significant components of the headgear, both worn and on display.

Snakes occur in various locations—near the baseline of the painting, encircling the feathered staff, behind the warrior holding the ax, and around the waist of the warrior in front of him. On the shelf above this last figure is a mask or headdress that features a thick white snake.

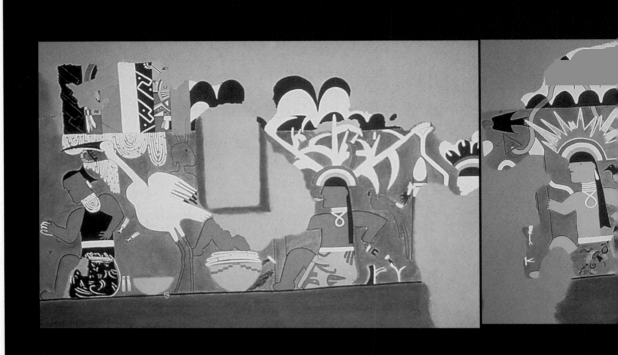

The warrior group moves across the walls of the kiva to face another group of ceremonialists in the vicinity of the niche in the center portion of the west wall. The latter group moves from right to left, starting on the east wall and extending across the north wall to the niche on the west side.[15] In this area of the mural, necklaces are suspended from the kiva shelf, and above these textiles hang in front of a long panel of crescentdesigns representing clouds, around which lightning snakes. The second group consists of seated ceremonialists with atmospheric headdresses comprised of clouds, ice, and rainbows, with clouds pictured rising out of the baseline on which the personages are seated. One person holds a netted gourd in his hand. A single standing figure,

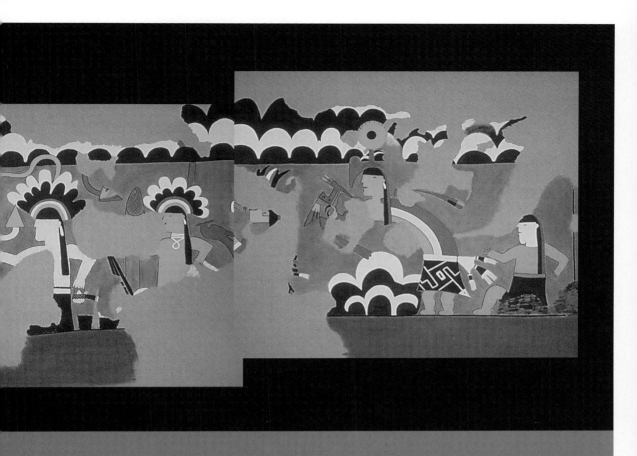

impersonating a rainbow, wears a sunflower on the head and holds a long-tailed crested bird in what appears to be a claw. The first five seated figures of this group, each with a bird at its back, are separated by tall, rather thick pointed sticks, that Hibben[16] interprets as "spears," although this is open to question. Several species of birds are represented. They include a barn swallow, a second species of swallow, a possible jay, a macaw, and a large figure of a whooping crane. This dramatic juxtaposition of clouds, lightning, birds, and war themes will be considered further in Chapter IV. (Photographs courtesy of *University of New Mexico—Albuquerque, Maxwell Museum of Anthropology.*)

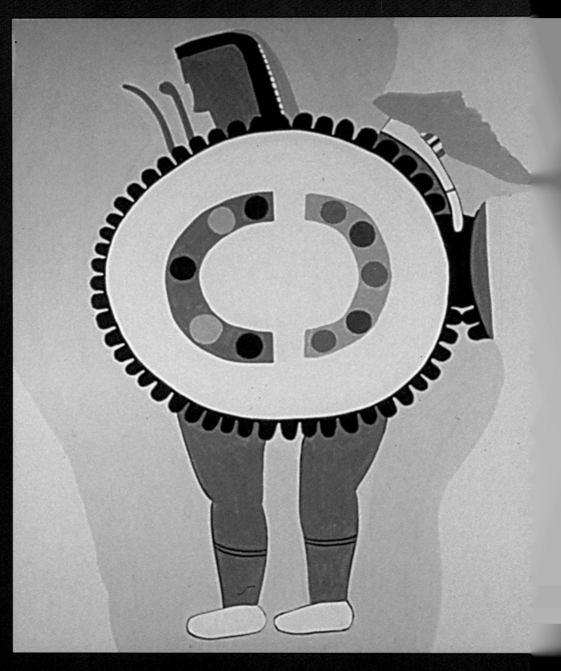

Plate 13
 Shield bearer, Pottery
Mound, Kiva 2, layer 3.
(Photographs courtesy of
the University of New
Mexico—Albuquerque,
Maxwell Museum of
Anthropology.)

Plate 14
This photograph is of the original plaster with grouped feathered stars with facial features as well as a reconstruction of same; note the absence of the eagle-feather headdress on the star on the extreme left of the reconstruction. *(Photographs courtesy of the University of New Mexico— Albuquerque, Maxwell Museum of Anthropology.)*

Plate 15
Jornada-style petroglyph of corn plant with a zigzag stem as an extension of lightning coming from a cloud, Three Rivers, New Mexico.

WARRIORS AND WEAPONS: ADDITIONAL WARRIORS, WAR-RELATED SUPERNATURALS, AND OTHER RITUALISTS

Rock art depicts a variety of other persons lacking shields but carrying bows and arrows, lances, or axes, or embodying other characteristics that the ethnographic record associates with the Pueblo war complex and roles related to protection, defense, and conflict, in addition to rain and fertility. Their involved symbolism and ritual roles will be examined in Chapter IV via ethnographic information. These figures include both supernaturals and human warriors.

Star-faced supernaturals holding weapons, black-faced kachinas with red feathers and ears, war gods wearing the characteristic conical headgear or a cap with an apical projection, and kachinas that function as guards or folkloric protagonists in inter-pueblo conflicts are among the war-related figures pictured in Classic period rock art of the Eastern Pueblos.

Weapons of various kinds have been described in the hands of warriors. In some cases the weapon is unidentifiable, but in numerous cases these artifacts of aggression consist of war clubs, arrows, long lances, spears, and yucca whips. Closely affiliated are the quivers of arrows that some combatants carry. Quivers, however, are pictured more frequently in the kiva murals, where they are better detailed and disinguished by the long tails of the mountain lions, the skins of which were and are used for this purpose. On rare occasions projectiles and stone axes are pictured as separate artifacts, as illustrated by this probable war club at Petroglyph National Monument (Fig. 3.14). When shown in the hands of shield bearers and other warriors, war clubs and projectiles are usually held in the right hand, while bows are in the left.

The simple bow, or D-bow, and the more complex recurved bow are illustrated in both the rock art and kiva murals of this period. Although archaeologists often assume that the recurved bow is sinew-backed,[4] both types may be either plain wood or sinew-backed,[5] and it is impossible to tell from representations in the rock art and kiva murals which type is pictured. There is no evidence, however, that the simple D-shaped bow was ever a sinew-backed bow among the Pueblos. The recurved bow, which may have been sinew-backed, does not appear in the art before the fourteenth century, in spite of Steven A. LeBlanc's discussion[6] that, without citing specific evidence, tries to link the appearance of this more powerful weapon with accelerated Anasazi warfare

3.14
Probable war club with blunt ends and tassels, pecked as a separate element on a boulder. Petroglyph National Mounment, Southern Tiwa.

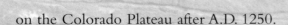

on the Colorado Plateau after A.D. 1250.

War clubs are also of two types. Although both are double bitted, one has rounded, blunt ends while the other is sharply pointed (Fig. 3.13,a). The bipointed axe appears to be a Plains-style axe not found in Pueblo archaeological collections, which raises the question of the ethnicity intended for the bearer of this weapon. The paired shield bearers on the Comanche Gap

dike, an intrusive igneous feature in the Galisteo Basin, carry each type, and there is no suggestion that they are not Pueblo figures (p. i and Fig. 3.13a). A second bipointed axe appears in the hand of a star kachina on Albuquerque's West Mesa (Fig. 3.17c), and again, this is not a "foreign" supernatural. Likewise, one is found in the hand of a bird kachina at Pottery Mound.[7] While the Pueblos were familiar with this type of war club and incorporated it into their pictorial repertoire, if it carried specific symbolic connotations, these are not readily apparent.

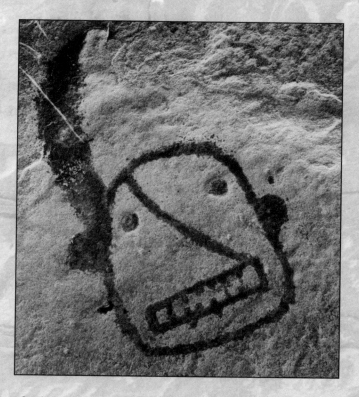

For final consideration with regard to weapons are representations of magical serpents in the hands of warriors. A case in point is the shield beaer from the Pajarito Plateau who holds a two-horned serpent in his left hand (Fig. 3.7a).

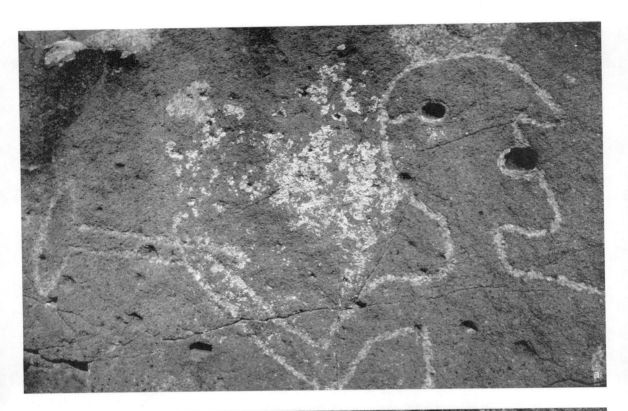

Fig. 3.15, a–e
(a) Unlike the stereotyped frontal faces, a number of the profiles of shield bearers and other warriors are individualized, approaching portraiture, as in this Northern Tewa figure with a war club. Natural holes in the rock define the eyes and mouth of this figure. (b Representations of warriors with and without shields include near-portraits of toothless old men wielding weapons (see also mural painting

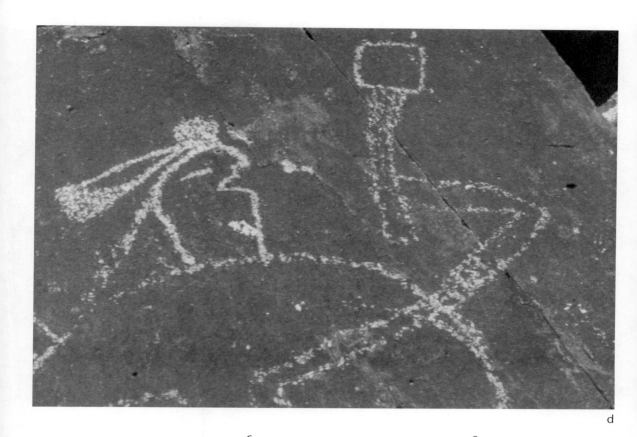

d

c

e

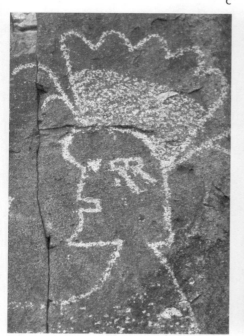

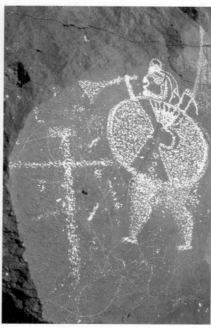

[Fig. 5.3] from Pottery Mound). (c) Others have Dick Tracy-like profiles characterized by prominent chins. (d) In contrast, the chin of another is lost in his neck. (e) A singular individual with a flute from the Piro district has a large nose and other prominent features. This petroglyph may date from the early historic period, as several nearby villages were occupied into the 1580s.

Fig. 3.16, a and b
 Although undistinguished projections are common suggestions of headgear on shield figures and other warriors, some images are much more explicit as to what kind of headpieces are intended. One or two short curved horns, feathers, and squat trapezoidal and other flat-topped "caps" are represented on occasion. Importantly, shield bearers and other figures identified as warriors are sometimes shown wearing pointed hats. (a) This detail of the head of a Northern Tewa shield bearer on the Pajarito Plateau shows a pointed cap covered with fine cross-hatching. Two eagle feathers are attached at the top. (b) A Southern Tewa War God wears a tall pointed cap and holds a barbed staff and possibly a plant.

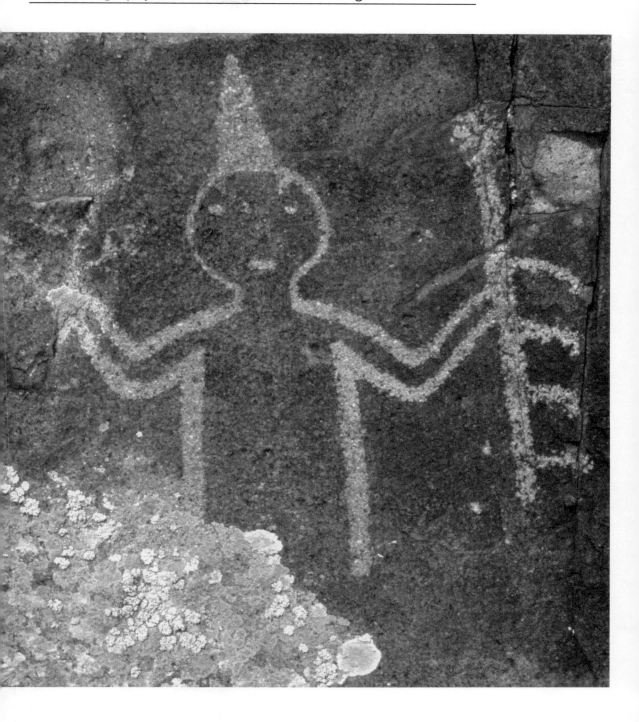

Fig. 3.17, a–f

Among the warrior kachinas are the commonly occurring Bloody Hand kachina (Plate 4) and

(a) the less-common Hilili, which has a diagonally divided mask and a long mouth full of teeth. In this petroglyph, his weapon, a long knife, is attached to the side of his head. Images of war gods, not visible in the photo, are pecked nearby. *(Photograph by David Grant Noble.)*

Star kachinas holding weapons are widespread throughout the Rio Grande region. In addition to their star masks, they wear fans of eagle-tail feathers as headdresses and kilts, some of which are deeply scalloped.

(b) A Piro rock painting of a pair of Morning Star kachinas shows them holding yucca whips. (c) A Southern Tiwa version of the Morning Star kachina in Petroglyph National Monument holds a bipointed war club in the right hand and a simple bow in the left.

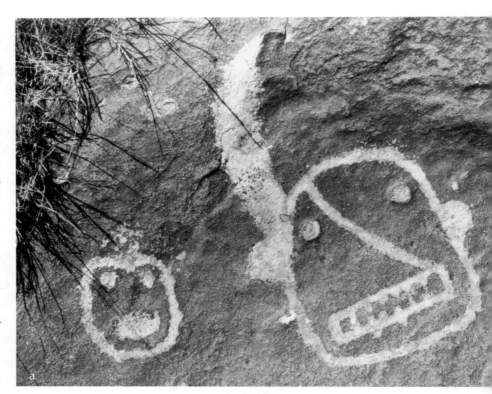

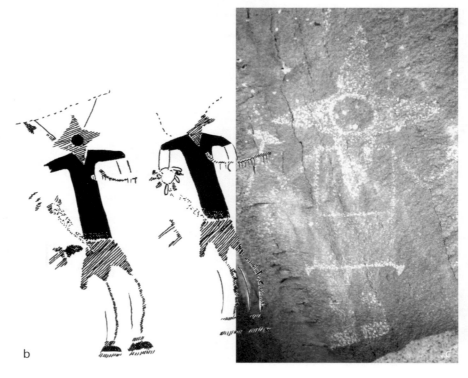

Among the complex role of the cone-shaped, armless Shalako kachina is that of a warrior and protector. This figure (d–e) is commonly depicted along the central Rio Grande Pueblo region in the context of more explicitly war iconography. (f) Shalako representations from late prehistory are typically broad-based figures, such as this Southern Tewa pair at Comanche Gap with backward-pointing headgear. The lower figure wears a tasselled manta, or shawl-like garment. *(Photograph by David Grant Noble.)*

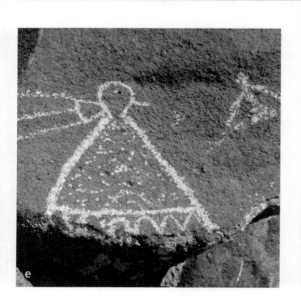

Fig. 3.18
 Repeatedly repre-
sented are profile
bird masks with flat
tops, like these
Southern Tewa depic-
tions. These kachinas
have sharply down-
curving beaks and
sometimes sport a
pair of short parallel
lines on the side of
the face below the eye.
Known as "warrior
marks," these lines are
sometimes described
by Hopis as the Elder
War Twin's footsteps.
They also are reminis-
cent of the facial
markings of a falcon.

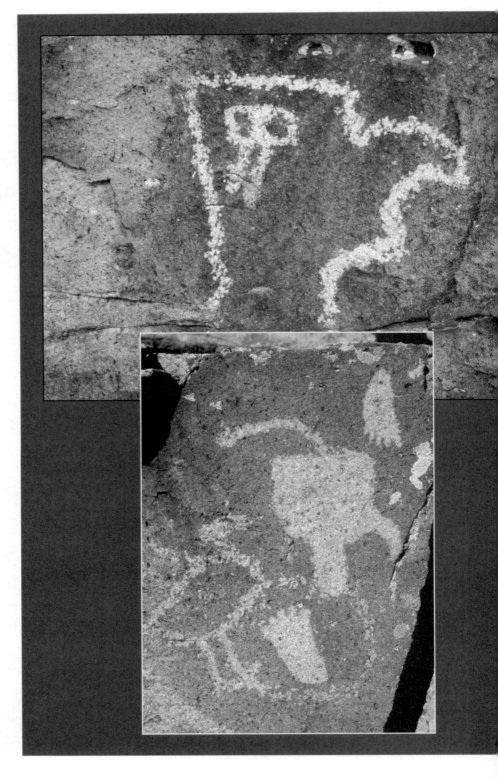

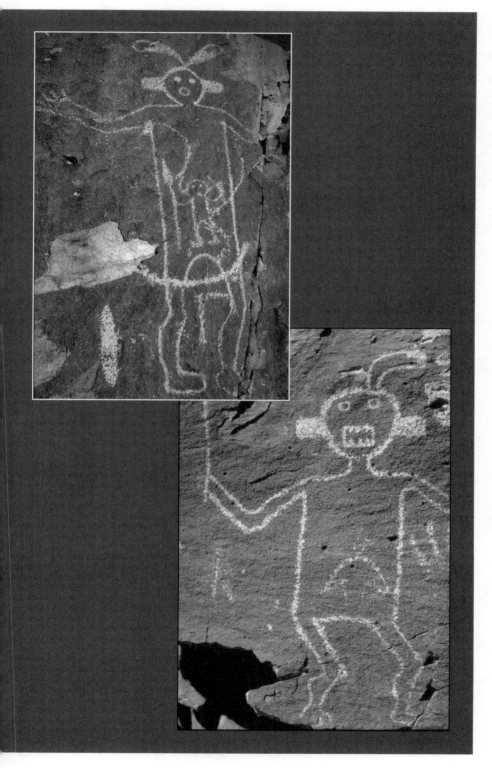

Fig. 3.19
There are numerous kachinas in the rock art that have warrior attributes but lack distinguishing features that would link them with clear contemporary analogues. At Comanche Gap, a large, long-eared female kachina with two eagle feathers as a headdress is shown with an armed infant warrior inside. Nearby a similar dramatic figure holds a staff and has a large toothed mouth. Both may be prehistoric versions of the Chakwaina complex, as discussed in the following chapter. The character on the body of the figure with the staff seems to depict Knife-Wing, a predatory eagle-like supernatural associated with the Zenith and war (see Chapter IV).

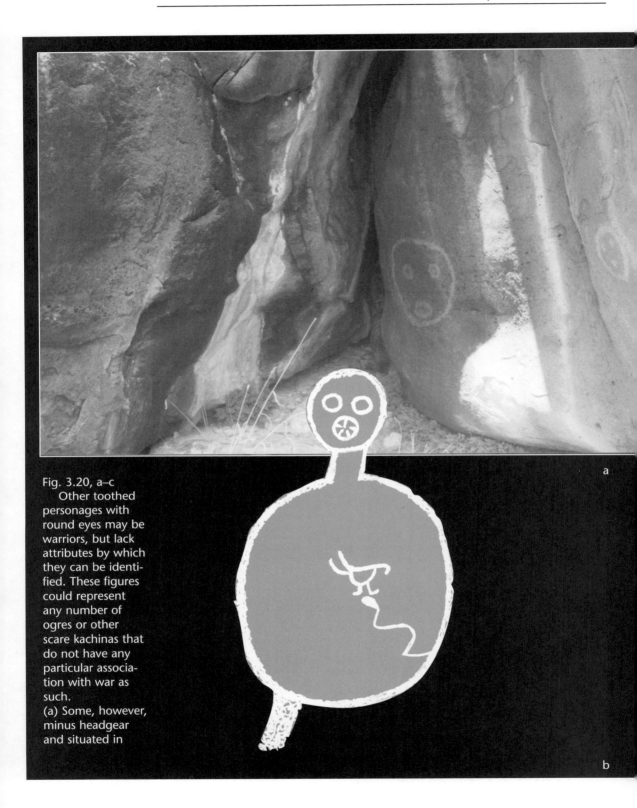

a

Fig. 3.20, a–c
 Other toothed personages with round eyes may be warriors, but lack attributes by which they can be identified. These figures could represent any number of ogres or other scare kachinas that do not have any particular association with war as such.
(a) Some, however, minus headgear and situated in

b

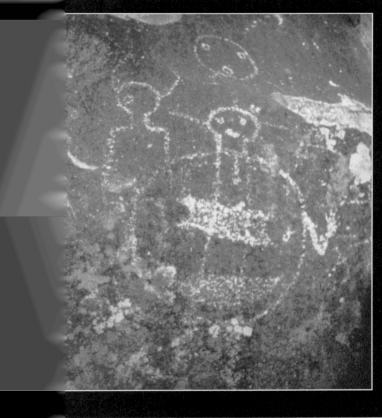

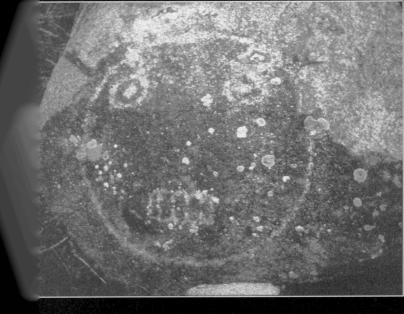

deep recesses or in or beside cracks leading into the rocks, appear to represent Masau, the god of fire and death who is in charge of the Earth, the Underworld, and the passages in between. *(Photograph by Curtis F. Schaafsma.)* This deity is periodically encountered in the rock art of the southern Tewa and Piro regions of the Rio Grande, where iconographic contexts and the physical situation of these prehistoric figures in or near cracks or at ground level substantiate not only the identification of this figure as Masau, but occasionally Masau in his warrior mode. His image is juxtaposed with shields in the rock art of the Galisteo Basin[2] and at Hopi. (b) A shield bearer from the Little Colorado River region is clearly Masau.[3] (c) At a Galisteo Basin site, a small cluster of petroglyphs includes a large shield bearer that dominates the group, and three of the surrounding faces/masks appear to represent Masau.

c

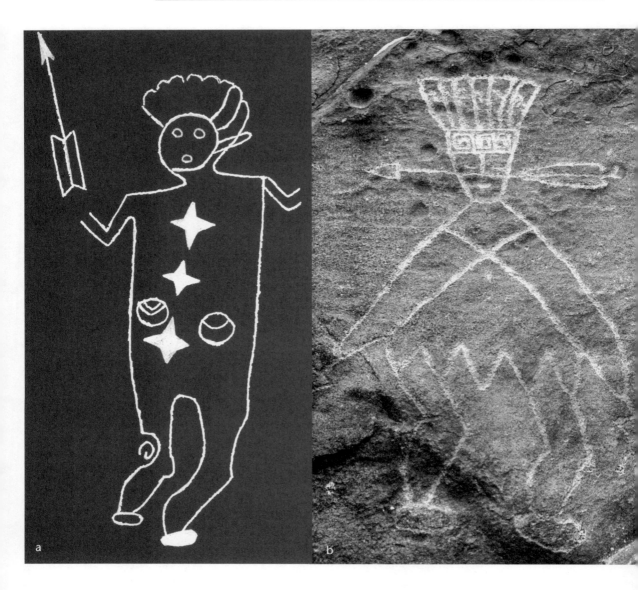

Fig. 3.21, a and b
Human ritualists are among the figures represented in Galisteo Basin rock art with warrior attributes or affiliated with war-related rites.

(a) Outstanding among them is the life-size, one-horned person near the Southern Tewa ruin of San Cristóbal, who wears a full crown of feathers and holds an arrow in his hand. His body is decorated with stars. The additional line at the side of the face suggests that he is masked, a kachina impersonator but not a kachina as such.

Petroglyph rendi- tions of participants in rituals associated with war include the sword and arrow swallowers in the Galisteo Basin and in the Piro province.

Galisteo Basin par- ticipants in arrow-swallowing rites are pictured frontally with arrows across their mouths. (Plate 5)

(b) This Southern Tewa ceremonial fig- ure wears a head- dress of tall feathers and possibly repre- sents an arrow swal- lower. His headband bears fret designs and his manta has large tassels. *(Photograph by David Grant Noble.)*

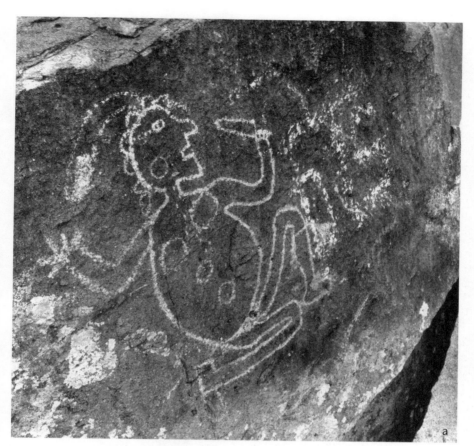

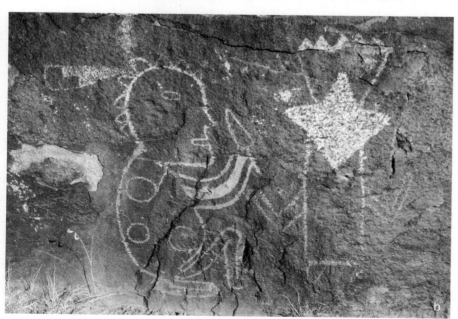

Fig. 3.22
Two others (a) and (b), both at Comanche Gap, are lifelike individuals shown in profile in a seated position with one leg bent underneath. Their bodies have rounded bellies like those of old men and are decorated with spots, and each wears a single eagle feather. Triangular serrations complete their head decoration. Each holds in front of his face a projectile, or "sword," that he is about to swallow. One of these personages faces a star kachina. *(Photograph by David Grant Noble.)*

ANIMAL WAR PATRONS, BIRDS, AND STARS

In addition to the variety of warriors and guardians both human and supernatural, numerous birds and animals are also included in the context of war symbolism and metaphor in Pueblo IV rock art. Although ethnographic accounts tell us that war was only one of several connotations that many animals had, spatial proximity to warriors and other war iconography confirms their association with war in numerous instances. In addition, the symbolic status of these animals is further denoted by feathers and pointed caps or, more rarely, by associating them with bows.

The mountain lion is known equally well as a hunt patron and a patron of war, and unless he is represented in the context of what is clearly war iconography, his significance is ambiguous. Just as the significance of the mountain lion can be unclear, it is likewise with the bear. Surprisingly, the bear is sparsely represented in prehistoric Pueblo art of this period, and with a few exceptions these images are confined to the Southern Tewa-region petroglyphs. Bear paws or tracks are fairly common and widespread, however, and are thought to have the same symbolic value as the entire figure. Again, a strong contextual placement is needed in order to ascertain that it is his role as war patron that is being depicted by a given image, and not his well-known power as a Medicine Society patron. Bear paws, for example, are featured in an unusual shield design borne by one of a pair of shield bearers at Comanche Gap (Fig. 3.13, a).

Stars are an integral part of Pueblo warfare iconography and are found in the rock art from the Piro country through the Northern Tewa region. They are more numerous, however, in the eastern and southern part of the Pueblo area. In kiva murals as well as rock art, the focus on stars in the late prehistoric period occurs in the eastern Pueblo domain. Feathered stars and stars with snakes and mythological serpents are featured on certain layers of the Pottery Mound kiva murals,[8] but the star is scarce and unfeathered in the Jeddito murals.[9] At Pecos on the eastern extreme of the Pueblo domain, stars are incised on clay pipes.[10]

In the rock art, stars as designs on shields, and as masks have already been noted. They also occur as independent elements and occasionally as body designs. We find a patterned juxtapositioning of stars with avian (eagle) elements, snakes, rattlesnakes, and horned serpents. Stars and star kachinas are sometimes represented in pairs, and fully defined anthropomorphic star kachinas, as described earlier, usually and hold weapons.

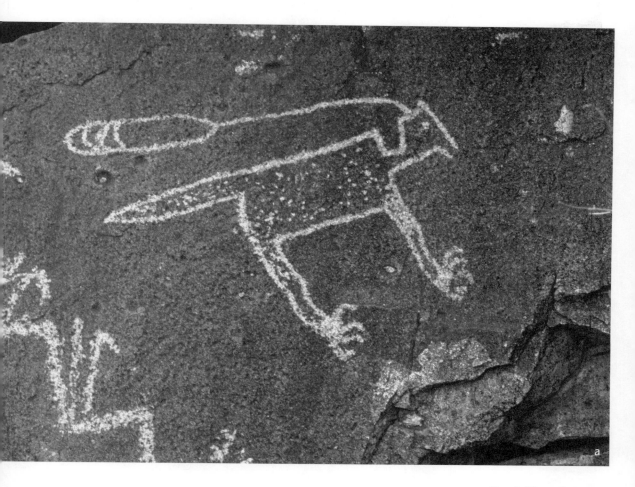

Fig. 3.23, a–d
In the rock art, mountain lions are shown with extended and often exaggerated claws (Plate 6), or symbolized by the portrayal of forelegs and paws with claws extended, or mere tracks. (also see Figs. 4.10 and 5.4). (a) A southern Tewa mountain lion with claws extended has a feather attached to his head, signifying the ritual importance of this animal.

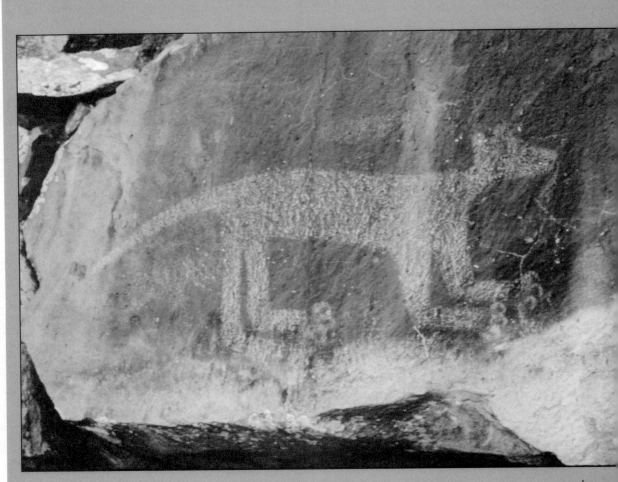

(b) Life-size petro-
glyph of mountain
lion, Pajarito Plateau.

b

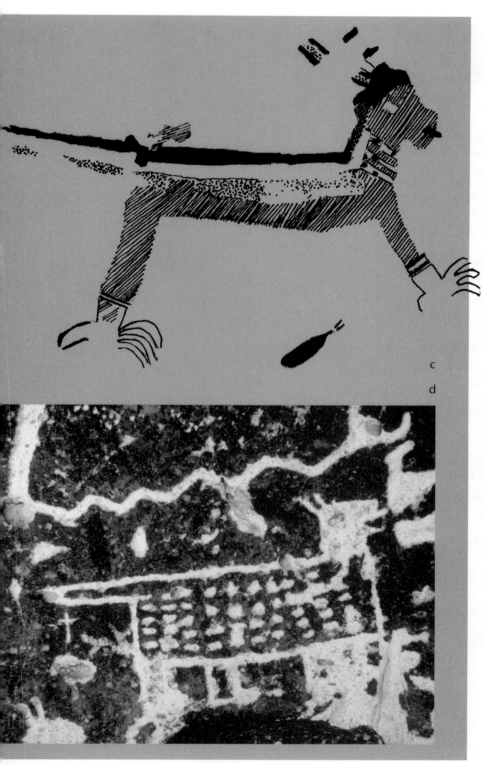

c

d

(c) A small (about 12 centimeters long) Piro painting of a mountain lion wearing a red feathered cap has extended claws painted in white. A red feather is also attached by a long string to the front foot. (d) Long-tailed spotted felines may represent jaguars, like this Northern Tewa spotted feline that appears in a smoke-blackened cavate room on the Pajarito Plateau. Although mountain lion cubs are spotted, it seems unlikely that juveniles would be selected as metaphors of power, and it is far more likely, lacking ethnographic references to the contrary, that we are dealing with mature animals and real jaguars. Nonbreeding populations occasionally extend into the Southwest today, and a recent sighting was photographically documented in southwestern New Mexico in 1996.[5] Until recent historic times (A.D. 1700 or later) they had a wider distribution that extended northward to Colorado.[6]

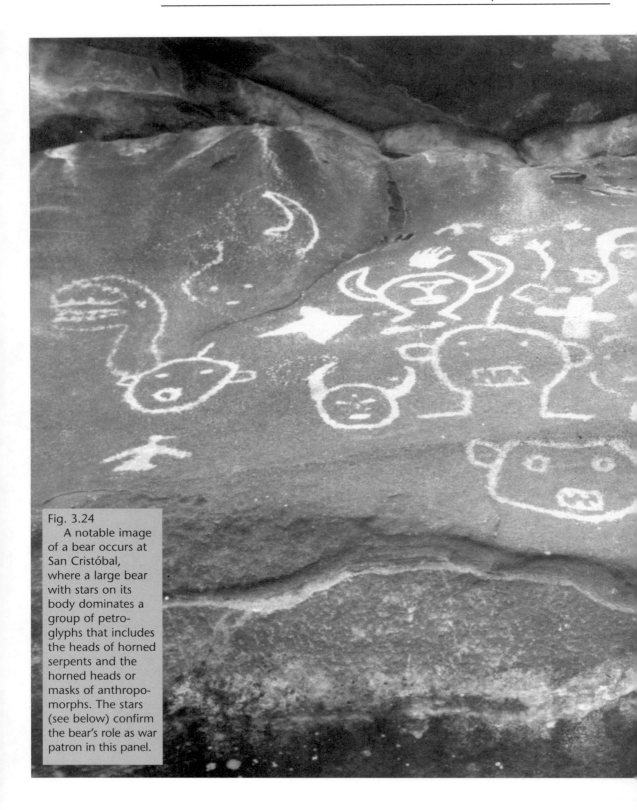

Fig. 3.24
 A notable image of a bear occurs at San Cristóbal, where a large bear with stars on its body dominates a group of petroglyphs that includes the heads of horned serpents and the horned heads or masks of anthropomorphs. The stars (see below) confirm the bear's role as war patron in this panel.

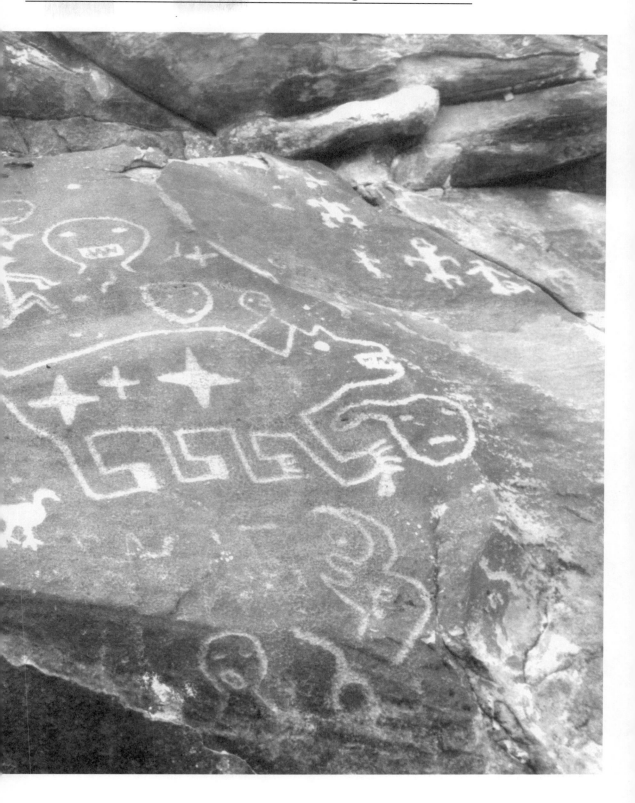

Fig. 3.25, a–c

Canines, including both coyotes and wolves, as well as other animals such as snakes, star-faced snakes, horned serpents, owls, and eagles and eagle-like birds are additional life forms represented in the rock art that frequently relate to war.

The eagles and eagle-like birds with wings extended, blunt tails, and occasionally with large, well-defined talons are identifiable as the Beast God of the Zenith, known at Zuni as Achiyalatopa, or Knife-Wing. In simplest graphic form this bird with outstretched wings may appear to be a swallow or swift, but its broad, blunt tail and

a b

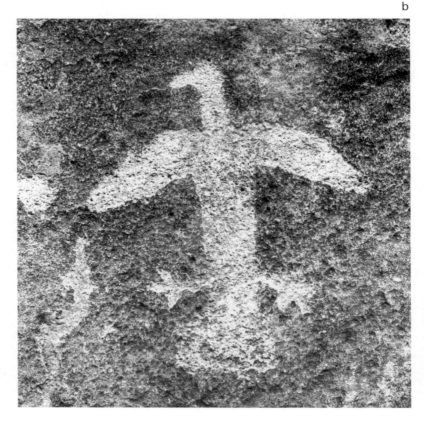

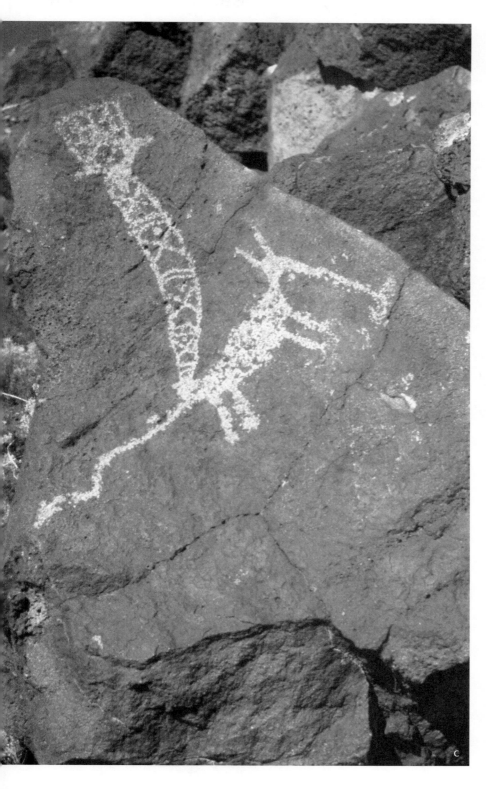

frequent juxtaposi-
tioning with shield
bearers and other
warriors as well as
mountain lions signal
that it is Knife-Wing
that is intended.
　(a) A red owl
beside a black-faced
kachina with red ears
and feathers. (b) The
large talons of this
Southern Tewa image
are related to the
bird's powers as a
scalper. When pre-
sent, talons leave no
doubt as to the bird's
identity. *(Photograph
by David Grant
Noble.)* Imagery
incorporating addi-
tional animal symbol-
ism pertaining to
warfare include (c) a
Southern Tiwa star-
faced serpent and
carnivore whose tail
ends in an arrow point.

Fig. 3.26, a–c
Feathered and
taloned stars are
notably well-repre-
sented in the south-
ern Tiwa petroglyphs
of Albuquerque's
West Mesa and in
Southern Tewa rock
art in the Galisteo
Basin. Tompiro rock
paintings and petro-
glyphs elsewhere por-
tray detailed star
kachinas. Variations
on Tompiro stars are
described in detail by
Stuart Baldwin.[7]

Star iconography
takes a variety of
forms. The simplest
stars are plain equilin-
ear crosses. Asterisks
with several points
representing stars are
extremely rare. Most
characteristic is a
four-pointed star with
points that expand
toward the center.
The points of stars
vary from thin to
wide, and they often
surround a central
circle. In some exam-
ples this circle may

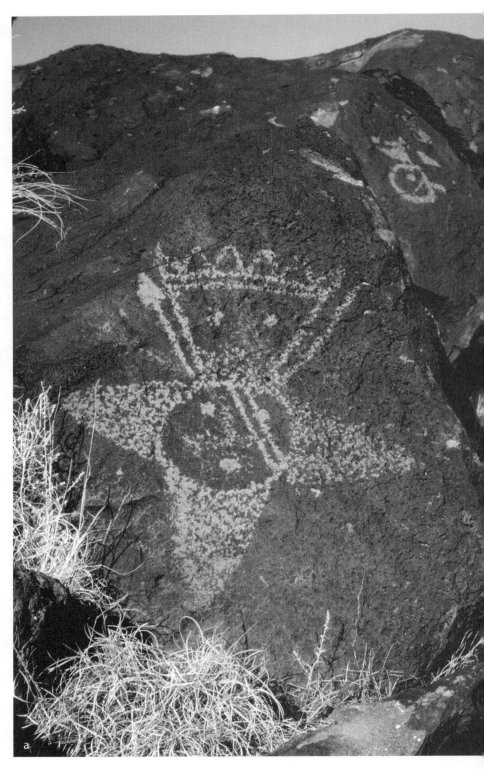

have a simple face indicated with dots.

Conflated star/bird images are achieved by adding talons on either side of the lower point, and/or a fan of eagle tail feathers as a headdress behind the upper point of the star.

(a) A few examples have projectiles beside the eagle feathers, such as this large Southern Tiwa star supernatural with a feathered crown. The small profile mask with a beak (upper right) is part of the warfare complex. (b) Some star petroglyphs show evidence of having been stained red, like this Tompiro example with a face and talons pecked beside a coiled snake. (c) Here, a painted Southern Tewa red star has rays that probably represent feathers. The color red has warfare connotations.

b

c

WAR ICONOGRAPHY IN THE KIVA MURALS OF THE EASTERN PUEBLOS AND THE HOPI JEDDITO REGION

A second significant source of war iconography is the kiva murals. Along with the suite of kachina and rainmaking icons of the period, war themes are an important component of the complex and colorful kiva paintings at Pottery Mound on the Rio Puerco southwest of Albuquerque, (Plate 7) and at Awatovi and Kawaika-a on Antelope Mesa, near Jeddito Wash.[11] These are the most complex murals discovered to date. In addition, shields are the dominant element in the limited kiva paintings from Pueblo del Encierro[12] near Cochiti Pueblo on the Rio Grande.[13] The complex and diverse images pertaining to war, scattered over the landscape as rock art, are synthesized in the kiva murals into meaningful symbolic statements in large integrated paintings. In some cases these murals feature many interacting figures and related subsidiary subject matter. Kiva mural art differs from rock art as well in that painting on smooth plaster was more conducive to the inclusion of many intricate details. Thus kiva paintings include more visual information than does rock art.

One of the difficulties in the study of kiva art, however, is the problem of preservation and partial survival of the images. Although the preservation was sometimes remarkably good, often the tops of walls have eroded away, leaving the upper portion of a painted scene missing. Fragmentation of the plaster itself also may have occurred, leaving a record that is tantalizing yet difficult to reconstruct, or open to varied interpretations. Painted and drawn reproductions of the murals, in many cases the only remaining records, may not always accurately reflect the original exactly, especially with regard to details. Nevertheless, the extraordinary complexity of these images and the detail they exhibit make the kiva murals extremely valuable for an iconographic study such as this.

The existence of the Jeddito paintings helps counteract the paucity of information in the Pueblo IV rock art of the Western Pueblos. Although similar war-related themes are expressed in the murals from both Pottery Mound in the Rio Grande and Awatovi and Kawaika-a at Hopi, the subject matter and emphasis are slightly varied in these widely separated Pueblo regions.

The pueblo of Kuaua, a Classic Period site on the Rio Grande north of Albuquerque well-known for its protohistoric painted kiva,[14] lacks almost all of the war-related figures found in

Landscape looking west from Pottery Mound. The down-cut bank of the Rio Puerco, a feature of an over-grazed environment, is visible on the right. When occupied, the site was in a riparian setting. *(Photograph courtesy of the University of New Mexico—Albuquerque, Maxwell Museum of Anthropology.)*

the above-mentioned sites. Also, the several painted kivas from Picuris Pueblo, dating from the first half of the fifteenth century to historic times, feature birds, stepped clouds, rainbows, lightning, and corn, while specifically war-related themes are absent.[15] Murals at Las Humanas, a Tompiro (mountain Piro) Pueblo also known as Gran Quivira, also lack potential war iconography with the exception of a small shield bearer and a quiver from different layers in Kiva N dating between 1416 and around 1500.[16] Evidence for other possible shields from Las Humanas is highly tentative.[17]

Pottery Mound, New Mexico

Pottery Mound is a large early to middle Classic period site along the Rio Puerco south of Albuquerque. Ceramic sequences indicate that Pottery Mound's primary occupation fell between A.D. 1325 and 1450, with a smaller residency persisting through the late 1400s.[18] The prehistoric linguistic affiliations of Pottery Mound are ambiguous. Although Frank C. Hibben[19] attributes this site to Keres speakers, ceramic correlations suggest that it was probably southern Tiwa or perhaps Piro.

According to Hibben,[20] 15 kivas at Pottery Mound had multiple painted layers that ranged in number from four to 38. While war-related subjects at Pottery Mound were scattered throughout several kivas (Kivas 2, 6, 7, 8, 9, 16),[21] these themes were most numerous in Kivas 2, 7, 8, and 9. Kiva 9 was a remodeled version of Kiva 8, and this complex was a particular focus of war iconography.

3.27
A Warrior with long red macaw feathers holds a shield and bow and arrow. Pottery Mound, Kiva 7, layer 8, south wall. *(Photograph courtesy of the University of New Mexico—Albuquerque, Maxwell Museum of Anthropology.)*

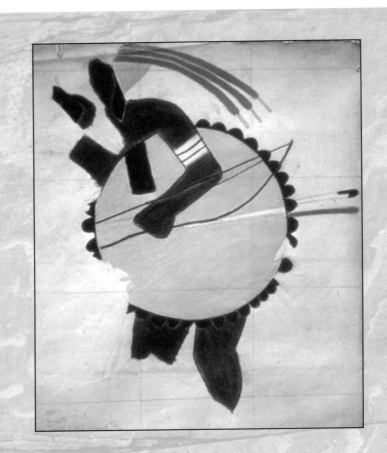

Only a few of the murals were preserved during the primary excavations and mural studies that were carried out at Pottery Mound in the late 1950s. Most of the paintings, once photographed and drawn, were scraped away to reveal the next layer below. (For stylistic consistency we will describe these and other kiva paintings in the present tense.)

For the most part, the repertoire of explicit war iconography at Pottery Mound echoes that in the rock art. There are sun shields, shield bearers, and warriors without shields holding weapons. Warriors in the murals are very reminiscent of those from the Galisteo Basin and Comanche Gap in particular, and include "Dick Tracys" with prominent chins as well as an old man with a war club. Some warriors are incorporated into ritual scenes featuring other participants and items (Plate 11).

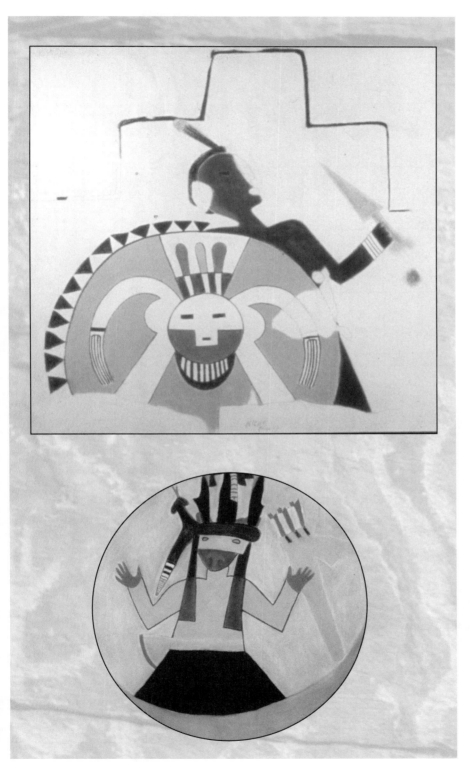

3.28
A warrior framed by a stepped cloud design holds a projectile and large body shield rimmed with flat-ended feathers that may represent turkey feathers. A mask, possibly the face of the sun, is the dramatic focus of the design on the shield. Pottery Mound, Kiva 9, layer 12, west wall. *(Photograph courtesy of the University of New Mexico—Albuquerque, Maxwell Museum of Anthropology.)*

3.29
A masked figure with antelope horns is framed within a circle. He wears a rattlesnake headband and holds a quiver of arrows, Pottery Mound, Kiva 8, layer 1, east wall. *(Photograph courtesy of the University of New Mexico—Albuquerque, Maxwell Museum of Anthropology.)*

Fig. 3.30, a–d
A row of 11 shield bearers pictured in profile move from right to left around all four walls of layer 3 in Kiva 2. Selected figures are pictured here. (See also Plates 8 and 13.) (a) The shield with the star, which is believed to represent the Morning Star (see Chapter IV), is on the east wall. Most of the shields have black scalloped edges, and the warriors carry quivers and weapons. There is some reason to think that such scalloping signifies that the shields were made of bison hides

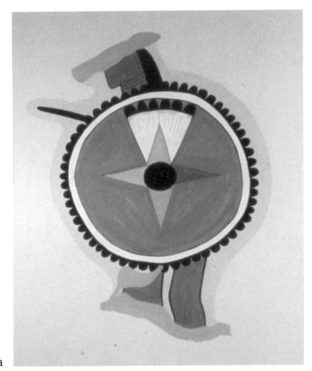

a

b

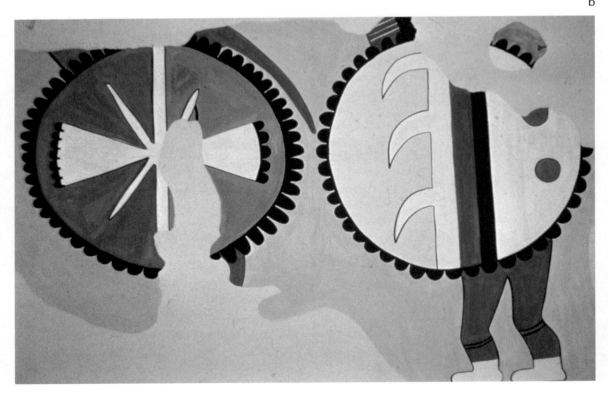

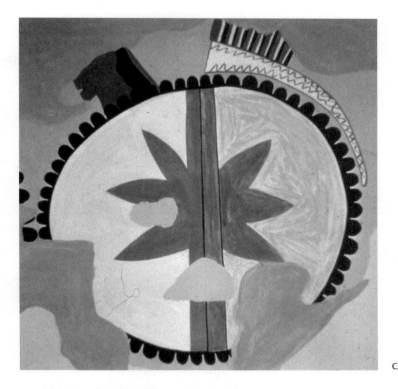

c

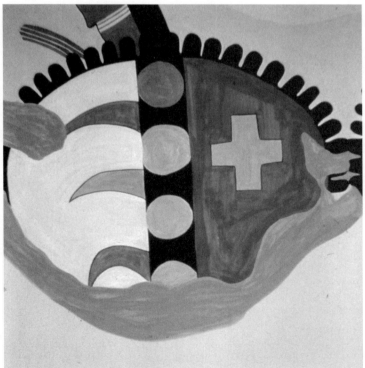

d

(see p.134). Bands or cords are sometimes tied around their legs below one or both knees.

Although a number of the shield designs, such as the curved bands with circles inside, appear to be distinctive to this site, others include stars and fans of eagle-tail feathers as well as other familiar motifs. There are numerous shields divided vertically by central bands that are further elaborated with curved elements, circles, cruciform designs, and so forth. Lunettes occur in the inner periphery in some cases.
(Photographs courtesy of the University of New Mexico—Albuquerque, Maxwell Museum of Anthropology.)

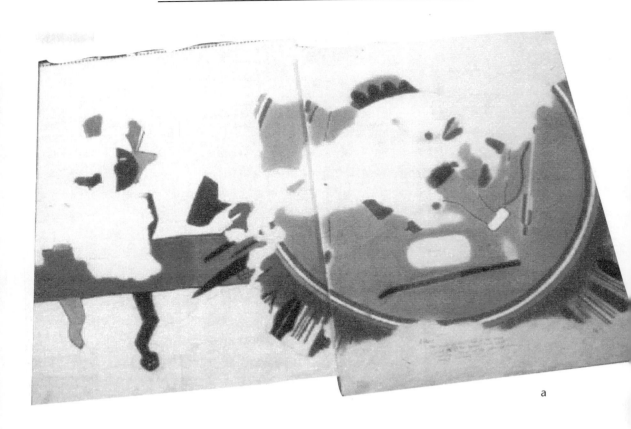

a

Fig. 3.31, a and b

Sun shields are suggested by colorful edging and long, radiating feathers.

(a) In Kiva 8, layer 14, shield circumferences are enhanced with narrow concentric rings. Outside of these is an irregular red edging from which projects a wide variety of feathers of differing widths and lengths. Bands extending from the shields are crossed by small snakes, and above are black-faced feathered stars. On the face of the shield itself is a figure with an eagle-feather headdress holding a bow and arrow. Similarly, a later painting from the same kiva (layer 5) pictures a large shield lacking outer rings but fringed with a variety of long feathers (Fig. 1.3). (b) Other shields on this layer with narrow outer rings and feathered edges have large four-pointed stars as designs. *(Photographs courtesy of the University of New Mexico—Albuquerque, Maxwell Museum of Anthropology.)*

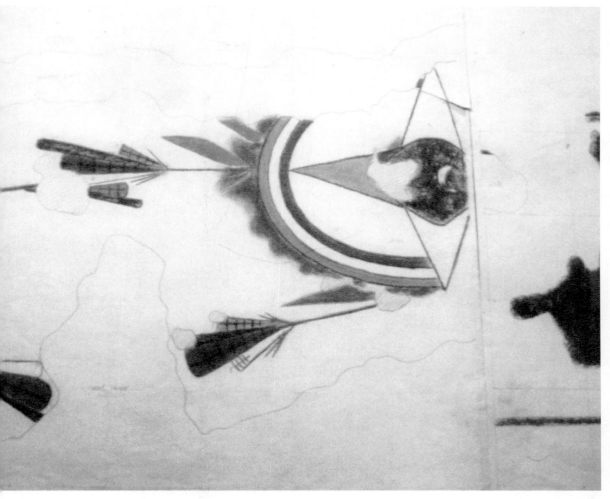

b

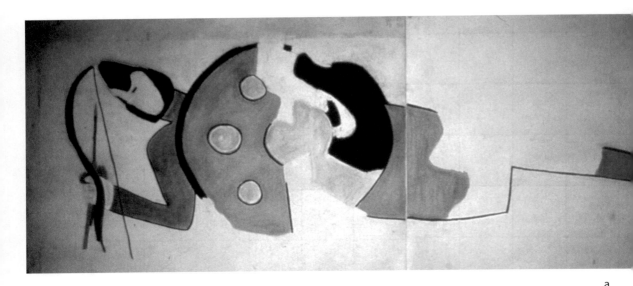

a

Fig. 3.32, a and b
In other Pottery Mound paintings, shields function as a central focus or point of transition in compositions involving mountain lions.
(a) In Kiva 8, layer 4, a human warrior holds a recurved bow, and his body becomes that of a mountain lion on the other side of the shield. (b) Similarly in Kiva 7, layer 11, there is a shield with dark scalloped edging. A masked head emerges on the left while the rear portion and tail of a mountain lion are visible on the right. *(Photographs courtesy of the University of New Mexico— Albuquerque, Maxwell Museum of Anthropology.)*

b

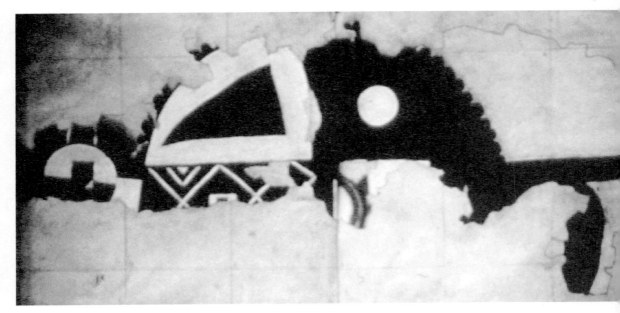

WEAPONS

Weapons consist of bows and arrows (Fig. 3.32) and war clubs (Fig. 5.3), while other paraphernalia includes staffs and quivers (Plate 12). Bows in the hands of warriors are of the recurved type. A notable exception is the simple bow held by the apparent captor in the scene from Kiva 2, layer 14 (see below). An element from Kiva 1, layer 4 is designated by Hibben[22] as an atlatl, or spear thrower, although atlatls are not known from the Pueblo archaeological record during this period. This item has every appearance of a spear thrower, but the seeming uniqueness of this representation calls into question this interpretation. Surrounded by fragmentary abstract elements, a suitable context with which to evaluate its meaning is unfortunately lacking.

In addition to the ritualistic figures with their wealth of symbols and ceremonial regalia, the human scene portrayed in Kiva 2, layer 14, appears to be a very straightforward representation of a prisoner with his captors.[23] One of the captors has a shaved Mohawk-style hairdo. The captive is held by a string around his neck, and the top portion of his head, horizontally demarcated above the eye, is dark gray and crosshatched in red and streaked in white. The possibility that he may have been scalped is suggested. On the other hand, it has also been proposed that this represents a kind of skullcap.[24] The captive also lacks hands, although so do some of the other figures, so it is unclear what the missing hands signify.

The complex symbolism and esoteric meaning that is characteristic of these murals continues in the realm of star and animal representations.

STARS AND ANIMAL GODS

Stars and feathered stars lacking talons occur in several contexts in the Pottery Mound murals—on shields, with snakes, and on the bodies and kilts of ritual participants. (Plate 14) A mural in Kiva 7, layer 9 displays a horned and feathered serpent juxtaposed with a starlike being with a downturned red mouth (Plate 9).

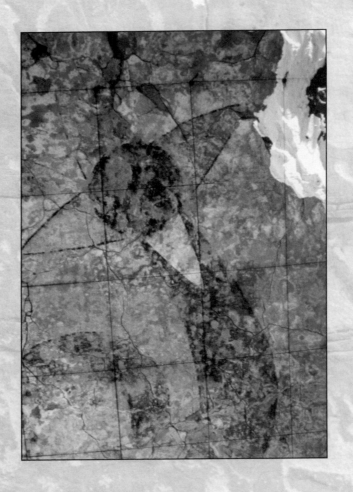

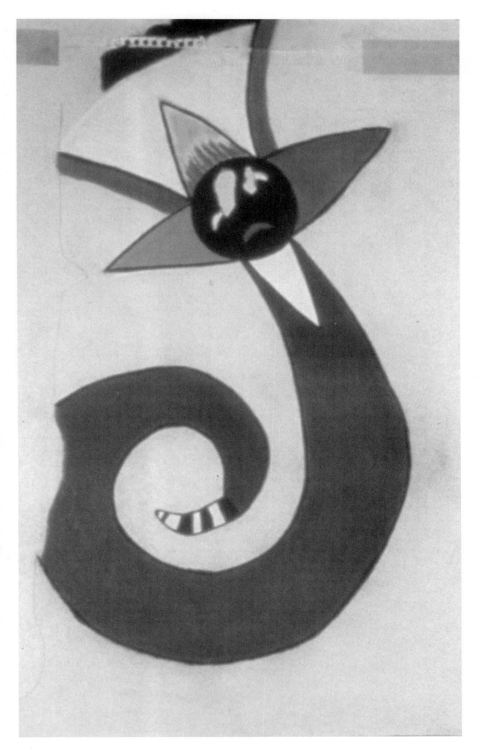

a

Fig. 3.33, a–c
 Reconstructed image of star-faced coiled rattlesnake with eagle-tail fan headdress, Kiva 8, layer 7, pictured on p. 82.

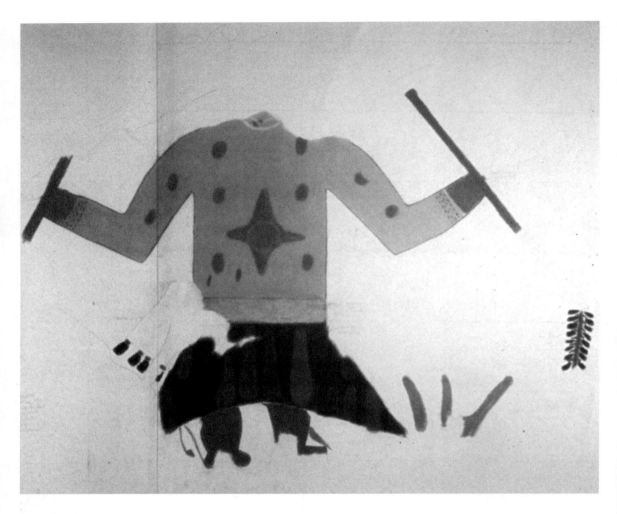

Also in Kiva 8, layer 15, is a painting of a ceremonial participant with a star on the torso and wearing a feathered kilt. (c) is a star person from Kiva 6. *(Photographs courtesy of the University of New Mexico— Albuquerque, Maxwell Museum of Anthropology.)*

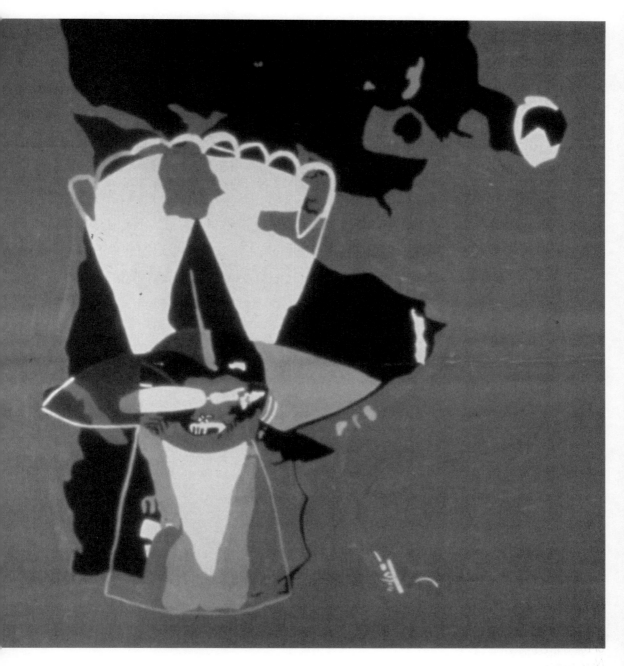

c

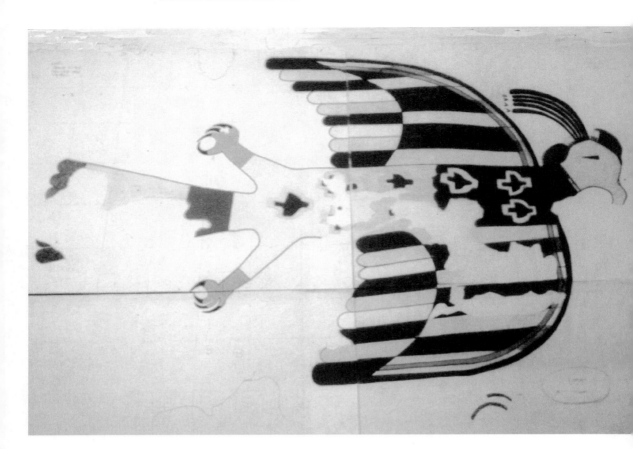

a

Fig. 3.34, a and b
(a) Knife-Wing or a similar supernatural seems to be the subject of the west wall of Kiva 9, layer 3. The bird has extended wings of multicolored feathers and a fancy feathered headdress. Talons, a key attribute of this supernatural, are carefully detailed in the mural painting. A series of small birds on the body are simplified versions of this figure as it appears elsewhere, including

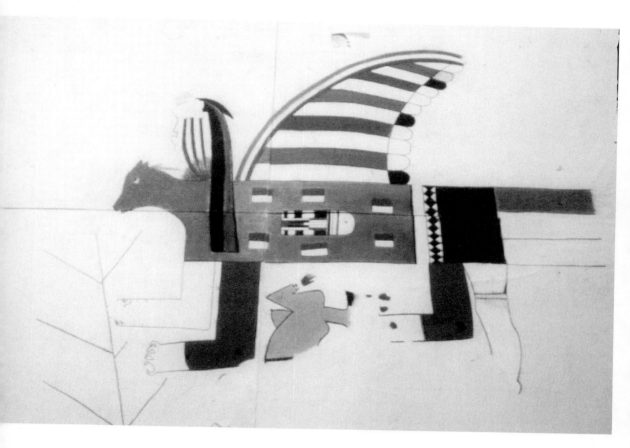

b

the rock art, where these small birds with wings extended and blunt tails are commonly affiliated with shield bearers and other subject matter related to war. (b) On the same layer, a feline forms the basic element of a composite creature involving additional bird and human attributes. *(Photographs courtesy of the University of New Mexico—Albuquerque, Maxwell Museum of Anthropology.)*

Pueblo animal deities, the so-called Beast Gods[25] associated with war and other societies at Zuni and elsewhere, are represented throughout the murals at Pottery Mound. Among them, as in the rock art, eagle-like birds and mountain lions are those most commonly incorporated into the iconography of warfare. These figures are represented with supernatural attributes to signify their deified status (Fig. 3.34).

The juxtaposition of felines with shields (Fig. 3.32), fixing the mountain lion's war affiliations during Pueblo IV, has already been discussed. Other representations of mountain lions are less explicit as to the affiliation intended. In Kiva 16, layer 4, a blue

Fig. 3.35
Blue feline super-imposed by a rattle-snake. Pottery Mound. *(Photograph courtesy of the University of New Mexico—Albuquerque, Maxwell Museum of Anthropology.)*

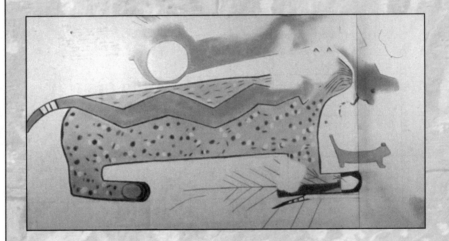

spotted feline is superimposed by a rattlesnake, the black and white banded tail of which is placed appropriately to be the cat's tail as well (Fig. 3.35). On the opposite wall of the same kiva, a canine is superimposed by a quiver made of a mountain lion's skin.[26] The cat's tail on the quiver skin is similarly banded, providing evidence for an intended conflation of feline and snake. The incorporation of rattlesnakes into the costumes of warriors in the Pottery Mound murals was described above.

The paintings on the east, north, and west walls of Kiva 6, layer 1 are noteworthy in this context. Like layer 1 of Kiva 2, this layer of plaster was the last applied and is the most intact. The painting on this layer features a comprehensive scene involving

seated human ritual participants alternating with felines with claws extended similarly seated.[27]

Among the group of cats, most of which resemble mountain lions, a red feline with black spots appears to be a jaguar (Fig. 3.36 and Plate 11). A bird with wings extended is painted in front of its face. All of the cats and some of the humans have slinglike quivers stuffed with arrows that they carry across their shoulders, and where the painting was intact, bundles of arrows or feathers emanate from the mouths of the human figures and possibly one mountain lion. One of the human figures has a finely crosshatched or netted design on his body.

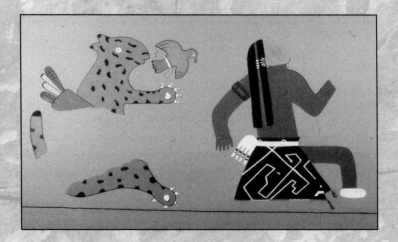

Fig. 3.36
Seated jaguar and human ritual participant, Pottery Mound, Kiva 6, layer 1.
(Photograph courtesy of the University of New Mexico—Albuquerque, Maxwell Museum of Anthropology.)

Lacking shields, war clubs, or any items of apparel that would link this scene specifically to warfare, there is some uncertainty as to whether this painting relates to war or hunting (see Chapter IV). Although according to Hibben[28] the star faces in Kiva 6 occurred on the west wall of Layer 1, this designation is incorrect; Layer 7 is where they were found.

The Jeddito Murals: Awatovi and Kawaika-a, Arizona

Although the number of plastered layers in the Jeddito kivas exceeded those at Pottery Mound, the Hopi layers contained fewer paintings.[29] They are, nevertheless, comparable in complexity to

those of Pottery Mound. Dendrochronological studies and ceramics indicate that war iconography occurred throughout the history of the painted kivas in the Jeddito, or from between the late fourteenth or early fifteenth through the early seventeenth centuries.[30] According to Helen K. Crotty,[31] shields and warriors appear on the earliest layers of Awatovi kivas located in the Western Mound section of the site.

The inventory of now familiar war-related elements is present, although warriors and the variations they manifest, as well as stars and snakes, are considerably fewer in number than in the eastern murals. The single clear example of a snake[32] lacks any contextual references that might indicate its symbolic connota-

Fig. 3.42
Shield from Pueblo del Encierro, Cochiti Reservoir, New Mexico. *(Photograph courtesy of ARMS, Museum of Indian Arts and Culture/Laboratory of Anthropology, Santa Fe.)*

tions. Stars with faces or star-faced supernaturals are absent entirely. One painting depicts a war god, and other murals illustrate actual or ritual combat between warriors holding elaborate shields. The most distinctive aspect of the Jeddito paintings with regard to war-related icons is in the realm of shields (Figs. 3.37–3.41).

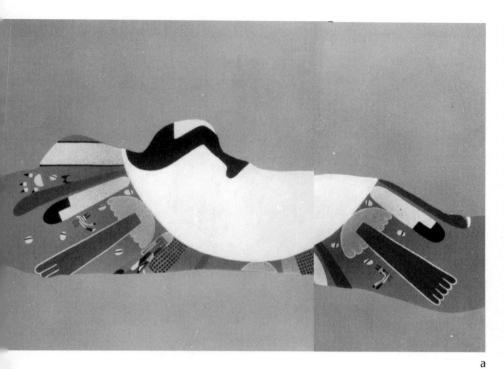

a

JEDDITO MURALS
Fig. 3.37

A few shield-bearing warriors carry body shields, and there is one clear example of a hand-held shield. Shields may be fully decorated, but most are rather plain. Sun shields[8]—plain white shields, edged with spattered red and an array of long, radiating feathers, birds, and other items—are frequent in the Jeddito paintings. Eagle tail and macaw feathers are common attachments, and on rare occasions shields have stars. Scalloped outside edging, so common at Pottery Mound, and lunettes around the inner edge each appear only once.[9]

(a) In this Awatovi mural (Test 14, Room 3), the rich display of feathers attached to a sun shield is supplemented by other radiating items such as arrows, *pahoes* (prayer sticks), and ears of corn. (b) Whole birds such as macaws, possibly magpies, and other showy varieties surround or cling to the circumference of this Jeddito sun shield from Kawaika-a (Test 4, Room 4). Such a conjunction of complete birds and shields is uncommon in the Rio Grande Valley, where it is found only on rare occasions in the rock art. *(Watson Smith, photographs reprinted courtesy of the Peabody Museum of Archaeology and Ethnology, Harvard University.)*

b

Fig. 3.38, a–c

As at Pottery Mound, the Jeddito murals contain several complex paintings in which felines and shields occur together. Several of these shields are sun shields.

(a) In one example from Awatovi (Test 4, Room 3) an animal, probably a bobcat, stands on a bow and arrow in the center of a shield. The inner circle enclosing the cat is rimmed with spiky triangular serrations, and bows and projectiles are attached to either side of the outer edge of the shield itself. Clusters of feathers are attached to the lower periphery. Further to the right is a second conjunction of a cat and shield. A feline head, this time puppetlike at the end of an arm, is superimposed on a small shield. A macaw or parrot is attached to the left-hand side of the shield, and an arrow falls tangent to the opposite edge.

In other Jeddito paintings, shields and sun shields are situated in the midsection of felines or composite feline-like animals. (b) A spotted feline with eagle and prob-

a

b

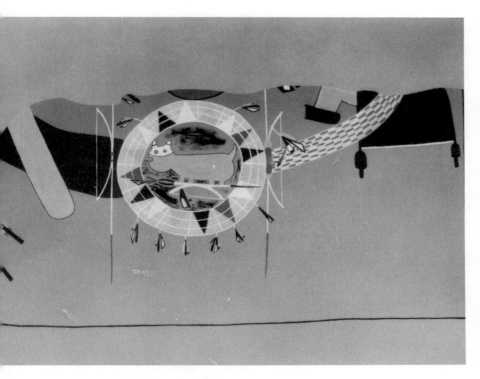

ably macaw feathers below its tail passes into a shield with a star motif at Kawai-ka-a (Test 5, Room 4). (c) In an Awatovi painting (Room 788) a blue and white feline-like animal with a bearlike foot passes through a halved, feathered sun shield. *(Photographs courtesy of the Peabody Museum, Harvard University.)*

The symbolic quality of the feline figures in these paintings is attested to not only by their juxtapositioning with shields but also by other unnatural characteristics, such as the use of blue and white, and their banded tails that more nearly resemble the tails of diamondback rattlesnakes. Although the spots at the end of a jaguar's tail might be stylized in this manner, the conflation of snakes and felines is explicit in one Pottery Mound mural previously described involving a blue spotted cat and a rattlesnake. *(Watson Smith, 1952 photographs reprinted courtesy of the Peabody Museum of Archaeology and Ethnology, Harvard University.)*

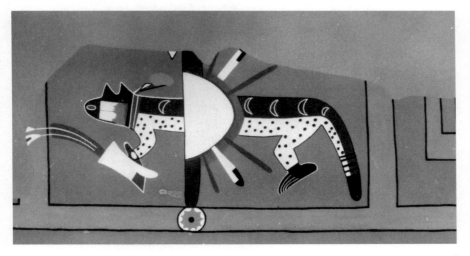

c

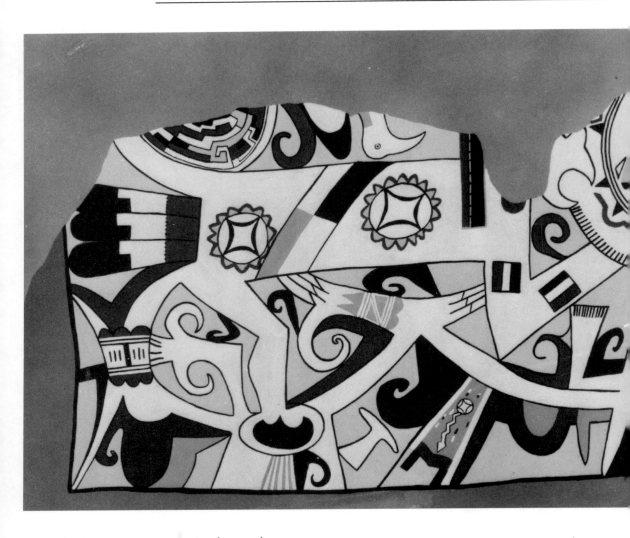

Fig. 3.39

One of the most symbolically complex animal paintings at Awatovi (Test 14, Room 3) is incorporated in a matrix of Sikyatki-like designs. Here are two composite creatures that are predominantly feline but which have human and avian attributes. The felines flank a central circular motif that resembles a sun shield with nar- row outer rings and spiky sun-ray elements along the periphery. This circle is superimposed by what Smith[10] desig- nates as a tiponi or society standard. The human aspect of the flanking figures is denoted by the back leg of the left figure, whose muscular calf is that of a human, and by the human heads with long hair and necklaces with

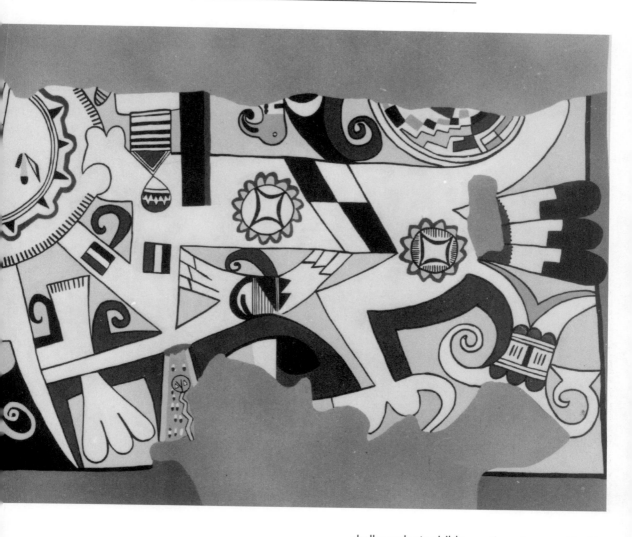

shell pendants visible behind the simple, highly stylized heads of the cats. The feline forms have large eagle feathers emerging from beneath their tails, and the hind foot of the right-hand figure is an exaggerated eagle's talon.[11] On their bodies are small, circular elements like medallions with serrated sun symbolism around the edges, and inside are four-pointed icons with a vague resemblance to stars. *(Photographs reprinted courtesy of the Peabody Museum of Archaeology and Ethnology, Harvard University.)* Likewise, a painting from Pottery Mound joins bird, feline, and human qualities in one composite icon (Fig. 3.34, b).

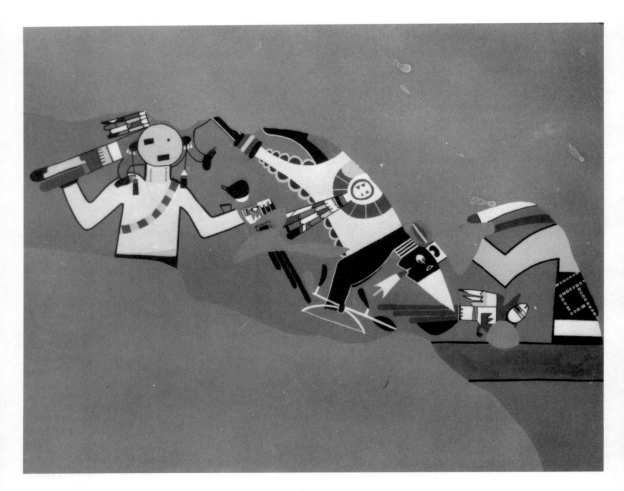

Fig. 3.40, a
 A diving figure replete with war symbolism at Awatovi is identifiable as one of the Hopi War Twins. This person in profile is painted black, and he wears a sharply pointed white cap. There is a paw print on his face, probably that of a bear, and he holds a simple bow and arrow. He wears a white buckskin garment, and in the center is a circular design that appears to represent a small sun shield. Parallels between this figure and contemporary War God images at Hopi are discussed by Watson Smith.[12] To the left is a masked person wearing a bandoleer and carrying an animal and perhaps a bird. *(Photographs reprinted courtesy of the Peabody Museum of Archaeology and Ethnology, Harvard University.)*

a

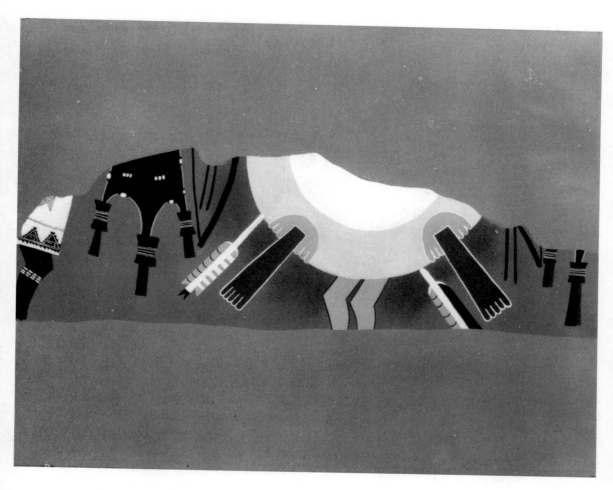

b

Fig. 3.40, b
Confrontation is implicit in the fragments of an Awatovi mural (also from Test 14, Room 3) that shows a shield bearer facing another individual. Arrows and stylized bird tails radiate from the edge of the shield.
(Watson Smith, 1952 photographs reprinted courtesy of the Peabody Museum of Archaeology and Ethnology, Harvard University.)

Fig. 3.41, a and b
(a) A ceremonially attired warrior with the bird-bedecked shield appears to actively confront a second, similarly attired person wearing an elaborate kilt in what would appear to be a ritual scene (Awatovi, Test 14, Room 3). (b) A third painting seemingly portraying conflict comes from Kawaika-a (Test 4, Room 4) in which an arrow is pointed toward the chest of a backward-falling figure whose eye is represented as a cross, giving the impression of being closed. On another wall on the same layer of plaster is the greater portion of a shield bearer, the individual that may be responsible for the other's demise. *(Watson Smith, 1952 photographs reprinted courtesy of the Peabody Museum of Archaeology and Ethnology, Harvard University.)*

a

b

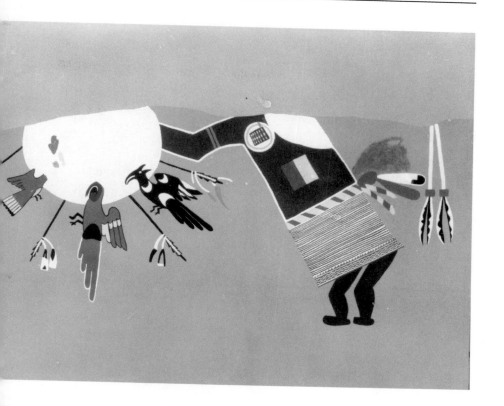

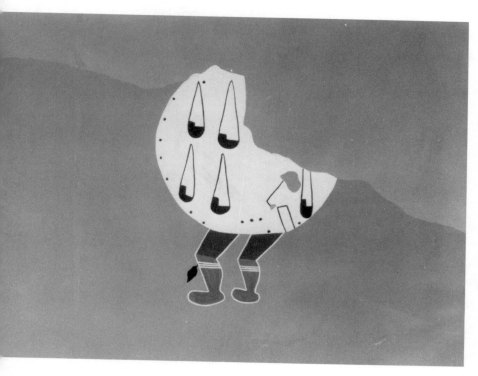

Pueblo del Encierro, New Mexico

In contrast to the complex paintings from Pottery Mound and the Jeddito, six shields and suggestions of animals with heart lines are the only subject matter preserved from a late fifteenth/early sixteenth-century circular kiva at Pueblo del Encierro in the Rio Grande valley near Cochiti.[33] These shields were painted on the east wall behind the fire pit and deflector on either side of the ventilator. The preservation was such that it was difficult to correlate the layers on which the shields were painted, but it is likely that the shield images were paired.

The shields range between 55 and 60 centimeters in diameter, with a simple concentric circle layout (Fig. 3.42, p. 90). Shields to the north of the ventilator have a yellow central disk surrounded by a wide unpainted or white band or ring, outlined in black. South of the ventilator the color scheme is reversed. In some instances a red fringe or red outer ring was added to the circumference of the shields, suggesting that sun shields were intended. The partial remains of animals that resemble bears with heart lines occurred beside the fringed shields.[34] If these are in fact bears, this is a rare association. In the Pottery Mound and Jeddito paintings, mountain lions are most commonly found in this context.

Holes about two centimeters deep, drilled through the plaster and into the adobe kiva wall, may have received prayer sticks.

Kuaua, New Mexico

Kuaua is located on the west bank of the Rio Grande near the present town of Bernalillo. Both the Keresans and the Southern Tiwa claim this site as an ancestral town.[35] Chronological data for Kuaua have been established largely on the basis of ceramic evidence that indicates an occupation from the 1300s into the early 1600s. According to Bertha P. Dutton,[36] however, the amount of early Glaze ware from the fourteenth

century is insignificant, and there is also a paucity of sherds representing the period between A.D. 1400 and 1475. Ceramic indications are that the major occupation of Kuaua began near the end of the 1400s with Glaze D (A.D. 1490–1515) and continued into the historic period. Thus for the most part, Kuaua postdated Pottery Mound, which would have been on the wane as Kuaua was coming into its own.

Kiva 3, rectangular in form, had more than 85 layers of plaster, and a significant number of these layers were painted. Estimates of the age of Kiva 3 vary, but in any case it is later than the painted kivas at Pottery Mound and many of the Jeddito murals as well. According to Dutton,[37] sixteenth-century fill from this structure indicates that the paintings must date from the late 1400s into some portion of the 1500s. In contrast, Bradley J. Vierra,[38] citing more specific ceramic sequences, states that the fill contained largely Glaze F sherds dating between ca. 1625 and 1700.[39] This implies that the kiva was still active around A.D. 1600, and abandoned early in the seventeenth century. It is noteworthy that the Kuaua murals lack the explicitly war-related themes discussed for Pottery Mound and the Jeddito such as shields, shield bearers, stars, and so forth. Although subjects believed to pertain to warfare were identified by Dutton's informant,[40] these references lack substantial visual clues.

It is significant that the one clearly war-related image from Kuaua occurs not in the murals but on an Agua Fria Glaze-on-red bowl that predates the mural paintings. The design on this bowl from the collections of the Museum of Indian Arts and Culture/Laboratory of Anthropology depicts a warrior wearing a shield with a spiky, serrated edge.[41] This pottery painting (ca. A.D. 1340-1425) indicates that this type of shield bearer was being made in the early or early-middle Classic period on the Rio Grande, and as such it helps to date comparable

figures in the rock art.

The most probable candidate for a warrior of some kind in the murals is a ceremonially attired personage wearing a flared scalloped garment and holding a crosshatched, blue, feline-skin quiver filled with arrows (Fig. 3.43).

In another painting, a very abstracted figure with eagle-tail feathers has warrior marks on his face.[42] Horizontal depictions of fish/men flanking the niche on the west wall (layer A-8)[43] are regarded by Marc Thompson[44] as symbols of the Hero or War Twins. In support of this interpretation is the occasional presence of fish with warriors and shields in southern Tewa and Tiwa petroglyphs.

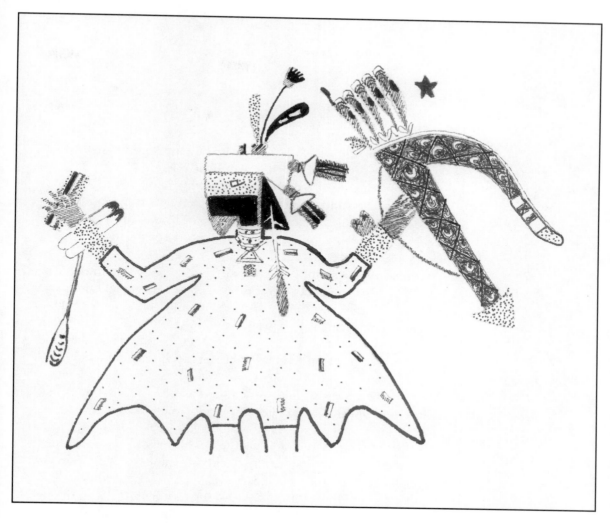

Fig. 3.43
This individual with a quiver of arrows and a flared garment is similar to the unusual Southern Tewa figure described earlier as a possible arrow swallower (see Fig. 3.21, b). The Kuaua figure from Kiva 3 occurs, nevertheless, in the context of a corn ceremony defined by ritual participants and corn plants.[13] Stripes on the tail of the blue mountain-lion skin quiver again resemble the banding on the tail of a diamondback rattlesnake, just as the crosshatching on the quiver suggests the pattern of this rattler. The conflation of cat and snake has been observed at both Pottery Mound and in the Jeddito, where felines with banded tails are associated with shields (Kiva 3, Layer H-31). *(Drawing after Dutton 1963: Frontispiece).*

CONCLUDING THOUGHTS

The Development of Pueblo War Iconography and the Historical Implications

What does this description of prehistoric Pueblo graphic imagery suggest about the history and development of an ideology pertaining to ancestral Pueblo warfare? Prior to the fourteenth century, Pueblo warfare iconography consists solely of shields and shield bearers and is found only in the northern and western Anasazi region adjacent to the Fremont area, where it intensifies along the border zone. Were post-thirteenth-century war-related images and their symbolic meanings rooted in this Anasazi/Fremont configuration? Does the iconography signify a continuous, insular, regional development with regard to warfare and its associated symbolism, metaphors, and institutions, in response to conflict beginning around A.D. 1250? Was this iconographic complex on the Colorado Plateau the sole ancestral antecedent to the vastly more complex developments that followed in the Rio Grande and Little Colorado? These issues will be addressed again in Chapter V.

As the foregoing pages indicate, there were major changes in the iconographic approach to the shield alone after ca. A.D. 1325. Although ceramics suggest that Kayenta populations may have moved south into the Hopi region, and to Awatovi itself at the end of the thirteenth century,[45] shield designs in the Jeddito murals display closer affinities with shields in the Rio Grande Valley, rather than having any particular ties with earlier ancestral shield motifs from the Kayenta.

While shield designs based on the concentric circle persist throughout, new elements reflect the new ideological developments that swept the Pueblo world in the fourteenth and fifteenth centuries. The feathered sun shield with a spattered red rim, for example, or the sun shield bordered by narrow rings of color, is absent in the rock-art iconography of the San Juan and Colorado River drainages to the north. Scalloped or serrated edges and several new layouts characterize Pueblo IV shields. Large active warriors portrayed in profile, wearing pointed caps and holding quivers and recurved bows, and stars with expanding points and warrior kachinas

are among the many new elements found throughout the Pueblo area for which antecedents in the north are lacking. As is also clear from the description of the images, the major iconographic innovations after ca. A.D. 1325 were accompanied by far-reaching changes in graphic style.

In spite of the full-fledged elaboration of war iconography in the Jeddito murals, war-related symbolism in post-thirteenth-century rock art in Little Colorado is less extensive than that of the Rio Grande Valley. Some of the shield designs are shared, and there are Knife-Wing–type birds. Mountain lions and bears are multireferent symbols within the Pueblo iconographic system, however, and in Little Colorado River rock art they lack the associated symbolism that would affiliate them with war themes, and in this context they may well have other meanings. This discrepancy between the Little Colorado rock art and Jeddito murals suggests that the Western Pueblo region was not the hearth of development for the iconographic system that later spread to the Eastern Pueblos, in spite of the fact that shield iconography appears earlier in the West.

In summary, all of these factors indicate that the development of the Pueblo shield and associated war-related content was not a linear one. Although some historical connection and carryover must have occurred between the Colorado Plateau and the Rio Grande, a comparison of the stylistic elements in Pueblo III and IV war iconography as well as a consideration of distributional factors indicate that Pueblo warfare ideology after ca. A.D. 1325 did not find its inspiration in the northern Southwest.

Among the new elements is the kachina cult, the ideological roots of which appear to lie in a larger interaction sphere reaching into central Mexico.[46] All of this suggests that the situation giving rise to Pueblo warfare and its concurrent ideological development is more involved than simply environmental factors, growth, and social complexity leading to increased conflict.

Within the new configuration described herein is couched a greatly expanded set of symbols and metaphors comprising a new ideology of war within a few decades after A.D. 1300. An exploration of these meanings and their relationships to the broader spectrum of Pueblo culture remains to be considered.

Fig. 4.1
 Sandia
Mountains, Rio
Grande Valley, New
Mexico. Several Rio
Grande Pueblos
view the top of
these mountains as
the home of the
War Gods.

TOWARD AN UNDERSTANDING OF THE IDEOLOGY OF PUEBLO WARFARE: Exploring the Pueblo IV Image

This rich inventory of war imagery dramatically documents that the late pre-historic and early historic Pueblos (ca. A.D. 1325–1600) from the Rio Grande in the east to Hopi in the west were not only conversant with conflict, but that they also had developed an elaborate system of graphic imagery that encoded a highly structured program of symbolism and metaphor, separated by only a few centuries from the ethnographic present. A shared symbolic vocabulary throughout the Pueblo realm after A.D. 1300 suggests a general-ized belief system was pervasive throughout all the pueblos, albeit with dif-ferent regional and temporal emphases.

Chronologically, war iconography is more prevalent between the four-teenth and the mid-fifteenth century in the kiva murals, although there are indications that the harder-to-date rock-art war iconography may not always conform to this pattern (see Chapter V).

INTERPRETING THE IMAGERY

Warfare symbolism was united with Pueblo cosmology, ritual, and social organization. Although war between Pueblos and nearby neighbors is now a thing of the past, and much of the ideology associated with it has been sup-pressed or forgotten in recent decades, ethnographic material collected at the end of the nineteenth and the early twentieth centuries, however, contains a significant amount of information pertaining to war rituals and their mean-ing. The ideology expressed in Pueblo IV imagery is amenable to interpreta-tion on the basis of ethnographic parallels.

A potential pitfall in this procedure is replicating the ethnographic record in the archaeological context under consideration.[1] Care must be taken not to force a mirror image of the present onto the past. Focus on the observable continuities between the ethnographic data and the old icons may tend to obscure the differences between them and the changes that have occurred, in this case with regard to warfare ideology, during the last several centuries. At the same time a judicious use of ethnographic analogy is extremely useful and appropriate for illuminating the symbols and metaphors of the past. As

observed by J. D. Lewis-Williams,[2] it is unlikely that we can discover the meaning in the art of other cultures "without some guidance from its makers."

From the historical record we know that warfare among the Pueblos, as among other tribal peoples, involved supernatural assistance. Warrior societies, composed of those who had proven their valor by having taken a scalp, controlled the supernatural forces and rituals necessary for military success. Supernatural aid and power objects such as war trophies served to justify conflicts for which several layers of causality seem to have been involved. The nature of Pueblo warfare itself is a subject to be addressed elsewhere, but in most cases it probably took the form of small-scale raids, neither seeking to annihilate the enemy nor to conquer new territory. The Pueblos were both instigators and victims. Social conflicts between villagers and non-Pueblo outsiders during the protohistoric period were not necessarily strictly happenstance phenomena. Careful ritual procedures were followed while preparing for battle and also during the victorious return. The intertwined complex of religious, economic, and social elements around Pueblo warfare is symbolized in Pueblo IV art described in Chapter III.

Sacred and secular issues are not separable in the Pueblo world view, and an interpretation of war-related imagery must proceed within a framework that takes into consideration the supernatural, a major component of the iconography. Rock art and kiva murals portray not only the familiar shield with its symbolic and magical implications, but also warrior deities with weather-control powers and their human counterparts, as well as certain animals, birds, and celestial symbolism, all of which are imbued with supernatural qualities potentially useful in military contexts. Rituals, implements of war, and perhaps even the heroes involved were also pictured.

War Shrines

Of additional interest with regard to rock art in particular is the relationship between the deities associated with war and how they are integrated with topographic features, contributing to the landscape's symbolic dimension. Specified places are regarded as inhabited by supernaturals capable of bestowing power on warriors. Sky symbolism that includes the sun, stars, and various birds is prominent in the Pueblo war cults. Among the Pueblos, high places where storm clouds gather and lightning strikes, such as the hills and mesas around Zuni or the Sandia Mountains in the Rio Grande Valley on the eastern edge of Albuquerque, are often viewed as homes or domains of the war gods[3] (Fig. 4.1). Lightning, a weapon of the War Gods, is indicative of their spiritual presence and their shrines are located in these places accordingly. At Zuni at Winter Solstice, wooden images of the War Gods are carried to their mesatop shrines open to the sky. These landscape abodes of the supernaturals may be described as frightening and dangerous. Visitors to these spots may carry offerings to invoke the resident spirits and, once activated,

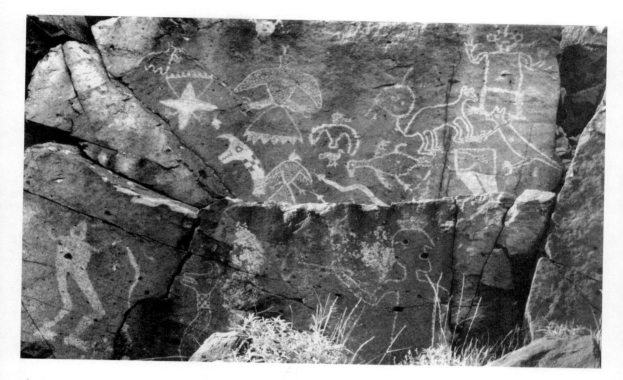

Fig. 4.2

A cluster of petroglyphs on the Comanche Gap dike suggesting a war shrine. Figures include snakes, horned serpents, Knife–Wing, a feathered and taloned star, and a butterfly. On the lower right, a figure in profile wields a war club and to the left is a man with a snake. *(Photograph by David Grant Noble.)*

their presence can be felt and heard and can cause strong winds.[4]

Rock art featuring war subject matter may be a guide to places regarded prehistorically as inhabited by supernaturals with war powers. The imagery in its landscape setting is believed to have contributed to the significance and power of such locations. Concentrations of war themes within the broader scope of petroglyphs at West Mesa near Albuquerque and in the cliffs above the ruins of San Cristóbal in the Galisteo Basin tend to be secluded, suggesting shrine-like contexts where offerings to these supernaturals might have been made. Several small isolated rock-art sites elsewhere in the Galisteo Basin of the southern Tewa feature shield bearers, star supernaturals, and other imagery related to warfare, and once again these appear to be war shrines (Fig. 4.2).

The high igneous Comanche Gap dike, for example, is significantly elevated above the surrounding plain of the southern Galisteo Basin (Figs. 4.3 and 4.4). In spite of the numerous boulders scattered down the slopes of this ridge, available candidates for receiving petroglyphs, the petroglyphs are concentrated near the top. The ridge east of the low pass, the latter generally known as Comanche Gap, is the focus of some of the most dramatic war iconography of the Classic period.[5] Because the nearest pueblos were abandoned early in the 1500s, presumably due to raids by non-Pueblo factions,[6] most of the rock art on this dike was probably made prior to this time. The amount and variety of war symbolism here suggests that between ca. 1325 and 1525 this topographic eminence was regarded as the residence of super-

Fig. 4.3
View of the Galisteo
Basin. Comanche
Gap dike is visible in
the distance. The
eastern end of this
topographic feature
reaching high above
the rolling grasslands
is a major focus of
Southern Tewa petro-
glyphs related to war.

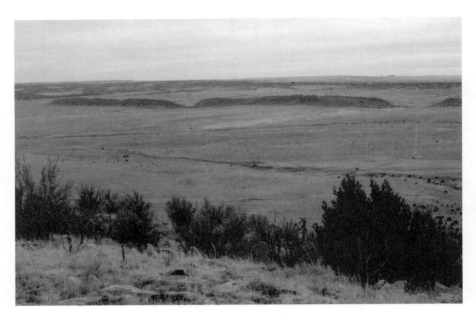

Fig. 4.4
View looking west
along the dike at
Comanche Gap,
Galisteo Basin.

natural powers that could be appealed to time of conflict. The numerous shield figures and the repetition of the war themes undoubtedly served to increase the power of the locality.

According to M. Jane Young:[7] "If rock carvings and paintings have power, a power that can be imparted to the places where they are created, then several images placed in close proximity to one another might make that place even more powerful. . . This is perhaps another example of the Zuni aesthetic of accumulation—the tendency to repeat certain images over and over

again so that their surroundings 'echo' those concepts with which they are most concerned."

The tumbled walls of small stone enclosures near the top of the dike are probably the remains of shrines. Galisteo Dike, a comparable but less imposing landscape feature several miles to the north, while not entirely devoid of war symbolism, lacks this impressive display. The one small shield bearer on the eastern section of this dike is unimpressive, although there are several representations of personages with arrows across their faces, possible depictions of arrow swallowers, ritual participants with war associations. In sum, indications are that the eastern hump of Comanche Gap was a primary, if not one of the most important, war shrine for the southern Tewa of the Galisteo Basin.

Symbols of war in the landscape (Fig. 4.5), like the shields in the occupied rock shelters of the Colorado Plateau, may also have served a protective function, only in this instance over a wide terrain. On the other hand, shields pecked on cliffs and boulders near open Pueblo IV pueblos may have been regarded as protective devices in the same way as the shield paintings near the cliff dwellings of the preceding period.

Fig. 4.5
View north across the Galisteo Basin from the Comanche Gap dike. A boulder with a shield is seen in the foreground.

Historically, war shields pictured on rocks along with tally marks at Hopi are said to have functioned as documentary statements of a successful fight,[8] the tally marks indicating the number of slain. In this particular historic example, however, the shields are those of the enemy, not the Hopi, and the friendship sign and moon on the Ute shield are said to relate to the event itself, without any magical implications. The practice of picturing the shields of the enemy is a noticeable break from the assumption here, based on shield designs and so forth, that all the prehistoric shields are Puebloan. Stephen does not discuss how the site for this commemoration was chosen—whether the spot had any prior importance in connection with war ritual, or whether it was based simply on the visibility of the rocks close to the trail and, therefore, the social impact the imagery would make.

In spite of the fact that the weight of the iconographic evidence examined here lies in the Rio Grande Valley, myths, rituals, and ethnographic documentation from Hopi and Zuni have provided the most valuable ethnographic material for comparison. The reasons for this seeming inconsis-

tency are several. Much of what is present in the Classic period iconography in the Rio Grande has been retained historically in the Western Pueblos, while pueblos in the east have been subject over the centuries to more severe pressures from the Christian church and other restrictions. In particular, conflict, and consequently ritual related to war, were curtailed earlier in the Rio Grande than in the west. In addition, conservative Rio Grande Pueblo factions migrated to the Western Pueblos before, after, and during the Pueblo Revolt, taking with them specific ideas and practices. Both the transference of Eastern Pueblo concepts to the Western Pueblos in the early historic period and the more remote location of the Western Pueblos away from the influence of the Spanish and Catholicism are factors that account for the ability to understand the Classic Eastern Pueblo iconography in terms of late historical ethnographic material collected at Zuni and Hopi. These same issues have been examined with regard to the kachina cult.[9]

Early ethnographies from the late nineteenth and early twentieth centuries reveal that war ritual and societies were more intact at that time at Hopi and Zuni than among the Eastern Pueblos. Titiev,[10] for example, in his field work at Hopi as late as the 1930s, received an account of the Momtcit war ceremony from the last surviving member of that order at Oraibi. Still earlier war data from Hopi was collected by Voth,[11] Stephen,[12] and Dorsey and Voth.[13] On the basis of these works as well as contemporary Hopi texts and folktales, Malotki and Lomatuway'ma[14] note that "the whole realm of war, with its tangible as well as intangible aspects, is conceptualized to a highly sophisticated degree...."

All of the above notwithstanding, war societies and related organizations, along with certain conventions and a formal ideology of war, still exist in many Pueblo villages, where they maintain changed but related functions.

THE SHIELD

The shield, both as an image in its own right or carried by a warrior, is the dominant and most compelling element in the suite of war-related images in the rock art and the Pueblo IV kiva murals. Its importance as a war icon was prime. The basketry shields made by Pueblo III Anasazi on the Colorado Plateau have been described in Chapter II, but it is believed that after A.D. 1300 shields were made of hides[15]—elk or bison would have served well for this purpose. Scalloped edges on fourteenth- and fifteenth-century depictions of shields suggest that these shields were made of buffalo hides (see p. 134). Spanish chroniclers mention that shields were among the gifts brought to Coronado's party in 1540 by Pueblo Indians from Pecos, but they are not described.[16] Historic examples are around 62 centimeters in diameter.

It is not clear whether the shield bearers in Pueblo IV kiva murals and rock art represent supernaturals or simply warriors as such; both may be the

subject. The paired shield bearers at Comanche Gap could represent individual warriors, the War Twins, or human impersonators of the War Twins. As numerous warriors in both the kiva murals and the rock art appear to depict individuals, it is possible that individuals permanently recorded their own prowess as warriors in such petroglyphs, although individual accomplishments and prominence are not characteristics promoted by the Pueblos, whose value system today, at least, seeks to emphasize group solidarity and identity rather than individual heroes.

Shield Designs

As mentioned in Chapter II, according to Barton Wright, shield designs in historic times may contain some measure of village identity, and it has been suggested that some designs could have reference to a specific society within a village, although this is not well substantiated.[17] Fewkes,[18][19] working at Hopi at the turn of the century, briefly mentions in passing that each society had its distinctive sun shield. It is not clear, however, whether or not the designs involved actually represented or symbolized the society as such.

On the other hand, magical powers ascribed to shields and their designs may have a long history beginning in the thirteenth century. The Pueblo war shield was much more than just a material protective device, but was believed to be animated by spirits[20] and to possess magic power derived from its design that was, in turn, transmitted to its owner.[21] In fact, the painting on the shield, designed to blind and confuse the enemy as it strengthened the user with supernatural assistance, was deemed more important than the shield's physical protective qualities.[22]

Although the meaning of the designs on many of the Pueblo IV shields is not always clear from today's perspective, others incorporate extant symbolism of the most powerful supernaturals associated with Pueblo warfare, supreme sources of strength and protection. Among these the sun, stars, and eagle-like Beast God of the Zenith—all celestial entities—figure prominently, and they have continued to embody the spirit of warfare in the Southwest historically. Feathers on the shield also imparted power.[23]

Stars are one of the most frequently encountered symbols on rock-art shields (Fig. 4.6). The four-pointed and often feathered Pueblo star with an expanding center is a multivalent symbol embodying several interrelated meanings and implications of war. The motif is by no means confined to shields, however, and it occurs in rock-art panels as an element in its own right, and occasionally even as a mask. The metaphorical implications of this motif, frequently combined with elements of the predator-eagle, are so complex that the star merits a separate discussion in itself (see below under Feathered Stars and Scalps). As a symbol of Venus, warrior and guardian of the Sun, and likewise symbolic of the War Twins, it is also called Morning Star. In its symbolic role of guardian, it is particularly powerful as a shield design.

The Morning Star was especially popular on shields during Pueblo IV and has persisted in use on historic shields.[24]

Sun Symbolism

The sun, moon, and shields are conceptually united entities in Puebloan thought. As previously described, sun symbolism is prevalent on Pueblo IV shields in the form of serrations, eagle feathers, red feathers, and horns on the outer rim, and there are implications that the sun disk/shield served as the sun's "mask."

The creation of the sun and moon in some Pueblo myths involves the making of a round shield. In Hopi stories from Oraibi, a white cotton mantle spun by Spider Woman, also known as Spider Grandmother, is used to create the sun and moon (or in lieu of a cotton mantle, a buckskin may be used as a sun shield).[25] Commonly, parrot-tail feathers were attached to make the sun's shield yellow or to simulate the light of dawn.

At Zuni, "The sun itself is conceived as a shield of burning crystal, which the Sun Father, who is anthropomorphic, carries as he makes his daily journey from east to west. Prayers are addressed to the invisible and esoteric bearer of . . . the shield, who travels over the road of day seated on a colossal turquois [sic], wearing beautiful buckskin clothing. . . ."[26]

At Zia the sun is described as wearing fringed deerskin clothing, "the kilt having a snake painted upon it; he carries a bow and arrows, the quiver being of cougar skin, hanging over his shoulder, and he holds his bow in the left hand and an arrow in his right; he still wears the mask which protects him from view of the people of the earth." The mask is decorated with eagle and parrot plumes and "the hair around the head and face is red like fire and when it moves and shakes the people cannot look closely at the mask . . . ; the heavy line encircling the mask is yellow and indicates rain."[27]

In the same account the comment is made that the Zia "did not see the sun himself, but a mask so large that it covered his entire body." A large painting of a sun-shield bearer in the Galisteo Basin manifests many of the qualities of the Sun himself as described in these accounts (Fig. 4.7). This figure, wearing white (buckskin) leggings with red fringe, carries a red and yellow shield with a flower design. The circumference is rimmed with serrations believed to represent the sun's rays. The red handprint at the lower right may signify one of the War Twins. Being red, it incorporates implications of warfare and blood. As noted in Chapter II, red handprints in association with shields also occur in pre-fourteenth-century rock art on the Colorado Plateau.

There sometimes exists some ambiguity between the Sun and his sons,

Fig. 4.6
A shield-bearer petroglyph with star motif, south of Taos and north of San Juan Pueblo. Northern Tewa or Northern Tiwa.

the War Twins. In one Tewa story it is the Twins who carry their Sun Father's shield across the sky.[28] In a Santa Clara Pueblo tale, the slower-moving Elder Brother is the hotter Summer Sun, and when the days are short, the quicker Younger Brother is the Winter Sun.[29]

Ethnographically, ritual participants wearing sun shields or masks may represent the sun. In the Hopi Flute and Snake ceremonies described at the turn of the century by Fewkes,[30] one flute-playing participant representing the sun wears a sun disk made of buckskin on his back. The edges of the sun disk have a sawtooth-plaited border of cornhusks, with radiating eagle feathers and red-stained horse-hair attached. Other sun shields or sun masks with serrated or sawtooth edging created by plaited serrated borders to indicate the sun's rays are illustrated by Fewkes[31] and Wright.[32]

Elements of the sun included in the above ethnographic citations are dramatically depicted several hundred years earlier in the rock art and kiva murals. As previously described, sun shields in the Jeddito murals are portrayed as plain white disks surrounded by a red edging.[33] Often the red perimeter

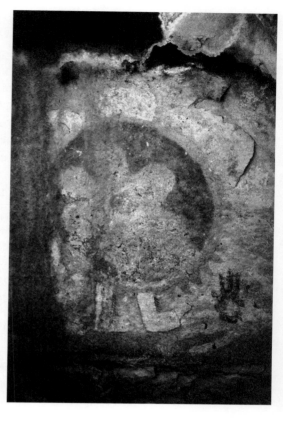

was applied by spraying to give it a diffuse appearance like the sun's rays. Radiating eagle and macaw feathers may be juxtaposed, as described above (Figs. 1.3 and 3.37).[34] In addition, the attachment of prayer sticks, projectiles, and even the whole macaw or parrot itself indicates that one is viewing a sun shield. In the murals, other birds such as the magpie also occur on the rims of these sun disks. As described in the previous chapter, many shield petroglyphs in the Rio Grande area display sun symbolism in the way of a feathered, rayed, or sawtooth edging. Petroglyph shields with sawtooth perimeters are particularly frequent in the Galisteo Basin in the Southern Tewa region, and one of these has a double sawtooth border (Fig. 3.2). Many of these shields are carried by warriors who may carry quivers and brandish weapons. Other shield bearers play flutes (Fig. 3.15, e). The sun himself as a warrior, or warriors appropriating the power of his symbolism, may be the subjects of these representations. The sun is sometimes also a horned figure. With or without horns, petroglyph shields with two circles placed like eyes in the upper section may also represent the sun's mask, much like the horned and feathered mask of the sun recorded at Zia by Stevenson.[35] Some of the masklike shields not inappropriately incorporate eagle motifs, the eagle also being symbolic of the sun.

Fig. 4.7
This large painted sun–shield bearer in red, white, and yellow wears white leggings with red fringe, Galisteo Basin, Southern Tewa. The serrated edge of the shield is still faintly visible. The painting is more than a meter in height.

The Sun, father of the War Twins and, in some tales, provider of their lethal weapons[36], is the supreme patron of war and a valued source of empowerment for those engaging in combat. A pair of sun-shield bearers from Comanche Gap may stand for the War Twins or their impersonators, although they lack the characteristic headgear. The bear-paw symbolism on one of shields is a contributing factor to this interpretation, since the bear is not only a war patron, but is specifically associated with a war god in the Awatovi murals.[37] Within the context of these considerations, the conflation of sun and shield and the sun shield of prehistory is an affirmation and symbol of the ultimate war power.

The sun is linked to the affairs of war and combat in numerous ethnographic contexts. Among the Rio Grande Pueblos, the war priest is identified with the sun.[38] In most if not all pueblos, the sun is appealed to for power in matters of both war and hunting, and he is sometimes referred to as a head-taker,[39] a factor that may hint at a link between this celestial entity and scalps as described below. Hopi texts reference human deaths as necessary to keep the sun moving, or high enough in the sky to keep the earth from being scorched, or simply hot enough, depending on the story.[40]

It is Masau who explains that "keeping the sun going will be possible only at the expense of human life. Only by flaming with human grease can the sun burn with such heat that it will produce enough light. For this reason people will have to die from now on."[41] Although the first death for this purpose is said to have been that of a girl ritually sacrificed to the sun to keep it spinning properly, subsequently natural deaths provide these means. Of further note is the observation that fat (applied by Spider Woman), not blood, is the key ingredient.[42] The necessity of warlike activities to secure a sacrificial victim for the sun once may have lurked behind this concept, although this is not stated or made explicit in ethnographic sources. Nevertheless, at Zuni and elsewhere, prayer wands were (are) regarded as living beings. Zuni ritual poetry suggests that offerings of prayer sticks to the sun near the winter solstice may have substituted for human sacrifice.[43] The concept of the need to sacrifice human lives for the sun was a well-developed theme in myth and in ritual in central Mexico.

Pueblo races are sponsored by the war associations both for the sun and as preparatory ritual for combat. In discussing the War Society at Santa Clara, a northern Tewa village, W. W. Hill[44] notes that "some of the rites held prior to the departure of a war party still existed in vestigial form as part of the Relay Race. . . ." During these rites, scalps were paraded on poles. Ritual racing, on the other hand, and kick-stick played by the War Twins in myths also facilitate the sun's proper movement. Tales of removing the heart of the loser of a race or battle, as well as beheadings and hair-cutting rituals in connection with kachina racing,[45] contribute to a sense of the inherent relationships between war, racing, the sun and sacrifice.

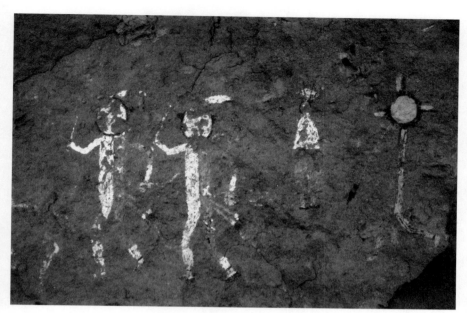

Fig. 4.8
A small, fragmentary, but detailed Piro rock painting in red and white of a running figure with a head that represents the sun (right). Also running are associated figures with bodies divided lengthwise in two colors and wearing long sashes. They carry objects in their hands.

While Pueblo racing also may be done to bring rain, to hasten the growth of crops, and to achieve long life, in the Tiwa Pueblos races are held specifically to regulate the journey of the sun.[46] Southern Tiwa races for the sun at Isleta, today the southernmost Tiwa pueblo on the Rio Grande, are conducted in late March or early April, when the sun itself is moving quickly near its equinox position on its journey north.[47] Comparable races are held at Taos, a northern Tiwa pueblo, in early May. Taos races are also held following the fall equinox in conjunction with San Geronimo Day in September, a counterpart of the spring races. Figures of running suns featured in Piro rock-art sites south of Isleta may depict equinox racing for the sun (Figs. 4.8 and 4.9). In the rock paintings, their white bodies are finely striped in red, and their faces or masks are sun disks rimmed with red fringe and feathers.

Spring races, relay races, and long-distance running are also connected to war ritual. At Isleta, relay races are part of a spring war ceremonial. The war ceremony is organized by the war chief and *kumpa*, also a warlike officer, and is closely connected to the scalp ceremony; Corn groups also participate. The feeding of the scalps in the wall niches is part of the ritual. The scalp in this case, according to Parsons,[48] is not a rain being, but functions to grant a strong spirit to runners who themselves may actually represent the sun (or the moon). In other words, in this context the scalp of the vanquished enemy contributes its power to the sun, and as a symbol of the sun, the runner is empowered by the scalps. The involvement of the Corn groups in the ceremonies described for Isleta confirms the importance of this ritual in the agricultural cycle, bringing together the ideological configuration of the sun, sacrifice, and corn (maize). Similarly, among the northern Tewa, summer sol-

Fig. 4.9
Pecked and scratched Piro petroglyph of a running sun.

117

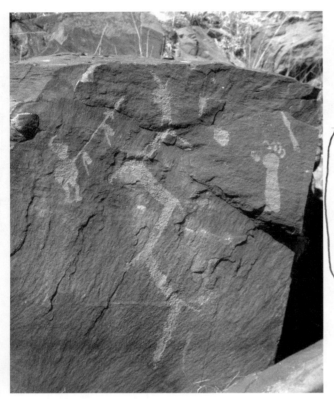

Fig. 4.10
A small shield bearer with a single horn holds a feathered spear as he confronts a horned and feathered serpent, Piro region. A mountain lion paw and leg is pecked to the right.

stice relay races are conducted to give the sun strength for this journey to its winter home.[49]

In addition to racing, other rituals to ensure the continued movement of the sun involved the participation of warriors and were sponsored by war associations. Probably the apex of ritual warlike activity associated with the sun's movement comes at winter solstice, when the sun is endangered at its southeast/southwest standstill positions at sunrise and sunset. Hostile powers are believed to threaten the sun at this extreme point in its annual migration, and one of the threats is thought to be p o s e d by the Plumed Serpent.[50] Fewkes classifies the associated ritual of Soyaluna on First Mesa at Hopi as "strictly a warriors' observance. . ." and draws a parallel between this ceremony and the Aztec Teotleco in that it is, strictly speaking, the "return of the war God," i.e., the return of the sun. The Hopi drama that Fewkes describes involves the propitiation of an effigy of the plumed serpent, followed by a mock battle in which sun-shield bearers are attacked in vicious assaults. Fewkes describes the visiting societies as "each bearing a splendid shield ornamented with the figure of the sun and a rim of radiating eagle feathers."[51] According to Fewkes: "If Soyaluna is a propitiatory ceremony to prevent the destruction or disappearance of the sun in winter or to offset the attacks of hostile malevolent deities upon him, we can see a possible explanation of the attacks and defenses of the sun as here dramatized."

Hopi Soyal altars feature war symbolism and are the locus of war rituals.[52] By the war altar at Hano, a Hopi-Tewa village on First Mesa, war songs are sung all night long to make the Tewa men brave and the hearts of the enemy weak, as Rattlesnake, Big Snake, the Sun, the War Gods, Bear, and Wildcat are invoked. The altar also has a medicine bowl containing various ingredients, including "powdered human hearts taken in ancient times." This reference to human hearts on the winter solstice altar, at the time when battle is done to empower the sun, is reminiscent of Mexican human sacrifice in which beating hearts were offered as nourishment to the sun. At Hopi, the medicine in the bowl is administered by a participant representing a war god in full warrior regalia, wearing a bandoleer (Fig. 5.3) containing the dried entrails of enemies killed in battle, a woven pointed cap, and painted with parallel

Pöökon marks on his body.[53] In Plate XXIX (op. cit.) this same personage wears a back shield, and a war club hangs from his elbow.

The singing of fighting songs and mock combat between kiva groups during *haniko*, Keres winter solstice rites, have been described for San Felipe as well,[54] and it is likely that they were enacted elsewhere among the Rio Grande Pueblos.

Winter solstice or Soyaluna rites similar to those described by Fewkes seem to be portrayed in both kiva murals and rock art. The Jeddito murals depicting warriors in combative poses, dressed in ceremonial kilts, and holding white sun shields bedecked with birds and arrows (Fig. 3.41a) are reminiscent of the Hopi kiva dramas. Following Fewkes, the threat to the sun in its endangered winter solstice position appears to be symbolized by the Horned Serpents confronting warriors with the sun shields in the Southern Tiwa and Piro petroglyphs (Figs. 4.10, 4.11)."[55]

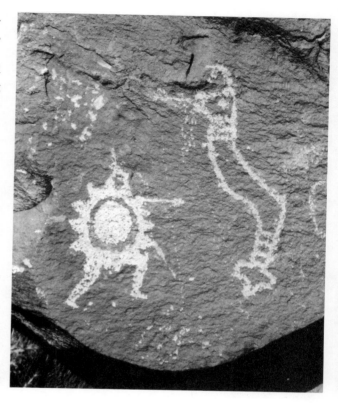

Fig. 4.11
Sun-shield bearer and horned serpent, LA 8983, Southern Tiwa. *(Photograph LA 8983–61–B courtesy of ARMS, Museum of Indian Arts and Culture/Laboratory of Anthropology, Santa Fe.)*

Spider Woman and her Magic Shields

Another aspect of the sun shield is dramatically pictured in a Jemez petroglyph of the sun with a sawtooth border and a spider web design on the face (Fig.4.12). It was recorded early in the century by Albert B. Reagan,[56] who notes that this image is both the sun and Spider Woman. A similar conjunction of imagery appears in an Awatovi mural (Fig. 3.38a).

This association of the sun and a spider web in the rock art, seemingly unrelated entities, is alluded to in the Hopi myth previously mentioned in which Spider Woman weaves a cotton mantle for the sun. The two are also brought symbolically together in a sun construction, described by Leslie A. White,[57] made at the Rio Grande Keresan Pueblo of Santo Domingo during the winter solstice ceremony of *haniko*. While in this case the piece does not resemble a shield, all of the mythological components of the sun's shield previously described are there—buckskin, cotton, and a woven piece, in this instance a Navajo rug. This last is an implicit, if not explicit, reference to Spider Woman. The sun construction begins with laying down the rug and on top of this, a buckskin. Next comes some native unspun cotton. Offerings, which include miniature bows, arrows, and shields, are wrapped in the cotton, and the package is then bundled together with a cord and finished with prayer sticks.

119

Fig. 4.12
This shieldlike pet-
roglyph with serrations
near Jemez Pueblo
combines elements of
both the sun and
Spider Woman.
*(Drawing after Reagan
1917:46.)*

In one of her aspects, Spider Woman, or Spider
Grandmother, recognized for her magical powers, is a goddess of
war. Although she may play a warrior's role herself, she
usually serves in an advisory capacity. In Tewa and Taos sto-
ries, Spider Woman gave the Blue Corn girls a war song and
taught them how to kill and to obtain scalps.[58] Parsons
suggests that the important role that old women play in
scalp ceremonies in Taos, Zuni, and Hopi may relate to
Spider Woman, who among the Hopi is the patroness of
old women.[59] The warrior role of the Blue Corn girls par-
allels that of the male War Twins, who are also assisted by
Spider Grandmother, who likewise provides them with super-
natural advice that assures success in their exploits. Figures of the
War Gods and Spider Grandmother appear together on the winter sol-
stice altar at Hano, the Hopi–Tewa village on First Mesa,[60] along with an image
of a feathered horned serpent. Spider Woman is not only represented in effigy
in Soyal rituals, but she has been impersonated historically in a conflict situa-
tion at Hopi.[61]

The role in war accorded to the Twin War Gods, Masau (God of Death,
the earth surface, the underworld), Kwatoko (Beast God of the Zenith), as
well as Spider Woman, is dramatically illustrated by the impersonation of all
these deities in 1891 in a conflict between the Hostiles at the village of Oraibi
and the U. S. Army. According to non-Hopis, Masau, two war god imperson-
ators, and Spider Woman met U. S. troops in the village plaza along with a
squadron of Hopi warriors.[62] The Spider Woman impersonator advised the
troops to leave. In addition, the Little War God, wearing a knitted cap and car-
rying a sun shield, along with Kwatoko, Beast God of the Zenith, were read-
ied for action behind the scenes. According to the Hopi version of this
encounter, the Hopi leader of the Hostile faction, Lomahongyoma himself,
was readied to act the part of Spider Woman (in this version of the story he
did not actually appear in the plaza). The exact progress of the events is not
important here, but the fact that Spider Woman was called upon at this major
juncture is significant to this discussion of spider symbolism on prehistoric
shields. As a protector, her symbolism on shields is logical.

In addition to the obvious spider-web/sun-shield conflation in the pet-
roglyph from Jemez, shields with lunettes around the inner edge may be a fur-
ther abstraction of Spider Woman's web. Lunette shapes are formed at the
outer edge of the web as it articulates with the inner circumference of the
shield in the Jemez example. Spider-web patterns on pyrite mirrors with
implications of war shields in Teotihuacan art in central Mexico (A.D.
150–750)[63] have similar inner perimeters.[64] There are suggestions of other
Mesoamerican parallels within this sun shield/Spider Woman complex as well.

A different shield design encountered on petroglyph shields throughout

the Pueblo area from the Rio Grande to Hopi may incorporate more obscure Spider Woman symbolism, although other interpretations of this rather frequent but enigmatic pattern are also possible (Figs. 3.8, a and b). Downward-pointing triangles attached to a line horizontally dividing a shield may represent fangs. Two or three circles are usually located in the space above. These circles suggest eyes and hence the sun's shield/mask. The whole, however, resembles the pattern on Spider Woman nose pieces from Teotihuacan that in themselves stand for this deity.[65] In the Mesoamerican examples, this design depicts the toothed arthropod mouth, usually with a longer central conical fang. In some cases the central triangle on a Pueblo shield is the largest. These fanglike elements have not survived in contemporary Pueblo symbolic vocabulary, however, and this projection of formal Mexican iconographic elements into a Pueblo graphic matrix, lacking few other such specifically Mesoamerican forms, should be regarded as highly tentative. This comparison is admittedly extreme in terms of time and space, although it should be pointed out that this symbolism was perpetuated in later central Mexican art. In light of other Mesoamerican conceptual parallels that appear in post-thirteenth-century imagery, including the symbolic and visual conflation of spider webs and shields that shows up in both areas, this similarity is at least worth mentioning, although it currently remains undemonstrated.

Within this general format, a pair of shields from near Los Lunas in the southern Tiwa district (Fig. 4.13) features heads of figures that resemble war gods with plain round heads as described from Hano by Voth.[66] If these are, in fact, war gods, the shield design may incorporate the complete package of Spider Woman and the Twins, and represents the use of these supernatural powers as protective elements on the war shield in a manner consistent with the use of Sun and Morning Star symbolism (see p. 113).

The conjunction of sun, shield, and spider web also introduces the consideration of magical properties of shields in themselves apart from their designs. Both the Sun and Spider Woman provide magic shields for the Pueblo War Twins. In some accounts, the magical netted shields of the Twins are said to be woven from clouds by Spider Grandmother.[67] They were worn on their backs and are referred to as "targets" made of cotton (representing clouds) and plaited with yucca.[68] These magic shields could repel weapons.

In a Zuni myth recorded by Cushing,[69] the Sun Father gave the Twins a great cloud bow and thunderbolts for arrows, along with "the fog-making shield, which (spun of floating clouds and spray and woven, as of cotton we spin and weave) supports as on the wind, yet hides...its bearer..." The Twins could not only hide behind this magic shield, but they used it as well as a means of supernatural travel. The nature of travel provided by the Twins' Spider Grandmother's magic shields is akin to that of a spider on its

Fig. 4.13
A pair of large shields near Los Lunas, New Mexico. Southern Tiwa. The large shield is More than a meter in diameter. *(Drawing from Schaafsma 1968: Fig. 10.)*

web: "on their cloud shield—even as a spider in her web descendeth—so descended they unerringly, into the dark of the underworld."[70] These shields could also transport the owner through the air and bring rain.[71]

Karl A. Taube[72] has suggested that the Zuni cloud shield as a means of magical transport is functionally identical to Huichol mirrors and "front-shields," as well as to ancient Mesoamerican mirrors."[73] In Teotihuacan, Spider Woman is also affiliated with war shields worn on the small of the back. Here shields are synonymous with pyrite mirrors, a medium of divination, and such mirrors were common in the following periods as well.[74] In connection with magical mobility, mirrors in Mesoamerica provided magical access to the Underworld. Similarly, in the Southwest, bowls of water act as mirrors and serve as media of divination and conduits to other realms, including that of the dead.[75] In sum, shields, mirrors, magic travel, access to the Underworld, and Spider Woman are loosely linked factors that are shared between the Pueblo Southwest and various groups in prehistoric as well as contemporary Mexico.

In Southwest ethnographic contexts, miniature netted shields are made as offerings to the Zuni War Gods,[76] and the effigy of Pööqangw, God of Protection and War at Hopi, has a netted back shield.[77] Netted shields are made for the Sun at winter solstice among the Keres. These netted shields are constructed by twisting the yucca fiber like a spider web rather than knotting it. Although netted miniature shields made of yucca fiber interwoven with cotton have been found in archaeological contexts,[78] Spider Grandmother's netted back shields have not been found represented in kiva imagery or rock art. Nevertheless, the magical implications of shields are pictured in the kiva murals.

SHIELDS AS POSSIBLE VEHICLES OF MAGICAL TRANSFORMATION

Although supernatural travel via magical shields through space as such does not seem to be the subject of prehistoric art, shields in kiva murals are shown as possible vehicles of magical transformation. The ability to assume the form of an animal in itself might be thought of as supernatural "travel" in a shamanic sense. Murals from Pottery Mound's Kivas 7 and 8 (Fig. 3.32) show a mountain lion's body entering a shield and emerging as a kachina in one instance, as a human warrior wearing a pointed hat and holding a bow and arrow in the other. As discussed above, within the greater interaction sphere of Mexico and the Southwest, parallels among shields, Spider Woman's web, and magical mirrors are linked to the concept of a passageway to the spirit realm. Within this paradigm, the shields in the murals under discussion appear to serve as vehicles of transformation between a warrior and his animal familiar. The human leg attached to a horizontal body that disappears into a shield in a Jeddito mural[79] may represent a similar theme, although the mural is fragmentary and most of the painting lost.

Although historically a Pueblo shield may have embodied properties of supernatural travel or provided magical protection to its wearer through its design, shields as instruments of magical or shamanic transformation are not described in the ethnographic literature. Thus, conversely, it might be argued that in these unnatural juxtapositionings of elements, the shield is merely an artistic device to illustrate a symbolic linkage between the human figures and the felines. Nevertheless, it is equally possible that the shield's magical functions may have been more elaborate or expanded in the fourteenth and fifteenth centuries than in the historic period.

WARRIORS, GUARDS, GODS, AND KACHINAS

Although shields and shield-bearing warriors are discussed at length in the previous section, there remains in the rock and kiva art a large number of figures and details pertaining to war, including additional supernaturals, human warriors, and ritual magicians.

Among the latter group are sword- and arrow-swallowers at Comanche Gap and elsewhere that are portrayed in the context of war iconography.[80] As noted in Chapter V, these ritualists perform in the context of several war-related societies. The seated sword swallowers at Comanche Gap have large spots on their bodies (Fig. 3.22), and although historic participants in these rites lack these spots, there is a reference in Voth[81] to Hopi warriors departing for combat being painted with spots by Kookop Clan members. These spots, made of a paste of War God vomit and clay, were applied on to make the flesh tough and immune to arrows.

Not all figures brandishing weapons are necessarily indicative of warfare in the usual sense of social conflict. In Pueblo cosmology, the realm of warfare is not restricted to human strife. Participants in symbolic combat, for example, such as those involved in the previously discussed solstice dramas, are warriors in the metaphorical sense and appear as warriors in prehistoric art. Other situations in which warriors may have a ritual role include curing rites of Medicine societies. Among the Keres, participants in witch hunts and curing rites, the *gowatcanyi*, war priest helpers, serve as guards. These rituals involve shamanic encounters (perhaps battles) with witches, the cause of most illness.[82] Often ceremonies involve the retrieval of the heart of the patient, which has been stolen by witches. In the course of the witch hunt, the medicine men are protected by the *gowatcanyi*, who walk in front, drawing their bows and aiming their arrows at the hundreds of witches that fill the air.

In this regard, it is noteworthy that stone figures of the Keres war gods, Masewi and Oyoyewi, along with bears and mountain lion fetishes, appear on the Medicine Society altars where curing takes place.[83] Skins of bear paws and legs are worn in the fight with the witches. Although no warriors have been identified as being associated with Medicine Society proceedings in the rock art and kiva murals, it is worthwhile pointing out that these relationships may

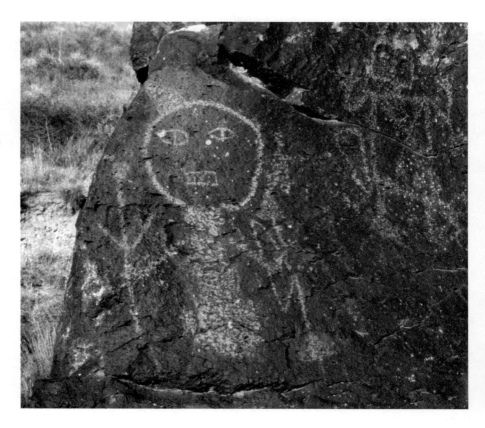

Fig. 4.14
A warrior or war god with pointed cap, holding bow and arrow in one hand and a staff in the other. Southern Tiwa, Petroglyph National Monument.

have gone unrecognized. Ambiguities, when they do arise, largely revolve around discriminating between Hunt Society activities and those dealing strictly with warfare. As noted, the Hunt societies are closely related to War societies and there is a great deal of overlap between them.

Along with the sun, considered in the section on shields, most, if not all, of the major Hopi war deities discussed in the ethnographic literature are represented in the Classic-period rock art and kiva murals of the Rio Grande Valley. Although Spider Woman herself has not been identified, as we have seen, her presence and symbolism prevail in connection with shields. Many warrior kachinas have been identified as well.

THE TWIN WAR GODS

As major deities among the Pueblos, the War Twins, sons of the Sun, also known as Elder Brother and Younger Brother, Masewi and Oyoyewi, and collectively at Zuni as the Ahayu:da, are symbolically complex and play many roles in Pueblo mythology. Exemplifying duality in their many aspects, they are not identical, but manifest "dynamic asymmetry."[84]

The War Gods, wearing conical caps or helmets with apical projections (Fig. 4.14), have already been described in numerous connections as they appear in both the rock art and kiva murals. The War Gods sometimes carry shields, as exemplified by the Pottery Mound example (Plate 12) or by a northern Tewa petroglyph shield bearer with a crosshatched conical headdress with two eagle feathers attached at the top (Figs. 3.7, c and 3.16, a).

Ethnographically there are references to both knitted or woven caps that might account for the crosshatching. Crosshatching might also account for caps made from feline skins, although this association is less obvious. Plate XXIX in Fewkes[85] shows a Pööqangw (Püükoñ) kachina, the kachina form of the Lesser War God, wearing a netted war bonnet with two eagle-tail feathers attached to the top. "There is a small conical extension on top of this bonnet, the usual distinguishing feature of the lesser war god."[86] Poqangwhoya, however, has a similar cap with apical extension,[87] while his brother, Palongawhoya, lacks the cap altogether. A reconstructed Soyal altar shows a ritualist wearing a woven pointed cap and a back shield.[88] Both knitted or netted war bonnets and those made out of feline skins commonly have two eagle feathers at the apex.[89]

At Oraibi and Hano, war-god fetishes simply have round, unadorned heads, or they wear a hemispherical white cap of buckskin with a warrior's feather bundle that gives the appearance of a cone when seen from the front.[90] At Zuni the alternate Shalako dancer, who is also a warrior (see Shalako discussion, page 134), also wears a white cap of buckskin with an apical projection. This cap is said to represent both clouds and scalps.

These war-god caps, sometimes crosshatched or netted, incorporate a

high degree of symbolism. There are suggestions that the net symbolism is fairly complex. As discussed previously, netted shields of the war gods are said to have been woven by Spider Grandmother, protector of and advisor to the Twins. Simultaneously netted shields are also referred to as "cloud shields," an allusion that also brings to mind mist, rain, and storms. In those miniature netted shields made as prayer offerings, the clouds are symbolized by the cotton used in their construction, and the unknotted "netting" suggests the weave of a spider web. In addition to this set of relationships, crosshatching also occurs in connection with the mountain lion (see below, p. 140), and some of the war-god caps are said to be made of the skins of this animal. Thus it is likely that the crosshatched design may have reference to both Spider Woman and the mountain lion, two important war powers.

It is interesting that in Teotihuacan, Mexico, the "net jaguar," a war power with references as well to water and fertility, is said to be affiliated with Teotihuacan Spider Woman.[91] Taube suggests that the Teotihuacan jaguar net has allusions to a spider web.

In the Southwest the cloud symbolism incorporated into the war god's caps may be related to the weather-control and storm-making capacities of the war gods. Their residences in high places in the landscape where lightning strikes was described in the beginning of this chapter. The rain-bringing powers of the war gods are well illustrated in an Acoma story, recorded by Leslie White,[92] in which the ability to cause rain is ultimately the task of the war gods. In this Keresan tale, the War Gods Masewi and Oyoyewi, danced each night in front of Iatik's, the Corn Mother's, medicine bowl. This dancing by the War Brothers caused clouds to rise out of the bowl and spread over the world to bring rain. Offended by Iatik, the War Brothers left for a long period of time, during which drought ensued. "No clouds rose from the bowl" even when the kachinas danced! This last phrase suggests a primacy of the war gods over the kachinas in the ability to bring rain.

Another symbolic aspect of certain other renderings of the war god's conical cap remains to be considered. In some examples the cap is unusually tall and pointed, closely resembling the point of a star as portrayed in this art complex. Such a cap, painted in white, is worn by the War God pictured as a falling figure in an Awatovi mural (Fig. 3.40). The striking resemblance between this cap and the point of a star visually suggests the connection between the War Gods and their aspects as Morning Star and Evening Star, warriors and guardians of the Sun. As Morning and Evening stars they serve as heralds for various ceremonial and agricultural activities.[93] Although Venus is the most commonly cited candidate for Morning or Evening Star, being the brightest planet and the one with the most obvious linkage to the Sun (faint Mercury is seldom if ever singled out in this role), several other planets, in its absence, may be called Morning and Evening Star. Nevertheless, all planets, as well as the stars in general, are closely affiliated with war (see Feathered Stars

and Scalps, page 144). The diving Jeddito war god may represent the setting Evening Star. There is little ethnographic information about "diving" figures as such, however, and the symbolic import of this and other figures similarly positioned among Northern Tewa petroglyphs[94] seems to have been lost. It is possible that all may have Evening Star implications, although this is by no means clear, and the Northern Tewa examples, unlike the Jeddito war god, lack celestial symbolism.

SOTUQNANGU

Morning Star or Venus symbolism is iconographically even more explicit in connection with Sotuqnangu, Heart-of-the-Sky God, another major Hopi war deity. Sotuqnangu and related star-faced kachina/warriors, holding axes or yucca whips in their right hands and bows and arrows in the left, appear in the rock art throughout the Rio Grande Valley. Ethnographically Sotuqnangu, the head of all the warriors who pray to him before doing battle,[95] is represented in Momtcit fall ceremonies at Hopi. Like the War Twins, he is also connected with lightning and summer thunderheads. He is described as "lightning shooting arrow-points from his fingertips" and as a scary war god "who kills and renders fertile" and who, importantly, initiated the practice of scalping.[96] Sotuqnangu taught the War Brothers how to kill enemies and get their scalps, and what songs to sing on their return. Further he directed that the Twins "should throw the scalps into the kiva, on the cloud symbol made with cornmeal by the warrior chief."[97] Scalps were transformed in the village of the victors into rain-bringing fetishes (see p. 149). Sotuqnangu shares his capacity as a scalper with Knife-Wing, Beast God of the Zenith, who has eagle-like qualities and huge talons that reach from above to grab the scalps of his prey (see p. 142).

Sotuqnangu, described in dramatic detail by Voth,[98] wears a mask made of points of ice. In other accounts his face is a star,[99] and he is closely affiliated with the Morning Star. One figure at Comanche Gap displays all the attributes of this deity (Fig. 4.15). Projectiles shoot out from either side of his eagle-tail fan headdress, and a bird, probably Knife-Wing, is pecked on his chest. Another projectile hangs from the crook of his right elbow [note that Poqangwhoya, the elder Hopi war god, hangs a club from his left elbow].[100] In his right hand he holds a plant and in the other an arrow that turns into a snake, the latter with implications of lightning or thunderbolts.

Mesoamerican parallels are found in the symbolism in this weapon. Marc Thompson[101] describes Mayan Chacob carrying stone hatchets that they throw to the earth as thunderbolts, lightning being the effect as these weapons are hurled through the air. These hatchets or celts are hafted in a serpent handle: "Each Chac carried in his right hand an axe with a stone blade set in a wooden haft, the end of which curled to form a snake's head."[102] Lightning,

Fig. 4.15
This Southern Tewa star-faced supernatural is believed to represent the Heart-of-the-Sky deity, or Sotuqnangu, today known only from Hopi. A thunderbolt, or war club, hangs from his right elbow, and he holds a plant and projectile-turned-snake in his hands. Knife-Wing appears on his torso. *(Photograph by David Grant Noble.)*

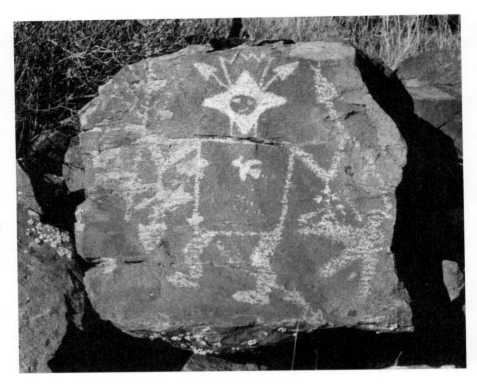

thunder, rain, warfare, sacrifice, and astronomical events involving Venus are the symbolic components of this complex in Mesoamerica. The symbolically similar Southwestern iconographic complex focused on lightning, thunder, rain, war, Morning Star, and scalping is discussed further under "Feathered Stars and Scalps."

MASAU

Outside of this iconographic loop, Masau, a multifaceted Hopi god of Death, is also prayed to for power in war.[103] Although he rules the Underworld, he is also known as owner of the surface of the earth, fire, and crops. As described in Chapter III, his image is not only identifiable in the rock art of the Rio Grande Valley, but it is also found in conjunction with shields, both in the Rio Grande and Little Colorado. Known for his death-dealing qualities, it is said that Masau was brought to Hopi by the Kookop Clan, the clan with the strongest war affiliations at Hopi today.[104] As was mentioned earlier, an impersonator appeared as a major participant in the Oraibi conflict of 1891. In kachina form his mask is characterized by spots and large round eyes and mouth. The mouth may be slightly broader horizontally and contains three teeth.

He is portrayed as a shield bearer in the petroglyphs in the Little Colorado[105] (Fig. 3.20, b), and his face is placed alongside shields and shield

bearers in the Galisteo Basin. Possibly his symbolic associations have changed, since the ethnographic material refers only to his weapons, his "instruments of terror," that consist of a club, his breath, and ashes scattered from a canteen or gourd.[106] It is worthy of note, however, that a canteen in the context of war iconography on the east end of the Comanche Gap dike could have symbolic reference to Masau.

At Hopi, Masau is associated with the Real Warrior Society that in the recent past (sometime in the nineteenth century) required that a scalp be taken by individuals seeking membership. The Real Warrior Society stood in contrast to the Momtcit, the ordinary warrior society that was joined by all able-bodied young Hopi men.[107] Masau, like Spider Woman, does not kill outright, but debilitates the enemy through instigating paralyzing fear that enables the Hopis to finish them off. Today Masau is honored only at Hopi, where his importance has increased in recent decades. "His complexity and wealth of associations within the Hopi scheme of the world is immense. Moreover, no other deity has undergone such drastic changes. . ."[108] His absence among the contemporary Pueblos of the Rio Grande may well be due to his Underworld connections. Recently he has been targeted by the Christian church as a manifestation of the Devil,[109] and this stance may also have been taken in the seventeenth century during the process of Catholic conversion.

WARRIOR KACHINAS

Iconography in rock art, kiva murals, and on ceramics indicates that the kachina cult, as well as the complex configuration of war symbolism, appear at essentially the same time in Pueblo prehistory. In general, the kachinas represent the masked ancestral dead who return as rain-bringers. These masked supernaturals, including the various kachinas that hold roles of warriors, guards, and protectors (Fig. 4.16), are well established in the fourteenth century, as demonstrated by their appearance in all these media. Their role as warriors as well as rain bringers is apparent both in the early Pueblo IV art as well in the ethnographic literature. In one Zuni story, for example, the War Gods request that the Kok'ko (kachinas) help in the war against the Kia'nakwe.[110] Like Sotuqnangu and the War Gods, many kachinas and the stories about them embrace the concepts of thunderheads and lightning, strife and scalping, and, of course, rain (Fig. 4.17).

Ruth L. Bunzel[111] has stated that "ideas of human sacrifice may lie but a little way beneath the surface in the concept of masked impersonators." Originally at Zuni, someone would die soon after the kachinas returned to Kachina Village after dancing at Zuni. The linking notion of blood sacrifice and scalping to fertility and rain is certainly present in Pueblo thinking although, historically at least, blood sacrifice as such seems to have been rarely

Fig. 4.16
This finely delineated Piro mask has a single horn and an eagle-feather fan headdress. The feathers and the down-turned mouth are features shared with star faces, suggesting that this is a kind of warrior kachina.

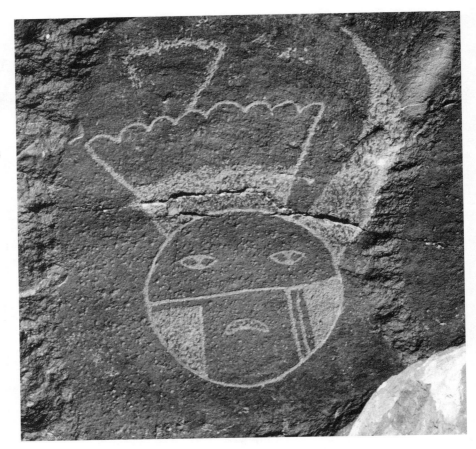

Fig. 4.17
A southern Tewa kachina mask with cloud symbolism. Lightning shoots from the base of the mask. The bump on top is reminiscent of the War God's cap. The boulder on which this petroglyph was made appears to have been displaced.

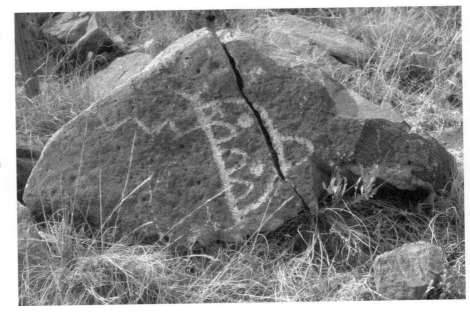

alluded to. However, the most pointed reference to sacrifice is ritually dramatized at Acoma in the battle with and the killing of the kachinas.[112] The blood spilled in this encounter (actually contained in a sheep gut fastened to the kachina impersonator's neck) was said to fertilize the earth. The kachinas were "sacrificed," and fecundity was the result. Likewise, the blood spilled in rooster pulls, an event introduced by the Spanish, is said to be "good for rain."[113]

Scalping, as opposed to sacrifice, was a well-documented practice, and numerous stories underwrite the rain-bringing powers of enemy scalps. Some of these stories are linked to specific kachinas that today appear as guards and runners or as participants in mixed kachina dances, their warrior roles being nonexplicit and suppressed. There is a story told in common by several pueblos that links guard and racing kachinas to inter-village strife, revenge, and ultimately death that may include scalping or beheading. In the Hopi and Santo Domingo versions, the kachina impersonator challenges the guilty party (a member of another village) to a race in retaliation for a murder. The identity of the avenging or killer kachina differs. At Hopi it is Hemsona or Homica, "He Cuts your Hair."[114] In this account, having to do with a feud between Walpi and Sikyatki, Hemsona of Walpi cuts the throat of the son of the village chief of Sikyatki. In this account the event led to the destruction of Sikyatki.[115] A longer version of this incident involving Hemsona (or Homsona) can be found in Lomatuway'ma et al.,[116] but in this case, it is the destruction of Awatovi that is at stake.

In the Santo Domingo version it is Hililika (or Hilili) who is the protagonist. In this tale,[117] a Santo Domingo seeks helps from a kachina group to exact revenge for the murder of his brother by someone from Zia. With four war-priest helpers, or *gowatcanyi*, he goes to Zia, puts on the mask of Hililika, finds the culprit, challenges him to a race, and when he catches him cuts off his head with a flint knife. Hilili is also impersonated at Hopi, where he was once regarded as a Witch kachina. He has retained a fearsome aspect and functions currently as a guard at Powamu.[118]

In a similar Cochiti story, a young man is challenged to a race by the Bloody Hand kachina, who upon catching him scalps the youth with a flint knife. In this instance no reason is given for the slaying,[119] but perhaps part of the story is missing. Henceforth, the Bloody Hand kachina at Cochiti, a guard kachina who was regarded as a witch, is no longer impersonated. Hililika is impersonated as the Hair-Cutter at Cochiti, but in his contemporary mollified role he, like Hemsona at Hopi, cuts the bangs of spectators whose hair is unkempt or of a runner defeated in a race.[120] This act, however, probably has the symbolic dimension of a scalping.

At Zuni the Bloody Hand kachina makes an appearance with connotations of conflict with Navajos, as opposed to inter-pueblo hostilities. Known at Zuni as Anahoho, like the War Twins, the Bloody Hand kachina appears in pairs. The handprints originated as the kachinas dipped their hands in Navajo

blood following a battle: "Then the elder brother Anahoho dipped his right hand in the blood of the Navajo and put it on his face and the younger one used his left hand. That is how you can tell them apart."[121] A similar kachina at Hopi, Matia, is a racing kachina.

Bloody Hand kachina masks, with a large handprint on the front, are pictured in early Pueblo IV and later throughout the Piro, Southern Tiwa, and Southern Tewa regions (Fig. 4.18, Plate 4). Hilili also appears in the southern Tewa rock art (Fig. 3.17, a). A Hilili petroglyph at San Cristóbal is pecked on a rock with a War God, the latter identified by his pointed cap. The pointed object on the left side of Hilili's mask is the long flint knife with which this figure is associated. In some contemporary impersonations the knife lies across the top of the mask. This kachina wears a warrior's bandoleer and carries a scalp bag.[122]

Ethnographically, women play important roles in scalp rituals, the Scalp societies of the women being an adjunct of the male War societies. This linkage between women and scalps is strengthened by mythological connections. In Zuni origin mythology, the scalp of Chakwaina (or Chakwaina Okya), also known as Ku'yapali'sa,[123] female warrior and defender of the enemy Kia'nakwe, was taken and divided among the victorious Zuni. The Zuni then held a dance of thanksgiving to ensure friendship with her ghost and therefore much rain.[124] Obviously in the Pueblo system, the scalp of this warrior-supernatural would have had potent rain-bringing powers, once brought into the Zuni realm.

Importantly, in some cases there seems to be an overlap or conflation in the identities of female warrior kachinas. Another woman warrior kachina, Kothlamana, appears on the side of the Zuni in the battle with the Kia'nakwe. Kothlamana is a kachina berdache with characteristics widely found beyond Zuni. This warrior kachina has hair done up in a female manner on the left, while the right side hangs in male fashion.[125] "The myths surrounding Kothlamana are most often about a young woman who, in the midst of having her hair dressed and put up, spied enemies approaching, seized her father's bow and arrows, and drove them from the village. The kachina's hairdo reflects this, as it is tied up on one side and hangs loose on the other. However, the personage is defined by other tribes as a newlywed young man who had allowed his wife to dress him as a woman; he then spotted the enemies approaching, seized his weapons, and drove them off."[126] Parallel stories revolve around He-e-e and the female Chakwaina at Hopi, who are similarly pictured with regard to their hair.[127] He-e-e carries a quiver of arrows as well as a rattle and bow and arrow. The female Chakwaina seems to be essentially the same person, although she has grandmotherly attributes.[128] Further, McCreery and Malotki[129] and Parsons[130] equate Chakwaina with the Hopi deity Tiikuywuuhti discussed in Chapter II. Tiikuywuuhti, however, is not a kachina, and lacks visual symbolism specific to the Chakwaina complex.

Toward an Understanding of the Ideology of Pueblo Warfare

Of considerable interest with regard to Chakwaina/Kothlamana is a warrior from Layer 1 of Kiva 2 at Pottery Mound (Plate 12), to date the most explicit prehistoric representation of this female warrior supernatural in the Rio Grande valley. The hair of the figure in question, the only one of the line of warriors not shown in profile, hangs down on the figure's right and is up on the left, as in the above-described contemporary kachinas. The hairstyle, an important feature in the texts regarding this warrior, is considered a reliable visual clue as to this warrior's identity in the prehistoric art. A vertically divided body may symbolize the androgynous character of this personage. The Pottery Mound figure also holds a bow and quiver of arrows.

There may be additional female variants on the Chakwaina theme in the petroglyphs at Comanche Gap. Among them is the aforementioned (Chapter III) warrior mother (Fig. 3.19), lacking the hairdo of the Chakwaina/He-e-e complex, but with a toothed mouth and round eyes, the round eyes being characteristic of many contemporary representations of this kachina in female mode. The Tewa petroglyph has two eagle feathers on her head and long ears that indicate that she is a kachina. Kachinas with similar feathers, round eyes, and long-eared masks are represented nearby and may also be female. One carries a long stick, as do certain contemporary female Chakwaina.[131]

The child inside the mother wears a two-horned headdress and carries a tall spear. A second person at this site displays a small figure holding weapons inside a shield that simultaneously suggests the rounded body of a pregnant female. I have been unable to locate Pueblo texts that address the birth of a ready-made warrior from a supernatural mother. The petroglyph scene, however, is evocative of the Aztec myth that accounts for the birth of Huitzilopochtli, who springs fully armed from Coatlicue's womb. Possibly this petroglyph pictures a similar story from Pueblo oral literature that has subsequently been lost.

Fig. 4.19
Chakwaina kachina on Jeddito Black-on-yellow bowl. *(After Hays 1994: Fig. 6.11.)*

We are, however, reminded of the visitation of the Hopi *kaletaka*, or real-warrior initiates, to the shrine of the goddess of childbirth. Discussed above in connection with scalping, at Zuni today Chakwaina Okya, the war leader of the Kia'nakwe, is associated primarily with the hunt and lends strength to women in childbirth, associations that also recall Hopi Tiikuywuuhti.

Traditionally, the origins of the Chakwaina complex are said to be in the Rio Grande, having been brought to Hopi by the Asa Clan, who claim that the Chakwaina kachinas are their clan ancients. These kachinas comprise a large related group of both males and females.[132] Early representations of what may be Chakwaina, however, are also found on fourteenth-century Jeddito

black-on-yellow bowls from the Western Pueblo area in the 1300s (Fig. 4.19). These images have crescent-shaped eyes, as do many contemporary Chakwaina kachinas. The fuzzy head or woolly hair of this kachina[133] is indicated by scallops similar to those on shields. It is possible that the scallops on the perimeters of shields indicate the woolly hair of a buffalo hide.[134] To date no kachina that combines a toothed mouth with the contemporary male Chakwaina's distinguishing crescent, inverted "v", or diamond-shaped eyes[135] has been noted in the prehistoric rock art. A twentieth-century Tsakwiana (Tca'kwena) mask from San Felipe[136] lacks distinctive features and is symptomatic of the instability of many of the formal aspects of kachina iconography.

Repeatedly represented in the rock art of the Rio Grande valley is the Shalako, a multifaceted giant kachina with a warrior component (Figs. 3.5, 3.17, d–f and 4.20). The presence of more than a dozen Shalako petroglyphs in the context of shields, shield bearers, Knife-Wing, and stars on the eastern end of Comanche Gap affirms the Shalako's capacity prehistorically as warrior and protector, roles for which the Shalako is still known.[137] (See Feathered Stars and Scalps). Shalako figures occur repeatedly in the rock art associated with stars or star personages (Figs. 4.30, 4.31). Shalakos were also depicted on Jeddito yellow wares by the late 1400s and possibly earlier.[138] Impersonated today only at Zuni and Hopi, the broad distribution of this figure prehistorically is testimony to its former widespread importance. Also, rock art representations of prehistoric Shalakos are varied, indicating a greater diversity in form and probably symbolic associations in the past.

Today the Zuni Shalako ceremony takes place just prior to the winter solstice, when the Shalakos come to the pueblo bearing seeds of all the plants known to the Zuni and blessings of abundance in all things. The two dance impersonators for each giant mask are called Elder Brother and Younger Brother, suggesting a conceptual overlap between the Shalakos and the Zuni War Gods. These latter, as noted (p. 145), share an identity with Venus or the Morning and Evening stars. Such a symbolic synthesis between the War Twins and the Shalako pairs is supported by a Classic period Southern Tewa star-faced Shalako (Fig. 4.33). War symbolism is apparent in the alternate Shalako's (the unmasked dancer) warrior's cap of white buckskin with an apical projection, as well by the stone axe in his belt and yucca whip.[139] The cap carries connotations of both scalps and clouds.[140]

The Hopi Shalako's associations are closer to summer thunderheads and lightning, atmospheric elements with which the War Gods are also affiliated, as previously described. Eagle feathers covering their bodies are symbolic of this sky connection, and these feathers may also be indicated in the rock art. Their flat faces are painted with rainbow patterns and their tablitas (headpieces made of thin wood) are filled with cloud imagery.

Another kachina that appears repeatedly in the context of Pueblo war symbolism in the rock art is characterized by a flat-topped mask viewed in

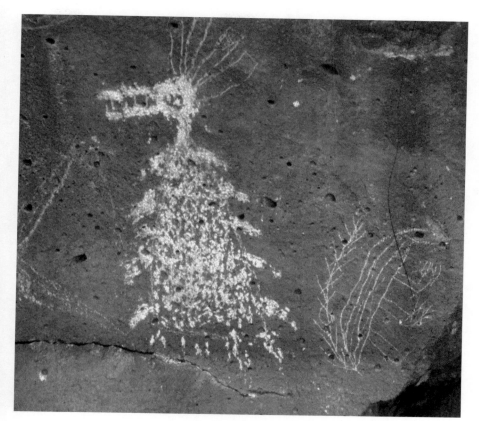

Fig. 4.20
A small feathered Keresan Shalako with beak with teeth, La Cieneguilla. Shalakos of this type also occur among Southern Tewa petroglyphs. This kind of Shalako with long beak and feathers is said to have been brought to Hopi around 1850 by a Tewa.

profile and a sharply downward-curved beak (Fig. 3.18). At times this mask has parallel warrior marks as well (see Chapter III). The association of three such masks with images of horned or long-eared owls on a boulder at San Cristóbal is suggestive that the masks are those of an owl kachina, although the masks themselves lack the "horns," and the beak could be that of a raptor. Other naturalistically painted horned owls with this beak, however, are found with black-faced warrior kachina masks at San Cristóbal.

Among contemporary Pueblos, owls play several roles. Although they are linked in some contexts with clouds, rain, and the Underworld, they are also well-known as war spies and messengers. Hamilton A. Tyler[141] relates a Hopi story in which a boy becomes the Owl son of Chakwaina, and in this capacity warns villagers when an enemy approaches. Today Mongwa, the Great Horned Owl kachina at Hopi, joins other warriors in punishing clowns for their behavior,[142] and it is possible that the role of Owl has shifted since Pueblo IV away from war as such to a disciplinary role within the Pueblo.

Further examination of the "owl" kachina image as it appears in rock art and the ethnographic record suggests a complex symbolism. The wide, flat top of the profile head may relate to burrowing owls with bowls on their heads as described in Pueblo stories.[143] The bowls are filled with yucca suds that

symbolize clouds emerging from springs and caves, for which the bowl itself is a metaphor.[144] Springs and caves, on the other hand, are also viewed as *sipapus,* or symbolic entrances to the underworld. Bowls of reflective water are also used for scrying, as described earlier, and as mirrors, and stand for supernatural passage and access to the underworld. Assuming that the rock-art images do represent a conjunction of bowl and owl, the divinitory powers and supernatural travel implied by this conflation would contribute to the owl's symbolic significance as a war messenger.

A parallel symbolic complex existed in Mesoamerica. There owls were associated with divinatory mirrors, also perceived as supernatural passageways, from the Middle Formative into the Post Classic (ca. 1000 B.C. to around A.D. 1500).[145] The Mesoamerican owl represents the earth, the underworld, caves, and darkness, and served as messenger between the spirits of the underworld and the living. According to Bernardino de Sahagún,[146] among the Aztecs, the screech owl was the envoy and "seasoned warrior" of Mictlantecutli and Mictecacihuatl, the Lords of the Dead.

There remains a number of other kachinas with warrior roles that also appear in Pueblo IV art, including a variety of one- and two-horned kachinas that function as guards and in other warlike and protective capacities in Pueblo ceremonialism (Fig. 4.16). Some horned kachinas and masks with broad mouths full of teeth, however, may represent ogres and disciplinary figures without any particular suggestions of warfare. Apart from the ogres, Wright[147] lists 34 contemporary Hopi kachina guards and warriors carrying bows and whips who appear in the contexts of ceremonial policing or as providers of spiritual protection. Others appear in Mixed Kachina dances. Among these are several different star kachinas, whose characteristics and functions will be addressed further under "Feathered Stars and Scalps."

In conclusion, warrior kachinas and other multifaceted kachinas with warrior roles commonly combine their roles as warriors with aims of bringing rain and fertility. Obtaining scalps that are converted into rain-bringing fetishes is one mode of achieving these desirable ends. In addition, several of these kachinas and their associated stories combine the elements of death and scalping with accounts of both strife between Pueblos and hostilities with an outside ethnic group, in this case the Navajo. References in Zuni poetry to the rain-bringing power of Navajo scalps are multiple.

The Animal (or Beast) Gods

The six Beast Gods, dangerous and violent supernaturals and deities of the six directions, maintain complex ideological and cosmological roles. At Zuni they are Mountain Lion (northeast), Bear (northwest), Badger (southwest), Wolf (southeast), Eagle or Knife-Wing (above), and Gopher or Mole (below).[148] At Hopi, Snake is the Beast God of the Nadir.[149] These supernaturals, positioned at the solstice points and above and below, guard the world.[150]

Toward an Understanding of the Ideology of Pueblo Warfare

Ethnographically Bear, Mountain Lion, and Knife-Wing or a similar eagle-like deity play significant roles as war patrons. These animal deities are represented on war altars. At Hopi, during the Momtcit ceremonies, members pray to these beings while war medicine is being mixed.[151] The invocation of various Beast Gods along with the Sun and the War Gods during Hopi Soyal rituals was described earlier in this chapter. At Zuni the Ant, Wood, Great Fire (with an Arrow Order), Hunt, and Cactus societies are war-related organizations "devoted primarily to the worship of the Beast Gods."[152] Pueblo Hunt societies are subsumed under the larger concept of war, certain symbolism is shared, and Hunt Society members recognize the same Beast God patrons as do the War societies. Hunters do not differ significantly from warriors, since conceptually there is little difference between killing men and game animals.[153]

Not only are these animal deities worshiped and invoked by the Pueblos, but under ceremonial and ritual circumstances it is possible that the boundaries between persons seeking power and the animals that embody that power may be blurred or lost. This apparent merging of human and animal, or possibly the acquisition of animal powers by human supplicants, seems to be portrayed by the composite beings in the murals. Most often humans and felines are combined into single entities, and sometimes eagle characteristics may be incorporated as well (Figs. 3.32, 3.34, b, and 3.39). It is not clear whether we are viewing in these murals a situation in which the identity between person and animal supernatural is an experienced phenomenon (i.e., shamanic transformation), or a metaphorical concept in which desired animal powers are made accessible to people.

On this note, a brief exploration of Pueblo world view with regard to human beings and other forms of life is worthwhile. The information in this regard comes from Zuni, but presumably these concepts do not differ vastly among the other pueblos. The lines between human beings and other life forms have never been sharply defined, and in the time of myth or the beginning, all animals could speak and people were reptilian and "unfinished," with tails and webbed digits.[154] At the time of emergence from the four Underworlds, they were made into "finished" or "ripe" beings, like they are now. All life forms fall along a continuum between raw and finished, and the degree of power one has to effect change in the physical world is directly correlated with one's degree of rawness.[155] Human beings, the most finished and thus powerless, must appeal to more powerful beings to act as mediators, to convey their prayers for rain, and presumably to intervene in other areas of need. "Such mediation is often effected by means of visual representations of the mediators"[156] Their image is thought to embody the qualities of the animal and can serve the same functions, thus making their powers accessible.

Of the Beast Gods, Knife-Wing or a similar mythical monster eagle and Mountain Lion are those most commonly represented in the rock art and kiva murals. Snakes, bear tracks, and mountain-lion tracks and forelegs are also

found in rock art with war symbolism in proximity.

Bear, a War Society as well as Medicine Society patron, is only occasionally represented in Classic period rock art, and fewer images yet occur in clearly war-related contexts. Southern Tewa bears associated with stars and shields are described in Chapter III. Among the Pueblos, the bear, however, is an animal with significant, multifaceted, supernatural powers and the attributes of a shaman. His role as a war power leads to success in these enterprises,[157] and his symbolism is widespread in ethnographic contexts in connection with war-associated activities.[158] At Hopi, for example, a bearskin is laid on the kiva floor at the return of a war party.[159] In addition, "Impersonation of Bear at the Snake initiation, the bearskin on the warrior's altar, bear herb or root in the pellets of the warrior's bandoleer, together with bear hairs, point to the association of the bear with war, which occurs in other pueblos."[160]

4.21
This symbolically complex Northern Tewa felinelike animal has bearlike feet and sun face. A snake bisects the neck.

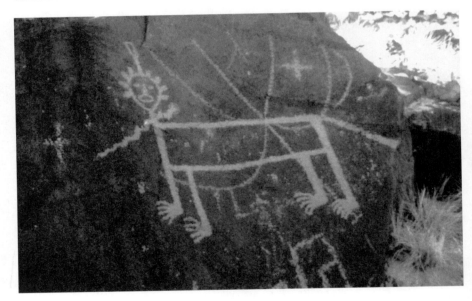

Taube[161] draws a parallel between the bear of the Southwest and the Mexican jaguar, observing that both are noted for their important roles in shamanic transformation and that both are associated with caves and war. It is worth mentioning that bearlike feet are portrayed on a spotted cat in the Jeddito murals (Fig. 3.38, c) and in a Northern Tewa petroglyph on a felinelike animal with a sun face (Fig. 4.21).

FELINES, SUN-SHIELDS, SNAKES AND EAGLES

The feline is a focal image that may incorporate the characteristics of several other war powers—Sun, Spider Woman, snakes, eagles, and even bears, whose strengths and sanctions are desired by members of the several war

societies.[161] His occasional conical warrior's cap and conjunction with shields emphasize the Mountain Lion's affiliation with war.

A number of felines in the kiva murals in the context of shields and sun shields have been described. These are usually mountains lions, although other cats, including a bobcat and a spotted long-tailed cat that probably represents a jaguar, are also represented with shields. In addition, there is the aforementioned Northern Tewa petroglyph of a catlike creature with a sun face (Fig. 4.21). The seemingly transformational, and at a minimum conflational, themes involving shields, cats, and humans in the Pottery Mound murals were discussed in the section under "Shields." "Seated" felines depicted in Pueblo IV art also suggest an identification between man and mountain lion.[162]

This merging of man and feline powers is still meaningful in the ethnographic present. Formerly, most pueblos had a war priest who ranked higher than his subsidiaries, the war captains, these latter being historically designated officers who are earthly manifestations of the War Twins, with parallels to the Evening and Morning Star.[163] Since the war priest represented the Sun himself, and in Pueblo mythology the Sun is the father of the Twins, these social relationships of the War Society were modeled on celestial mythological prototypes. In addition, the head of the O'pi Warrior Society (or scalp-takers) at San Felipe was also known as Mountain Lion,[164] and there are other examples where the war priest is perceived as embodying the powers of the mountain lion.[165] Thus the war priest provides a link between feline symbolism and the sun, a relationship that is made explicit in the visual imagery of Pueblo IV, in which shields and sun shields are involved with felines. Although Pueblo ethnography is all but mute on the subject of shields and felines as a conceptual unit, this symbolic connection may have

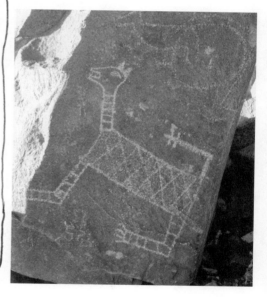

Fig. 4.22
A Jornada-style mountain lion with crosshatched body and rattlesnake tail, Three Rivers, New Mexico.

been lost historically with the reduction of warfare and the waning of the War Priest's office, while the mountain lion's prominence in the realm of hunting, and where shield symbolism is absent, was maintained.

As described in Chapter III, on Layer 1 of Kiva 6 at Pottery Mound is a line of seated ritualists consisting of both men and long-tailed felines. The men and cats are given equal emphasis (Fig. 3.36).[166] The ritual context is ambiguous, as the mural could relate to either war or hunting. It is worth exploring the possibility, however, that the light crosshatched pattern on the human participant, in the context of feline company, as insignificant as it seems, may carry connotations of felineness, Spider Woman, and war. As noted previously, crosshatching occurs on pointed warrior's caps that may be netted or made of mountain-lion skin. The symbolic properties of both of these

Fig. 4.23
Eagle-like bird, or Knife-Wing, with two-horned serpent emerging from his mouth. A kachina and another Knife-Wing are among the other figures on the face of this boulder. White Rock Canyon of the Rio Grande, Keres. *(Photograph by Curtis F. Schaafsma.)*

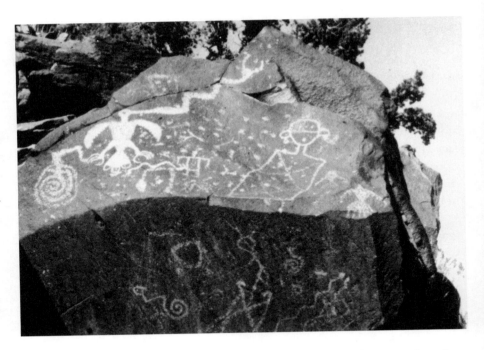

war patrons may be combined in these caps. Other crosshatching is found on the (back) leg of a personage in an animal position, passing through a sun shield in a mural fragment from Awatovi.[167] Whether the figure in question is human or feline is not clear, and perhaps this distinction is not important. The foot looks human, but the same kind of foot occurs on a mountain lion in the Kiva 6 scene.[168] Crosshatching is found on felines elsewhere, including the mountain-lion-skin quiver with a banded tail from Kuaua murals, where it ambiguously resembles the pattern on the diamondback rattlesnake, whose symbolism is present in the bands on the cat's tail. There is also a crosshatched mountain lion with a rattlesnake tail among the stylistically related Jornada Mogollon petroglyphs at Three Rivers, New Mexico (Fig. 4.22).[169]

There is little or no ethnographic information as such from the Pueblos that explains the significance of the crosshatching in association with cats, and its meaning remains obscure, although a reference to Spider Woman was suggested previously. Both the jaguar and the spider cave creatures are associated with, among other things, the underworld and war.[170] As we have seen, Spider Woman also has a role in war in the Southwest. Although she is never pictured, a web symbolizing her powerful presence could easily have been simplified into simple crosshatching, as it tends to be at times even in Mesoamerica.[171] The fine nature of the lines of the hatching in the Pueblo examples from Pottery Mound and the Jeddito also suggest the delicacy of a spider web.

This study addresses numerous kiva paintings and rock-art images in which feline symbolism is combined with that of snakes. This conflation of

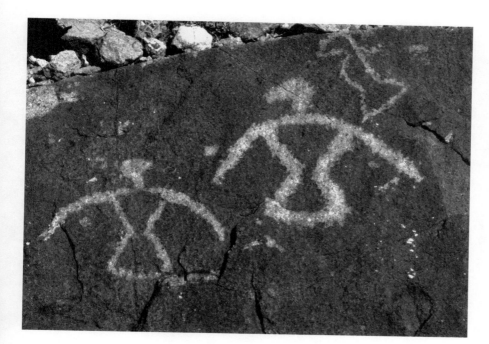

4.24
A pair of simple birds with extended wings and broad, blunt tails, thought to represent Knife-Wings, Southern Tewa. Nearby petroglyphs also have war connotations.

animal powers, obvious on tails of mountain-lion skins fashioned into quivers, is graphically explicit in a Pottery Mound painting where a rattlesnake is superimposed on a cat, the tail of the snake becoming the cat's tail. The clear conflation of the mountain lion and rattlesnake is a visual statement that compounds their metaphorical war powers.

Snake Society members at Hopi are regarded as warriors. A militaristic element of the summer Snake rites is described by Voth, wherein the Snake men were painted like warriors of former days prior to entering the plaza. Voth[172] says only that "no doubt that a certain relation exists between the Snake ceremony and perhaps certain war ceremonies that may formerly have been in vogue. . . ." Snakes and lightning bolts are conceptually linked in Pueblo thought, the latter often perceived of as supernatural weapons of the War Gods and other war deities. Two horned snakes in the rock art appear to represent such lightning weaponry when portrayed in the hands of warriors, and a predator eagle, or Knife-Wing (see below), pictured among the petroglyphs under Cochiti Reservoir, has a two-horned snake, symbolic of lightning, emerging from its mouth (Fig.4.23). Although contemporary Northern Tewas have denied any knowledge of the two-horned serpent, a Hopi Antelope Society sand painting from the turn of the century at Mishongnovi shows two-horned snakes rising from a field of clouds, where it is apparent that they symbolize lightning.[173]

In Pueblo cosmology, the eagle, sun, and war constitute a symbolic complex, and the eagle itself, like the shield, may actually symbolize the sun. Eagle feathers are ubiquitous in ritual and imagery. As noted previously, eagle sym-

Fig. 4.25
In a Southern Tewa site in the Galisteo Basin, a broad-tailed bird with talons, presumably Knife-Wing, is pictured near a feathered star also with talons. The latter is believed to represent the Morning Star.

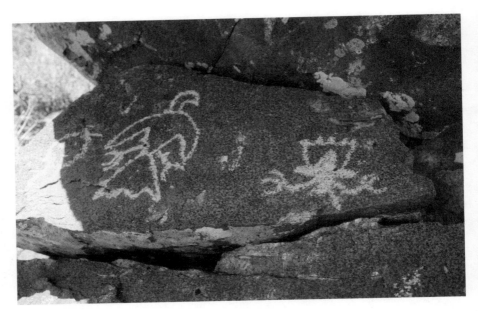

bolism is commonly featured on Pueblo shields, and these shield bearers may be real bird warriors with the heads of eagles.

Among the Beast Gods in Pueblo IV rock art, the eagle-like predator and war patron known as Knife-Wing, or Achiyalatopa at Zuni, is probably represented the most frequently (Figs. 4.24-4.26). A comparable figure at Hopi is Kwataka,[174] or Kwatoko.[175] I have used the name "Knife-Wing" to reference this entity with tail and wings of knives,[176] although names vary among the different Pueblo linguistic groups. As the epitome of celestial symbolism, he is associated with clouds, lightning, and scalping, as well as the Zenith and the sun. Knife-Wing, who is described as descending from above and tearing the scalp from the enemy with outstretched talons, is prayed to for power in war.[177] Eagle symbolism on shields may be a reference to this deity and his special skills.

Detailed paintings of Knife-Wing or a similar predator deity occur in the kiva murals of Pottery Mound and Awatovi, where great attention was given to the rendition of the feathers and talons.[178] In one Awatovi painting, an eagle-like bird in frontal view with exaggerated claws is flanked by lightning.[179] Remnants of ears of corn painted on the wings are visible below the deteriorated upper portion of this mural. As a whole, this graphic complex incorporates the connected symbolism among Knife-Wing, scalping, rain, lightning, and the fertility of corn.

Knife-wing is commonly conflated with another sky deity, Morning Star. The resulting symbol also has strong reference to scalping, and is discussed at length in the following section.

Mountain Lion, Eagle or Knife-Wing, Sun, and Morning Star together create a powerful symbolic war complex with Mesoamerican parallels. In

Toward an Understanding of the Ideology of Pueblo Warfare

Mesoamerica, the jaguar holds a symbolic role in war parallel to that of the mountain lion in the north. The shield and jaguar, along with the owl, form a symbolic war complex as early as Teotihuacan,[180] where the conflation of man and feline is also pictured. Later at Tula (A.D. 900–1200)[181] there are friezes of prowling jaguars, coyotes, and eagles, and these friezes were copied by the artisans of Aztec Tenochtitlan (1450–1521), where this traditional symbolism was repeated. Mexica warriors donned jaguar costumes, and eagle and jaguar warriors ranked among the elite. With their patron animals they were pictured in several media. In central Mexico this eagle/jaguar pairing reflected a deeper duality between the sky and earth, the jaguar standing not only for the earth, but also for caves and the underworld. Yet both the eagle and the jaguar could represent the sun: "Both refer to valiant warriors: the eagle is a creature of the sky, however, and the jaguar a creature of the land . . . of the underworld and the animals were in some ways opposites like the sun disk and the earth monster. Both can also be images of the sun while descending (eagle) and while dead in the underworld (jaguar)."[182]

Pasztory (op.cit.) notes that the solar association of these animals had to do with the primary function of the Aztec war cult, which was to provide victims to nourish the sun. Similarly, via the power of the Beast Gods of the Pueblos, scalps were provided to promote rainmaking, and as noted earlier, death in itself is believed to aid the sun on its course. Hopi tales such as those previously cited state that the sun is kept moving at the expense of human life. Although Pueblo texts do not make reference to war victims for sacrifice, sun and warrior motifs are frequently brought together in Pueblo art.

In summary, a variety of animals known for their predatory skills were credited with supernatural powers to assist the Pueblos in warfare. As the graphic imagery indicates, corroborated by ethnographic material, warriors themselves could assume the strengths, skills, and special qualities that these animals embodied. The acquisition of these forces empowered the warrior in combat. Importantly, the Knife-Wing/eagle and the mountain lion were also identified with the sun, a supreme war power. Further, references to lightning, clouds, and scalping and bloodletting in the symbology of Knife-Wing inextricably links the themes and concerns of fertility with the activities of warfare.

Power quests and identification with these animal supernaturals and their strengths, as far as the ethnographic material indicates, took place on a ritual front involving visits to shrines, offerings, the recitation of prayers, and the utilization of feathers, mountain lion and bear skins, and other trophies. Shamanic practices with the goal of achieving altered states of consciousness and transformation with direct access to and involvement with the supernatural realm in which these powers are believed to reside are not described. An exception to this, at least in the ethnographic material available, is in the realm of the Bear doctors in curing ceremonies, who do manifest shamanic transformational behavior.[183] However, the Beast Gods were prayed to in the

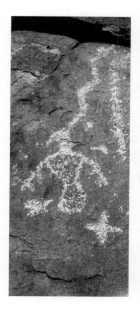

Fig. 4.26
This small Knife-Wing has "fringed" wings and a lightning serpent that extends out of the top of his head. The star emphasizes the war implications of this set of symbols. Southern Tewa.

Fig. 4.27
 A star with a face,
Southern Tewa.

act of going to war and could even be impersonated in advance of actual conflict, as testified by Kwatoko's historic appearance at Hopi. In addition Spider Woman, as a diviner, protector, and advisor, provided wise counsel.

Mesoamerican parallels, which include the roles of the sun, predators, and Spider Woman, can scarcely go unnoticed. Venus, or Morning Star, also figures prominently in both Puebloan and Mesoamerican warfare.

FEATHERED STARS AND SCALPS

A star with four points expanding around a circular center has been mentioned repeatedly in the foregoing pages (Fig. 4.27). This is a significant visual metaphor in Pueblo IV art.[184] To grasp the symbolic implications of this star, which is often a conflated image combining the attributes of both star and bird (Fig. 4.28), one needs to examine its various attributes and contexts. Each context provides a further opportunity for refining our understanding of the meaning of this image. As with all symbolism under discussion in this volume, each rendering varies according to the understanding of the individual artist and purpose of each representation. Nevertheless, there seems to be a cultural consensus of the star's general, if multiple, significance.

To begin with, the star may have a face, and it is clearly a person in the Pueblo sense of the word, a significant person (like a kachina), culturally and ritually defined and given symbolic expression.[185] In painted examples the face, like that of Pueblo warriors, is usually black (Plate 9). The pairing of stars and star kachinas, the presence of eagle tail-feather fan headdresses, talons, and even projectiles are attributes that contribute further to an understanding of the meaning of the anthropomorphized star.

Ethnographically, all stars are said to have an anthropomorphic, divine character and to bestow blessings or punishment.[186] All stars are associated with war, including falling stars and comets, and among the Taos and Tewas, stars are prayed to in time of war.[187] The Zuni scalp chief was said to pray to all the stars, "our night fathers, our night mothers."[188] Above the War Society's altar at Hopi hang two sticks, crossed like a star, as a sky symbol.[189] The significant role played by stars in war prehistorically is confirmed by the many shields adorned with stars in Pueblo IV petroglyphs and kiva paintings.

Elsewhere Parsons[190] specifies that it was Morning Star that was asked for help. As will be considered later, Venus is the most probable planet to be designated in this role, although other planets could also function as Morning Star. Baldwin[191] argues that this four-pointed star in Tompiro rock art references the Morning Star and that simple dots represent true stars. Morning Star as a deity plays a prominent role in Pueblo cosmology, and is (was) important to both hunters and warriors. Coyote-like animals found in conjunction with stars in Pueblo IV rock art may symbolically denote this association with hunting,[192] although implications of war cannot be excluded. It

is the Morning Star's connection with war that is most explicit in Pueblo IV iconography.

At Zuni, Morning Star is regarded as the sun's War Chief, never far from the Sun and going before him at dawn.[193] The Pueblos often ambiguously associate both War Gods or War Twins with Morning Star, the messenger and guard of the Sun,[194] although in some cases both the Morning and Evening Star are considered in this role: "The morning star still guards the entrance to the sun [sun's house] in the front, the evening star the entrance in the rear.[195] As previously noted, historically the War Captains are viewed as earthly manifestations of these deities. While Evening Star was sometimes also thought of as an old woman,[196] this description may denote that the Evening Star is the feminine component of the duality that Venus and the War Twins represent. As discussed earlier, the "falling" or "diving" War God as represented at Awatovi (Fig. 3.40, a) could symbolize the setting Evening Star aspect of Venus. In times of war, Morning Star was addressed as "Dark Star Man" by the Tewa,[197] an appellation that may underlie the concept of this figure as a warrior with darkened skin and would account for the black-faced stars and the dark bodies of star kachinas in Pueblo IV rock paintings. Historically, warriors painted themselves with powdered manganese to make themselves brave, strong, and invulnerable.[198]

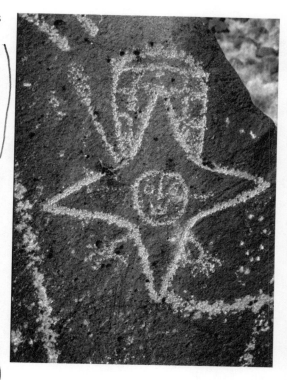

Fig. 4.28
At Petroglyph National Monument, this Southern Tiwa feathered star with face, feathered headpiece, and talons probably represents the Morning Star.

Star supernaturals may take kachina form, and there is a variety of Hopi star kachinas. The Chasing Star or Planet kachina is paired, suggesting the Twins.[199] Na-ngasohu, Chasing Star or Planet kachina, is distinguished by a single large star on the mask and a long headdress of eagle feathers.[200] An early twentieth-century painting by a Hopi artist (Fig. 6.1) depicts an identical pair of kachinas referenced as Coto. Coto also wears a mask with a single large star, is outfitted with numerous eagle feathers, and his paraphernalia is characteristically red in color.[201] In one hand he carries a yucca whip, in the other a bell, the sound of the Morning Star rising.[202] Sohu, yet another Hopi star kachina, also carries yucca whips and is listed as a guard or as a participant in the Mixed Kachina dance. This kachina wears a fringed hunting shirt and a skirt of turkey feathers and has stars in his headdress to which red-stained warrior feathers are attached.[203]

Antecedents for contemporary star kachinas described in ethnographic sources are found in Pottery Mound kiva murals and in rock art. The Pottery Mound murals show paired figures with stars on their bodies and feathered

Fig. 4.29
A small Southern Tewa star kachina holding staffs, and other items are suspended from the elbows. A second star occurs at lower right, Comanche Gap, Galisteo Basin.

kilts that specifically resemble the Hopi Sohu kachina (Fig. 3.33, b). Erosion of the top of the wall removed the heads of these figures, so it is uncertain whether they had star headdresses, but the remaining imagery suggests that they embodied the same concepts as the similarly attired historic Sohu kachina. In their hands they hold feathered staffs. In rock art, kachinas with a single star as a mask appear singly or in pairs (Figs. 4.29 and 3.17, b and c). As described previously, kilts may be straight across the bottom or scalloped, and commonly star kachinas carry a war club or a yucca whip in the right hand and a bow in the left, in the manner of other kachina warrior impersonators.[204]

Also previously discussed (pp. 127–128) was Sotuqnangu, warrior deity in charge of summer thunderstorms and initiator of scalping, who also has the face of a star and embraces the concepts of war and fertility, epitomizing the duality of Pueblo war ideology.

SCALPS, STARS, AND KNIFE-WING

A theme explicit in the fearsome aspect of Sotuqnangu is the linkage of Morning Star with scalping. This relationship is dramatized in a Zuni ritual in which the act of scalping was reenacted during Bow Priesthood initiations "just as the Morning Star appeared."[205] Morning Star himself as a scalper appears in a Taos narrative in which he kills seven redheads so that the Corn Girls can bring their heads into the pueblo on poles. Redheaded enemies are described in several Taos stories.[206] Implicit is a connection between Morning Star, scalps, the color red, rain, and ultimately maize. Among the Hopi–Tewa at Hano, descendants of the Rio Grande Southern Tewa, scalps themselves are called "Morning Star", or conversely, "stars are scalps."[207] At Taos, red pigment, possibly symbolic of blood, is offered to both stars and scalps, which are painted red inside.[208] Classic-period star petroglyphs in the Galisteo Basin and at Tenabo maintain to this day a red stain that appears to be the result of once having been smeared with paint, the paint possibly being such an offering (Figs. 4.32 and 3.26, b). Another is painted in red. It was noted previously that feathers in the headdress of Sohu, one of the Hopi star kachinas, are stained with red.

According to Hibben,[209] Acoma informants described the massed star faces in the Pottery Mound (Plate 14) murals as "soul-faces," an interpretation that is reminiscent of the Aztec association of stars with dead warriors and sacrificial prisoners.[210] If stars, in fact, are equated with those killed in war, then it is easy to extend to stars the symbolism of scalps taken in conflict.

The association of Morning Star with death in general and scalps specifically is made clear in several other Pueblo tales. One describes the origin of Morning Star and Big Star, the latter in this case probably another planet, as occurring when a man was chased by his dead wife.[211] In the story of how Circle kachina and his wife became stars, Circle kachina tells his wife to meet

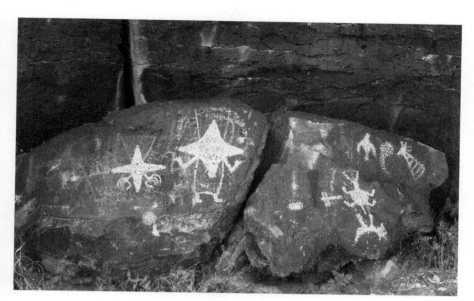

Fig. 4.30
An overall view of secluded "star shrine" boulder featuring a star kachina and a star with talons and a large feathered head-dress. Note Knife-Wing, probable corn sprout, and small Shalako figure on the right, Petroglyph National Monument, Southern Tiwa.

him at the place were the scalps are dressed.[212]

Although in another Taos story stars are described as birds with bright breasts like those of hummingbirds,[213] the taloned and feathered stars in the rock art embody the attributes of Knife-Wing, the eagle-like Beast God of the Zenith and patron of scalping described earlier. The conflation of the star/Knife-Wing images, so common in the rock art after A.D. 1300, are explained in a Zuni story that says when Knife-Wing was killed, his head and heart were thrown into the sky, where they became the Morning and Evening Stars.[214] The Isleta assessment that "stars are mean"[215] is in keeping with this image.

In rock art, Knife-Wing is frequently represented near stars and shield bearers (Figs. 4.26 and 4.34). The previously described star-faced person identified as Sotuqnangu, inventor of scalping, has such a bird on his chest (Fig. 4.15). Images of this monster eagle on altars show him wearing a terraced cloud cap and with arms or wings hung with eagle feathers, lightning lines, or flint knives. In addition to his knives, Knife-Wing's weapons include a lightning arrow (Figs. 4.23 and 4.26). Lightning in itself has overtones of both killing, fertility, and specifically the growth of maize.

War, scalping, rain, lightning, and the subsequent fertility and growth of maize are the involved and culminating themes of this star complex. It will be recalled that lightning is also a weapon of other star-related war deities—Sotuqnangu and the War Twins. The association of lightning, fertility, and maize is a complex prevalent even today in both Mexico and the Southwest.[216] In Mesoamerican mythology, lightning penetrating the earth results in maize (Fig. 4.35), and in Mayan stories lightning alone can break the rock within which precious maize seeds are enclosed.[217] Interestingly, it was

Fig. 4.31
Overall view of a boulder in Petroglyph National Monument with a large Shalako next to a feathered star. A snake is also part of this scene.

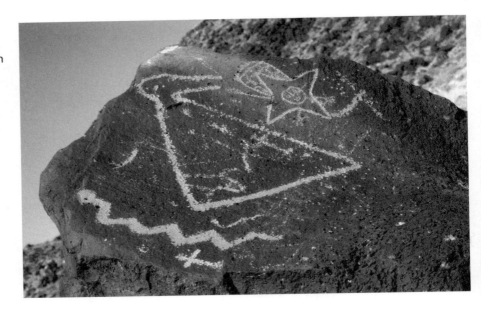

Fig. 4.32
A mask, snake, and pair of stars from the Galisteo Basin. The lower star has a red stain. Two faces without outlines are visible on the lower left.

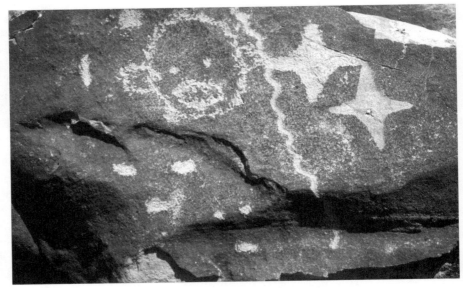

Red Lightning, little brother of White Lightning, who accomplished this feat.

Likewise in the Southwest, references to lightning and corn are numerous. Parsons,[218] for example, refers to the fertilization of maize by Lightning and a Flute Society altar at Hopi in which a field of corn kernels is spread out beneath a large figurine of Lightning. This symbolic complex in the prehistoric Southwest is found throughout the iconography of the Jornada Mogollon/Rio Grande style/Navajo art tradition. In New Mexico, corn stalks are represented in the zigzag shape of lightning (Plate 15; Fig. 4.36). In the Jeddito murals, maize ears are attached to lightning, or lightning is shown

striking an ear of corn.[219] The scalpknot fastened to the zigzag corn in the Navajo petroglyph signifies the linkage of corn with Born-for-War, the Lesser Twin, whose color is red.

Again we are reminded of the Zuni myth in which the linkage between enemy scalps and rain-bringing power is made explicit[220] (see page 132). Scalps themselves, under the charge of the war chief, were often hung on shields in the kiva or on the kiva walls.[221] Much more than a war trophy, a scalp, once obtained and ritually brought into the pueblo, is transformed into a rain-bringing fetish. Bunzel[222] refers to scalps as water and seed beings. A quote from a Zuni text regarding a Navajo scalp illustrates this point: "For, though in his life the enemy was a worthless lot, now through the Corn Priest's rain prayers . . . he has become a rain person."[223] There are references in Zuni ritual poetry and other texts to the scalp as a "water-filled covering."[224] Reference was made earlier to the Shalako dancer with his close-fitting warrior's cap of white buckskin, viewed symbolically as a "cover of thin clouds,"[225] a reference to water, rain, and, above all, scalping. As a War God impersonator,

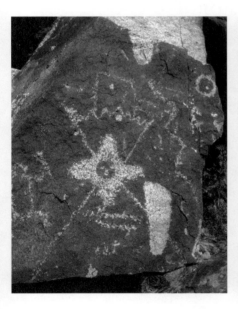 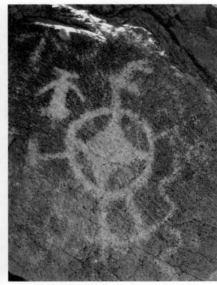

Fig. 4.33
An unusual star-faced Shalako, Southern Tewa.

Fig. 4.34
A shield bearer and Knife-Wing near a Northern Tewa Pueblo village site in the Chama drainage.

the Shalako dancer by extension is affiliated with the Morning Star, scalping, and ultimately rain, and as the masked Shalako he also brings seeds, including corn, to the pueblo.

The two aspects of this complex figure embody a fundamental duality in Pueblo life. Scalps and rain clouds are juxtaposed in descriptions of war rituals at First Mesa at Hopi.[226] Three cotton clouds hang over the previously mentioned War Society altar along with the wooden cross as a sky symbol.[227] A scalp ceremony marking the reentry of victorious warriors to the village involves women throwing the scalps onto ground drawings of clouds. This rit-

Fig. 4.35
A contemporary mural in the Palacio Municipal in the city of Oaxaca showing lightning striking a field of corn.

ual is repeated twice—once as the women come to meet the victors at some distance from the pueblo, and again as they emerge onto the mesatop. Finally the scalps are thrown down the kiva hatch, symbolic of the rainmakers' chthonic origins.[228] An early twentieth-century photograph[229] shows a kiva hatch marked with clouds during a Niman ritual, or the Home Dance.

Further, it is well known that ethnographically scalps were carried on a poles in public Pueblo ceremonies (Fig. 6.2). Jornada Mogollon rock art in southern New Mexico pictures figures holding clouds on poles (Fig.4.38). It is thus possible that the symbolism involved in the Pueblo ritual display of scalps on poles is tied to their significance as clouds.

THE QUESTION OF VENUS AS MORNING STAR

With the exception of the star faces at Pottery Mound, where there are presumably too many of them clustered together to represent either Morning Star or Evening Star as such, a relationship between the various manifestations of the feathered star in Pueblo IV and the Morning Star as a mythological and symbolic entity seems clear. The question remains as to whether the conflated bird/star image that incorporates the meanings of Morning Star, as described in Pueblo stories and other ethnographic sources, is also the planet Venus. The ancient and widespread tradition involving Venus and warfare and hunting in Mesoamerica[230] and the symbolic parallels between the Morning Star complex and war (as well as hunting) in the Pueblo Southwest raises this issue, as well as the possibility of a relationship between the two areas. In Mesoamerica movements of Jupiter and Saturn, along with those of Venus, also served as indicators for war activities for the Maya.[231]

Although the Morning and Evening stars are observed by the Zuni for the purposes of timing ceremonial events,[232] Mars and Jupiter as well as Venus can have this role.[233] Typically the Pueblo identification of Venus in particular as Morning and Evening Star is inconsistent or unclear. John Peabody Harrington[234] claims that "The Tewa did not know planets other than the Morning Star and the Evening Star. [They] are now one planet, now another, but they did not know it."

In other words, any bright planet, perhaps Jupiter, could function as the Evening or Morning Star, especially in the absence of Venus. Venus, however, would often qualify as the brightest star seen in the morning, a male divinity also known as "Big Star,"[235] and only Venus as both Morning and Evening

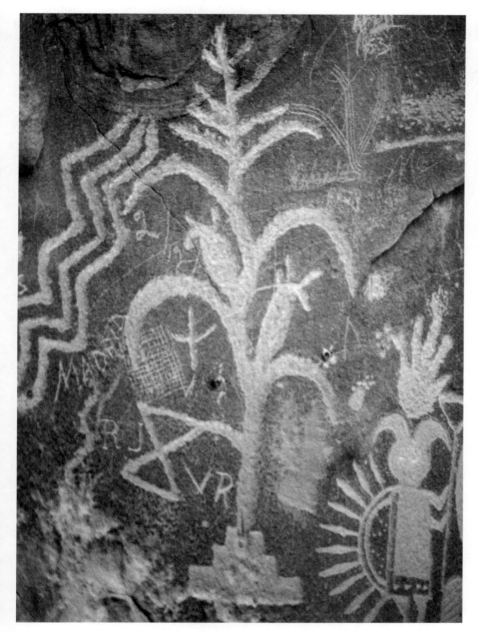

Fig. 4.36
Eighteenth-century Navajo corn plant in the form of lightning with a scalpknot attached. The scalp-knot is a symbol for the Lesser Twin War God, Tobadsistini, whose color is red. Monster Slayer, the older Twin, is repre-sented by the zigzags or lightning on the left, Largo Canyon drainage, New Mexico.

Star, because of its proximity to the sun, has the aspects of a twin, guards of the Sun, hence the War Gods. Although at times both War Gods seem to be associated specifically with the Morning Star aspect, Reagan[236] reports that the Morning and Evening stars were created as two brothers who are now the sun's guards. Thus it would seem that the basic metaphors ascribed to the Morning Star would have derived originally from observations of Venus itself.

Fig. 4.37
 Southern Tewa
stars and snakes.

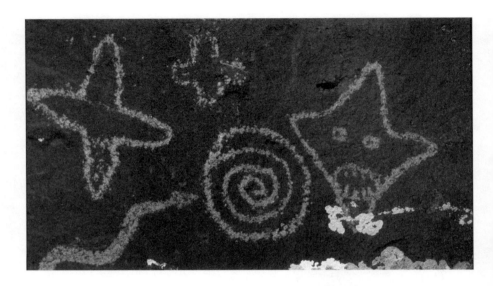

There are additional Pueblo iconographic elements associated with stars that have Mexican analogues connected with Venus. Among these is the strong association between stars and snakes (Fig. 3.25, c, 3.26, b, 3.33, a, and 4.37), or mythological serpents, a relationship that in the Mexican case has well-established Venus connotations associated with Tlahuizcalpantecuhtli, or Quetzalcoatl as Venus. Star-faced serpents in Pueblo art unify the star/serpent concept, and the twinned aspect of some of these figures would seem to reinforce the Venus association. An additional, tentative parallel may exist between the scalloped kilts or aprons of some star kachinas and the Venus glyph apron at Cacaxtla, a Highland Epiclassic site in the state of Tlaxcala, Mexico.[237] In addition, Mexican Venus glyphs with knives from Aztec Tenochtitlan[238] are strikingly parallel in concept, if not in formal graphic elements, to the Pueblo star/Knife-Wing conflation described here.

Although ideology in the Southwest linking Venus or the Morning Star with warfare may have had its origins in the widespread Venus-regulated warfare and accompanying system of ritual sacrifice in the complex states of Mesoamerica, this borrowing was vastly simplified and generalized among the Pueblos. As will be discussed in Chapter V, conflict in the Southwest did not involve conquest. Also, there are no indications that the Pueblos observed and followed the Venus cycle, much less scheduled war events according to a Venus calendar. Although Morning Star and Evening star served as heralds for various ceremonial and agricultural activities at Zuni, this seems to have been on the basis of nightly appearance, and any bright planet could have functioned in this role.[239]

In conclusion, the Pueblo IV star as an element in the rock art and kiva murals is a multivalent symbol predominantly associated with war and fertility. Venus as the observed Morning Star is loosely implicated. The star icon

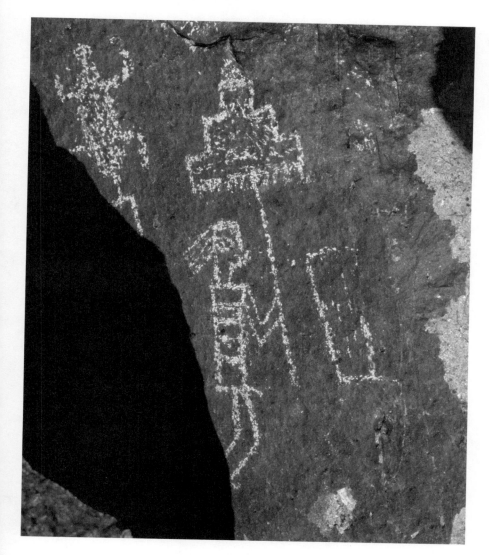

Fig. 4.38
Jornada Mogollon petroglyph of figure supporting cloud on a pole, Three Rivers, New Mexico.

in its feathered and taloned form incorporates aspects of Knife-Wing, Beast God of the Zenith, associated with scalping.

In spite of a recent suggestion by Stephen Plog and Julie Solometo[240] that warfare as a means to bring rain and a source of fertility decreased by the early 1500s in favor of other methods to achieve these ends, the ethnographic record indicates otherwise. Diverse sources, including poetry (see pp. 1 and 156) and other ethnographic accounts assure us that rain and fertility continued as a primal focus of Pueblo warfare as long as fighting took place. That a desired outcome of Pueblo warfare was the acquisition of scalps, valued for their power as rain fetishes and hence the growth of maize, is well entrenched in Pueblo ethnographic accounts:

"The purpose of the Warriors' society in the old days was two-fold: military and ceremonial. . . . In taking scalps of slain enemies, in 'taking care of the scalps' in the pueblo, and in performing rituals and dances with the scalps, the Opi brought *ianyi* (power, blessing) to the pueblo. This in concrete terms of pueblo ideology meant bringing rain—and, perhaps health and strength."[241]

Elsewhere White[242] comments that "killing was not as significant as overpowering him [the enemy] on the supernatural plane and taking his scalp." Scalps were adopted through proper ritual treatment into the pueblos as rainmakers. Fed, given tobacco, and periodically bathed, they became potent bringers of rain. Stevenson[243] describes the role of warriors at Zuni in fall thanksgiving ceremonies for crops. Included in these events are prayers that the enemy (Navajo) may be destroyed so that the corn will grow: "The songs of the warriors become more hilarious, growing louder and louder as they appeal to the gods of war to give them the lives of their enemies, that they may have rain and bountiful crops."

THE DUALITY OF WAR AND FERTILITY

Throughout this consideration of Pueblo IV imagery, war and fertility have been shown to be inextricably linked since the fourteenth century. One of the roles of the War societies is that of controlling the weather, and warriors themselves are expected to extend their powers to this end. A number of war deities pictured in the late prehistoric art as well as ethnographically are associated with fertility in diverse ways. Those associated with Venus or the Morning Star and War Twins have fertility roles linked to rain. The famed scalper, Sotuqnangu, the Heart-of-the-Sky-God, is associated with summer thunderheads, lightning, and the maturation of maize. He is the perfect embodiment of war and fertility, encompassing and merging the dual roles of warrior and rainmaker. Deities like the War Twins, also symbolized by Venus and famous as diviners, gamblers, athletes, and hunters,[244] extended their war powers into the realm of rain-bringers, and in the previously recounted Keresan story their powers as rain-bringers exceeded even that of the kachinas. Furthermore, we have seen that in addition to their other functions, their magic cloud shields also bring rain. Also, the War Gods and their earthly counterparts at Zuni, the Bow Priests, are connected to lightning in particular, and upon death they become lightning makers. In addition, Florence Hawley Ellis[245] adds that both returned warriors and scalps were regarded as rainmakers.

It has been shown, too, that the Shalako kachinas in their warrior and fertility roles are another manifestation of this complex that embraces the concept of the Twins, and in the rock art are associated with Morning Star, a connection that seems not to have survived into the ethnographic period.

Further, the distribution of the Shalako in its several manifestations is more widespread in Pueblo IV than in the historic period, indicating a former greater importance assigned to this figure. Today this supernatural is impersonated only at Zuni and Hopi. Knife-Wing, conflated with the Morning Star image and famed as a scalper, is another participant in this sphere of relationships.

Finally, the Horned and Feathered Serpent also plays a role in this complex. Twinned horned and feathered serpents, twinned star-faced rattlesnakes, and the close association of snakes in general with stars is suggestive of war implications, although their role as fertility figures in these contexts has not been as fully explored. Again, the association of the Horned Serpent with war and the Morning Star in particular seems to have been of greater importance prehistorically than it is today. Ethnographically the horned serpent is usually described as being in charge of streams and springs and all the underground waters of the earth, and his role in this capacity is active.

Outside of this symbolic loop is Masau, who has a powerful role in both war and fertility, and the regenerative powers of the earth are within his domain. His association with the earth's fertility, however, resides in his connection with fire and warmth, not rain. His ability to provide the requisite warmth for plants to grow, a yearly concern for maize farmers on the northern edge of the corn-growing frontier, is more reminiscent of the role of the sun in the agricultural cycle. Again, it is significant that the sun is heavily implicated in Pueblo texts having to do with warfare, both as a warrior and in the crucial role his movement in the sky plays to ensure the growth of maize.

On a general front, this exploration of the iconography and its meanings has demonstrated that embedded within Pueblo ideology are explicit linkages between war-related rituals and the movements of the sun, fertility, and weather control. Murals and rock art depicting suns, sun shields, warriors with sun shields, and the like are readily explained by ceremonies presided over by Pueblo War societies to ensure the proper motion of the sun, especially at winter solstice and the equinoxes. War rituals carried out by the Scalp societies may be connected to both empowerment rites for runners for the sun or with rain-bringing rites. Thus warfare, even when manifested as raids and conflicts resulting in few deaths, could have been rationalized and even necessary in the annual cycle. Scalps, bloodletting, and human death on a small scale were deemed necessary for the successful production of maize and the consequent economic security of the Pueblo people.

Contemporary Zuni ritual poetry recalls the taloned stars, predatory birds, and even mountain lions with oversize claws in Pueblo IV rock art and kiva murals as it expresses the relationships between maize and scalps and the need for blood and water to fertilize the earth (see Zuni War Cult poem at the beginning of this volume).[246] In a similar later stanza it is specified that:

Beast bow priests,
With their claws,
Tore from the enemy
His water-filled covering
Into the country of the corn priests,[247]
The enemy made his road enter.

The iconography of Pueblo IV art demonstrates that war and conflict were a significant part of Pueblo social and religious life during the centuries before the Conquest. Ethnographic information makes it clear that this visual material is underwritten by a complicated ideology in which warfare, cast in the realm of the sacred, was woven into the fabric of Pueblo life. As elements of war were incorporated into the Pueblo definition and arrangement of the cosmos, war and its associated activities became part of the fabric of several political and social organizations. The overwhelming presence of war themes, symbols, and metaphors in the art indicates the specific symbolic dimensions given to warfare and how it was understood in cosmic terms. War and the ideology of agriculture became linked in a dualism consisting of war and fertility. Although the spoils of war had other powerful ramifications in the social and economic realms (see Titiev for Hopi practices of distributing spoils so that the dead would not come after the killers for their belongings), scalp-taking and obtaining the power to control moisture contributed to the general power and welfare of the pueblo as a whole. In sum, Pueblo warfare was not an insular activity involved solely with defense or revenge, but was integrated with the primary business of maintaining cosmic balance and ultimately Pueblo well-being. Iconography is essential to understanding Pueblo warfare in the face of the meager information provided by burned pueblos and defensive architectural design.

The graphic imagery addresses an interrelated web of relationships showing that Pueblo warfare was not rigidly defined as an isolated activity. The seemingly disparate categories of fertility, curing, hunting, and war are not discrete or independent of one another, but the lines between them are blurred and overlapping, and they embody a vocabulary of symbols and a system of relationships that define a conceptual universe that is distinctly Puebloan. It has been noted that Hunt and War societies have the same animal patrons, and distinctions between killing humans and game are not significant. Warriors may be involved in witch hunts to effect a cure. Chakwaina kachina pertains to hunting, war, childbirth—a single figure embraces all of these ideas. Particularly important to this discussion, however, is the linkage of warfare and cosmic forces that foster both the maintenance of the sun and its proper movement in the sky and rain and fertility, both of which contribute to the success of the maize crop and the well-being of the Pueblo people.

Fundamentally, a duality between war and fertility is an overriding theme in Pueblo warfare ideology of the ethnographic period, and this duality

is apparent in the rock and kiva art. In conclusion, the relationship between rain and warfare is probably nowhere better summed up than in the figure of Sotuqnangu, who appears in the rock art, or in the previously described Layer 1 from Kiva 2 at Pottery Mound. Embracing three walls, this kiva mural links summer thunderstorms and sky supernaturals with warriors and perhaps even sacrifice. The line of warriors is led by the war gods, the leader holding a shield with a large cross-type star, probably representing the Morning Star. Behind, in a line of other warriors, the horizontal figure of a woman lacking ceremonial regalia, possibly an initiate or even a sacrificial victim, appears above the figure of a bird-warrior impersonator. The entourage advances toward a line of ritualists wearing cumulus cloud and rainbow headdresses who are seated below a spectacular band of clouds. Birds fly below and wavy lightning moves from cloud to cloud. A rainbow person adds yet another dimension to this stormy scene. The total mural balances and unifies the symbolism of war and the deities thereof with a world of clouds and cloud persons, joining the forces of war with storm, rain, and fertility (Plate 12).

At the same time that this "distinctly Puebloan" configuration has been described, parallels with Mexican cosmology and Mesoamerican ideas have been constantly referenced. Many of the same categories of supernaturals appear in both places. Esther Pasztory,[248] Marvin Cohodas,[249] John B. Carlson,[250] among others, describe a similar duality in Mesoamerican symbolic structure pertaining to war: "The Tlaloc Venus warfare incorporates the ancient Mesoamerican archetype of the creation of rain, human fertility, and agricultural abundance—particularly for the maize—from the transformation of blood into water through ritual warfare resulting in the capture of prisoners for sacrifice."[251]

In the Southwest, scalps, not captives, were the goal, and as in Mesoamerica, the value of the sacrifice rose in proportion to the status or bravery of the captured or slain. While enemy leaders were sought as the most valuable sacrificial victims in Mesoamerican conquests, in Pueblo warfare only one or two scalps were taken, and these were those of "the meanest" (bravest) enemy.[252] As in the Southwest, a scalp was referred to as "my son" by its taker;[253] so too among the Aztecs, the sacrificial victim was called "my son" by his captor.[254] The complex ideology of Mesoamerica regarding the supernatural powers pertaining to sacred warfare seemed to be expressed in the late prehistoric and historic Southwest, albeit adapted to a simpler socioeconomic base. Nevertheless, the greater Mesoamerican ideographic sphere provides a useful general template upon which the structure and metaphors of Southwestern warfare can be understood within a broader, culturally interactive framework.

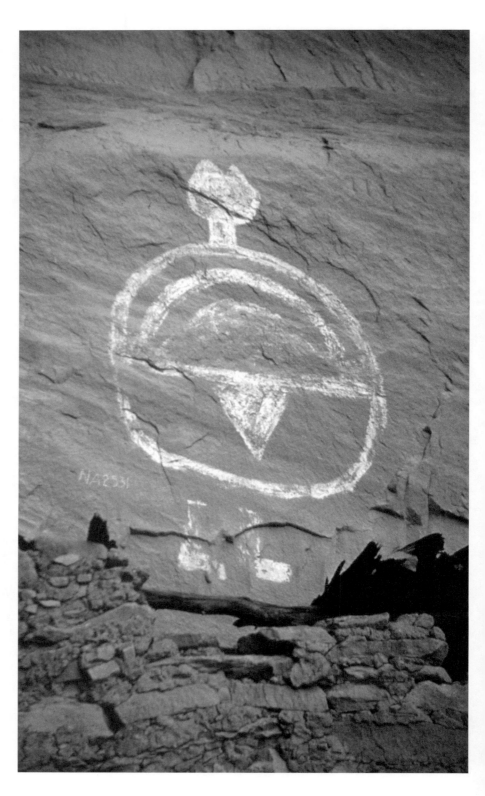

Fig. 5.1
Shield bearer with two–pronged cap, Bat Woman House, Tsegi Canyon drainage, Arizona. *(Photograph by Curtis Schaafsma.)*

ANCESTRAL PUEBLO ARCHAEOLOGY OF CONFLICT AND THE IMPLICATIONS OF CHANGE IN PUEBLO IV

The extensive ancestral Pueblo war imagery considered here addresses conflict in the past on social and ideological fronts. Thus it is appropriate to consider the social and religious contexts out of which these visual systems pertaining to war materialized. How does the iconography of conflict articulate with the underlying religious framework? How do the symbols and issues raised by the imagery concur with traditional archaeological evidence, historical documents, and Pueblo social institutions past and present? More specifically, what was the nature of conflict prehistorically? What was the scale of the hostilities and who was the enemy? What precipitated aggression? Does the archaeological record contain evidence of inter-village hostilities or alien ethnic nomadic groups raiding the pueblos, or both?

It is the consensus of archaeologists that conflict is to be expected in any situation involving sedentary agricultural villages located in marginal environments.[1] Although sparse, often sporadic, and frequently inferential or indirect, evidence of warfare as an element in ancestral Pueblo life is present in one form or another throughout the archaeological record beginning in Basketmaker times.

ANCESTRAL PUEBLO CONFLICT: AN OVERVIEW

Conflict in the Southwest has been for the most part low-level and episodic, and Linda Cordell[2] complains that the archaeological "evidence" cited for hostilities is "a litany of ambiguous cases." With the exception of a few elements in Basketmaker II petroglyphs and rock paintings, symbols or icons of warfare have not been identified in the vast array of art available to the archaeologist until around A.D. 1250.

As mentioned in Chapter I, flayed head skins painted in several colors may have had trophy status and may be indicative of early hostilities among the first farmers on the Colorado Plateau between ca. 200 B.C. and A.D. 400. A loop attached on top for carrying suggests ritual use. These head skins are represented in Basketmaker rock art, where they occur in greater numbers than they do as actual material items retrieved from excavations. Although this

is to be expected, since they are perishable items, the fact that they are represented repeatedly in the rock art indicates that they held symbolic importance. It is likely that they attained the status of fetishes in Basketmaker religious practices, and in one site in the Butler Wash drainage, painted handprints, indicative of prayer requests, are found in association with such a head.[3] In addition, Basketmaker anthropomorphs holding handfuls of darts and/or pierced with darts have been interpreted as literal evidence of ethnic conflict between Basketmaker groups during this early period.[4] Alternatively, a more highly metaphorical meaning may be assigned to these figures within a shamanic paradigm.[5] The "wounded man" element, commonly encountered in rock art throughout the world, has recently been interpreted as representing "shamanic suffering and initiation" closely associated with somatic hallucinations.[6] The fact that many of these persons wear bird headgear, a device that commonly signifies shamanic flight, supports the latter view. Thus symbolic death, combat with supernatural forces, or contention for power between shamans may be the subjects of these scenes, rather than internal confrontation between San Juan Basketmaker groups. Possibly relevant to this discussion is the fact that these figures are distributed well within the Western or San Juan Basketmaker region and not near the boundaries of the two ethnic divisions, defined on the basis of house forms, dart points, and perishable remains.[7]

Iconography with implications of conflict does not appear again in ancestral Pueblo rock art until around A.D. 1250 in the northwestern Pueblo region. Timothy A. Kohler and Carla R. Van West[8] describe the Anasazi situation in the late thirteenth century as one in which self-interest provoked by various stress factors was substituted for an earlier prevailing pattern of cooperation and a pooling of resources, reciprocity, and redistribution between Anasazi groups, a peaceful state that reached its apex between A.D. 1100 and 1129 and remained stable until the mid-1200s.

Depending on the data reviewed, however, the picture of cooperative behavior among the Anasazi does not necessarily reveal a culturally homogeneous pattern over a large region at any one time. According to Christy G. Turner and Jacqueline A. Turner,[9] the average date for cannibalism among the Anasazi is also around A.D. 1100. They relate this phenomenon, however, to the development of the Chaco system as a method of intimidation and social control of neighbors outside of the Chaco loop. Ironically, as Kohler and Van West[10] themselves note, "Cannibalism perhaps represents the ultimate in negative reciprocity." Interestingly, neither the shield nor any other identifiable war iconography correlates either temporally or spatially with the Chaco phenomenon, which theoretically involved both greater reciprocity and "pooling" within the system itself and, according to the Turners, horrific intimidation of peripheral social factions.

At around A.D. 1250, painted shields and shield bearers associated with

cliff dwellings in the northwestern Anasazi region initiated war iconography among the prehistoric Pueblos (Fig. 5.1). In the final decades of occupation of the Colorado Plateau by the Anasazi, habitation sites located in defensible locations and moves toward an aggregated settlement pattern are often cited as evidence of social stress that, along with drought and environmental degradation, led to the evacuation of the region.

The question is not whether we are dealing with conflict during these years, but rather who the enemy was. Haas and Creamer[11] develop a case for intra-Anasazi strife due to horticultural hardships and consequent economic stress. Haas[12] argues convincingly that in the face of high population density, a deteriorating environment, and the nutritional problems that ensued, "warfare is a predictable response." Haas and Creamer maintain that the aggregation of Anasazi villages took place as a defensive measure, and they have identified clusters of Kayenta pueblos that they feel represent allied Anasazi groups that fought against each other. The retreat into the cliffs and the location of habitation sites on top of nearly inaccessible rocks and mesatops were part of this resettlement strategy. Mass graves and disarticulated skeletal remains with missing parts are further dramatic evidence of conflict.

On the other hand, as mentioned in Chapter II, Richard J. Ambler and Mark Q. Sutton[13] make an equally convincing argument for an invasion of predatory Numic hunting-gathering bands out of the Great Basin during this time, driving Anasazi farmers east and south. Under conditions of drought and economic problems already besetting the Anasazi, the negative effects of pillaging would have been even more devastating. Fremont populations who abandoned the remainder of what is now Utah at about this same time or slightly later)[14] would also have been adversely affected.

Archaeological evidence indicates that the Fremont culture was replaced by Numic invaders as opposed to being ancestral to later Numic speakers in the region.[15] Archaeological evidence for the presence of hunter-gatherers in the area during the last phase of Anasazi occupation has not been forthcoming, however, although the minimal remains of transient campsites of small groups of mobile raiders might easily be overlooked. Nevertheless, the apparent lack of such sites remains problematic, and there is also a decided lack of agreement among archaeologists as to who has the strategic advantage in a situation in which a large population of sedentary farmers becomes the target of small marauding bands that raid and plunder.

As discussed previously, the shield paintings appear to represent an ideology that developed under such adverse conditions, the shields in themselves possibly being regarded as having powers of supernatural protection. It has also been noted that the greatest diversity and vigor of shield iconography occurs in the Colorado River drainage of southeastern Utah and in the nearby northern drainages of the lower San Juan. While motifs on shields seem to lack any clear-cut distinctions related to ethnicity, headdresses and body shape

indicate a Fremont presence in the Colorado River sector, where rock art in the Fremont tradition is found in conjunction with Anasazi architectural sites. The question of Fremont/Anasazi confrontations has not been addressed by archaeologists. It is also possible that Fremont and Anasazi groups shared a common ideological response to nomadic invaders, as reflected in the imagery of the shields and shield bearers. It is not certain, however, whether the Fremont and Anasazi occupations of this region were sequential or contemporaneous, and this whole issue bears further investigation. As Geib notes,[16] a consideration of all the available knowledge on this issue to date has not resulted in a clear-cut picture. Further, although the Numic invader hypothesis is consistent with the pattern of withdrawal and abandonment by the Anasazi and the Fremont, it is not the purpose of this study to resolve this issue, which is undoubtedly more complex than the available archaeological data reveal.

It is apparent, nevertheless, that the social conditions on the Colorado Plateau at this time provoked a social environment fraught with tension and hostilities that generated the creation of icons of warfare before the area was vacated by the Anasazi at the end of the thirteenth century. The limited subject matter that pertains to conflict, however, suggests that this ideology was not particularly well-developed, especially compared with that in the following centuries to the south and southeast.

The florescence of war iconography following the Anasazi migration out of the San Juan drainage and adjacent regions of the Colorado Plateau raises many questions. What social processes fostered the picturing of the many war icons and kachinas among other new elements in Pueblo art in the fourteenth century? What social changes accompanied the Pueblo resettlement in the Rio Grande valley and the Little Colorado? Does the increase in warfare iconography indicate escalation of actual warfare itself, or simply the formation of social institutions whose identity and beliefs were stated in and reinforced by kiva paintings and rock art?

The sophisticated and highly symbolic content of Pueblo IV war iconography suggests that during the fourteenth century warfare ideology became integrated with Pueblo cosmology and ritualized, leading to the formation of various social institutions, including warrior societies. In contrast, there is little or no conclusive evidence in the rock art for the existence of such formalization and institutions of warfare and ritual in the thirteenth century. While it has been suggested that the shields had an ideological component linked to supernatural powers believed to be inherent in the shield itself, no particular associated ritual is implied by the paintings, nor at this point can the shield designs or shield bearers be said to represent particular war cults or other social groups.

Further, the focus of late thirteenth- and early to mid-fourteenth-century shields and shield bearers in the northern and western part of the Anasazi

region, and especially in the Colorado River drainage where connections to Fremont culture are apparent, raises the question as to how and to what degree this artistic/ideological development of shields without significant subsidiary iconography was historically and culturally related to that of the following period. With the possible minor exception of shields scratched in plaster at Cliff Palace, shield paintings and the ideology they embodied are absent in Mesa Verde sites, the occupants of which are believed to have migrated into the Rio Grande. Some continuity between the last Anasazi on the Colorado Plateau and later sites is suggested, nevertheless, by the shields and shield bearers themselves, and it was previously noted that red handprints are sometimes associated with shield paintings in all areas discussed. Horned shield bearers are also found throughout.

Nevertheless, the fourteenth century in the Rio Grande and the Hopi regions saw major innovations in shield design and symbolism (Fig. 2.4). On the whole, shield designs are more formalized and standardized than previously. Variation in shields patterns is less random. Flamboyant elements added to the perimeters of shields also contributed to the new symbolism evident in Pueblo IV.

Overall, the differences between the Plateau and Rio Grande art styles vastly exceed the continuities, and the specific environmental/cultural/historical factors that provoked conflict on the Colorado Plateau would have changed radically or vanished with the evacuation of that region. Accelerated expression of warfare iconography in the following period would have been a response to a new set of social problems that gave rise to conflict. Additional historical/cultural factors certainly seem to have entered the picture, which contributed to major iconographic changes conveying new social and religious meanings. The new symbolic complex encodes a belief system integrated with a larger cosmology of which warfare was very much a part, little of which is in evidence in the Anasazi symbolic system on the Colorado Plateau.

The changes involve a relatively rapid shift away from the iconography of the Colorado Plateau Anasazi during the final years of occupation, which featured, in addition to the shields, spirals, sheep, lizards, stick figures, and fertility themes. It was replaced by flamboyant imagery that includes the war-related icons and symbols, including kachinas, described in this volume, all of which is rendered in a dynamic style, often on a larger scale (Fig. 5.2). Patricia Crown's claim[17] that kachina imagery exists in the iconography at Chaco and Mesa Verde is not backed up by substantial archaeological evidence.

A potential model for addressing the major iconographic/ideological changes such as those described herein for the fourteenth-century Southwest is provided by Richard L. Burger,[18] who, in the context of explaining the Chavin horizon of Peru, develops the thesis of crises and the consequent "revitalization movements"[19] as factors of ideological and religious change. Aspects of this model may well pertain to the Pueblo Southwest when it is

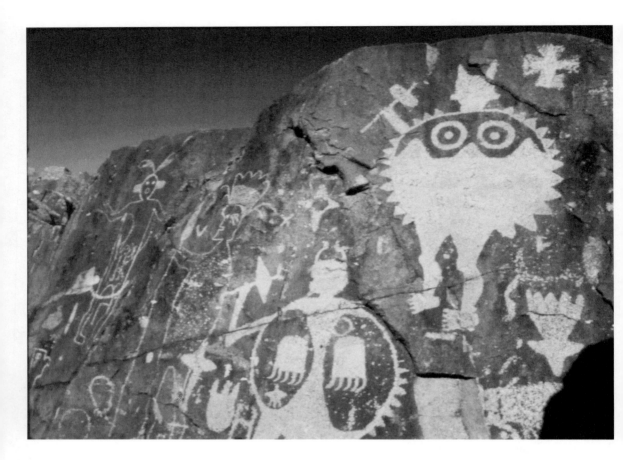

Fig. 5.2
Large, finely delin-eated shield bearers and other warriors at the top of the Comanche Gap dike. Other symbols relat-ed to warfare, such as the feathered star, are interspersed among the warrior figures.

taken into account that the new art and its contents developed shortly after the departure from the Four Corners region and resettlement in the Rio Grande and Little Colorado river regions. Most certainly these migrations out of ancestral homelands were a response to environmental and social crises as outlined elsewhere. In the model Burger proposes, the viability of old belief systems is lost due to the developments of inadequacies and inconsistencies between the old beliefs and new or developing social realities. The stress thus engendered leads to a period of accelerated change, during which a new reli-gious ideology better suited to the new circumstances is formulated.

These general conditions appear to have been operative in the fourteenth century, during which time a seemingly new cosmology overrode or replaced many aspects of the older regime. Although elements of continuity, like flute players and fertility, can be singled out, these conservative elements are minor compared with the additions and innovations that occur. The new graphic art forms are among the most evident and dramatic in the archaeological record, although there are significant accompanying shifts in ceramics, ceramic designs, and architecture as well. Similarly, Crown[20] has documented a four-teenth-century change in designs on Salado polychrome ceramics in an area

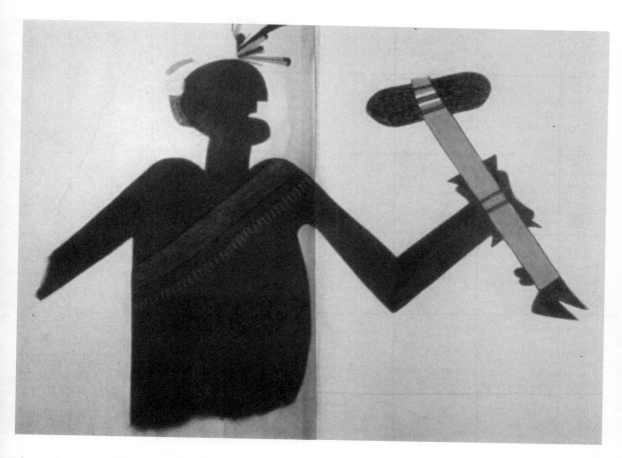

that overlaps the Western Pueblos, but that is primarily to the south of the Pueblo area under discussion.

Not only is there a major change in Pueblo graphic-art styles and content at this time, but the rock art and kiva murals that display the new symbolism, metaphors, and even rituals become a much more prolific medium of communication. The complex kiva murals and the volume of rock art imagery at many sites would have functioned on one level to legitimize and sanctify the new cosmology together with the new socio-political orders, in this case the much larger villages with their various integrating institutions, such as the kachina cult and war associations. These institutions, in turn, may have been the agents that promoted the new ideologies, as they validated their existence. The new ideology expressed in the art of Pueblo IV and the associated rituals would have been better able to satisfy the social and interpretive needs of the times.

Fig. 5.3
An old warrior wearing a bandoleer holds a war club. The double fringed bandoleer is peculiar to warriors. Pottery Mound, Kiva 9, layer 12. *(Photograph courtesy of the University of New Mexico— Albuquerque, Maxwell Museum of Anthropology.)*

WAR SOCIETIES IN PUEBLO IV

The vastly more involved Pueblo IV war iconography implies the prob-

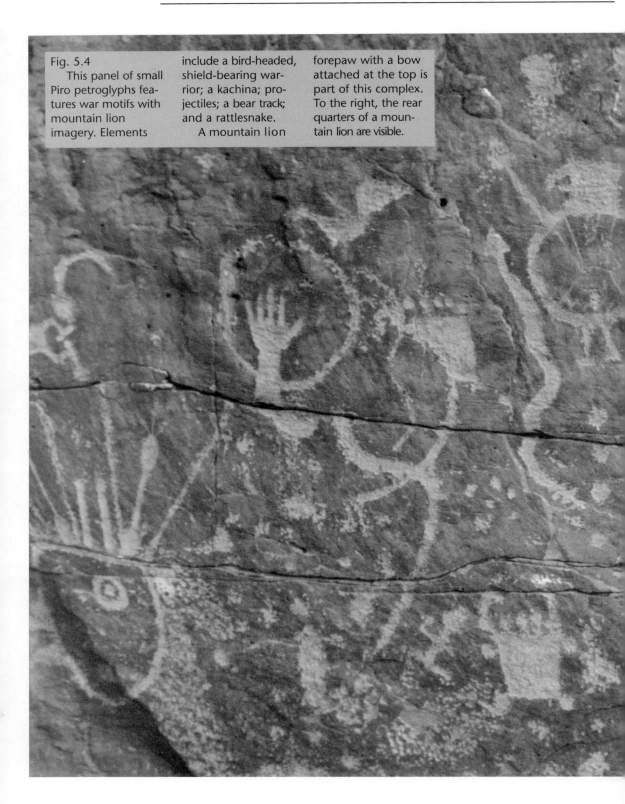

Fig. 5.4
This panel of small Piro petroglyphs features war motifs with mountain lion imagery. Elements include a bird-headed, shield-bearing warrior; a kachina; projectiles; a bear track; and a rattlesnake.

A mountain lion forepaw with a bow attached at the top is part of this complex. To the right, the rear quarters of a mountain lion are visible.

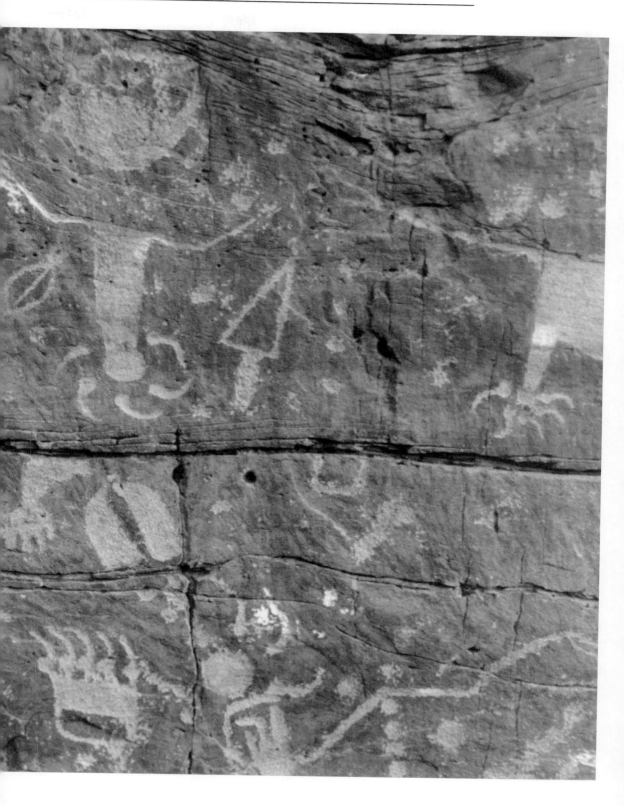

able existence of several symbolically complex war cults and societies beginning in the fourteenth century. It also shows that warfare after the thirteenth century was fully integrated with Pueblo cosmology as a whole, lending to war ideology and activities a pervasive role that linked war to agricultural success and probably other areas of concern. Pueblo warfare has never been an exclusive institution dedicated solely to militaristic pursuits. In the Pueblo IV imagery, rituals involving a variety of participants are pictured, and ritual conflicts involving sun shields, horned serpents, war gods, and other supernatural figures have been described. Although real warfare should be distinguished from ritual warfare, the two were ideographically linked. In the kiva murals, actual ceremonies are pictured involving many figures, among them warriors, and there is good reason to believe that activities of War societies as such are the subject matter of these paintings.

In this regard, the scenes painted on the latest layers of plaster in kivas 2 and 6 at Pottery Mound merit further discussion. On layer 1 in Kiva 6,[21] the row of seated men and felines with quivers appear to represent a war society ritual in which an identity between warriors and the mountain lion and other felines is implicit in their like seated positions (Plate 11).

Of particular interest, however, is the large number of snakes pictured in various contexts throughout the mural on layer 1 of Kiva 2, suggesting that this may have been a Snake Society war ritual (Plate 12). Layer 1 of Kiva 8 at Pottery Mound also features a masked warrior holding a quiver and wearing a rattlesnake headdress (Fig. 3.29). As stated by Parsons in Stephen[22] with regard to Hopi, the Snake Society is a "sometime war society." Ethnographically, Parsons[23] describes a War Snake Society at nearby Isleta consisting of both men and women. Further, also at Isleta, the permanent War Chief is also the Scalp Chief and Chief of the Snake Society. Additional bringing together of snake and war symbolism is also found in the Isleta office of *kumpa*, assistant to the Town chief. *Kumpa* has warlike characteristics and is sometimes referred to as a War Chief as such.[24] He is said to have a special relationship to snakes and the Horned Serpent. Snakes in power roles in the now extinct Keres Kapina (Spider) Society connected with warfare are also mentioned by Parsons.[25] A similar set of relationships among war, snakes, and social organization appears to be pictured in the prehistoric mural, and a historical connection is perhaps implicit in the proximity of Pottery Mound to Isleta Pueblo, a distance of not more than about 20 kilometers.

From further afield, however, at Hopi all Snake Society members were regarded as warriors[26] and, as noted previously, Big Snake and rattlesnakes are invoked to lend their power in war.

The sword, arrow, and stick swallowers in the rock art represent other probable war-related prehistoric orders with contemporary analogues. In the last century at Hopi and Zuni, those enacting extraordinary swallowing feats were members of particular orders. At Hopi the Stick Swallowers were an

order of the Momtcit War Society,[27] with the war-affiliated Spider and Kookop clans owning the paraphernalia.[28] After performances, the sticks were deposited at Spider Woman's shrine.[29]

The Big Firebrand Society at Zuni has both warrior and stick-swallowing functions,[30] but at Jemez and Acoma stick swallowing was a ritual of the Fire and Flint-Curing societies. Bunzel[31] and Stevenson[32] also report that the sword swallowers of the Wood Society, or Hle'wekwe, at Zuni performed in the context of curing and weather-control rites replete with war symbolism. The presence of such "swallower magicians" in Pueblo IV rock art juxtaposed with war-related subjects suggests that the sponsoring orders existed among the Rio Grande Pueblos between the fourteenth and seventeenth centuries.

The kachina organization is to be included among the many societies that appear at this time, along with those that are more explicitly made up of warriors. According to Plog and Solometo,[33] both Adams[34] and Crown[35] regard the kachina organization and other ritual changes indicated in the iconography as evidence of solutions to social difficulties "reducing conflict and stressing cooperation and common identity." It remains to be asked why warfare iconography escalated in equal proportion to religious cults that supposedly offered a solution to social stress. While the kachina cult, with its focus on weather control and abundant harvests, contributed to village integration, it also seems to have had a role in war ritual, with which it was interconnected in the overarching ideological dualism embracing war and fertility. The war-related aspect of the kachina cult is apparent in the previous consideration of warrior kachinas and their roles as scalpers, the obtaining of scalps being one means to ensure the rainfall necessary for the crops. The interconnectedness of war and kachina themes that include scalps, blood, and rain has been emphasized recently by Plog and Solometo[36] as they address processes of cultural change among Western Pueblos. Acknowledgment of both the integrative functions of the kachina cult as well as its role in war ideology supports the contention considered below (p. 173) that village aggregation and social consolidation went hand in hand with inter-village strife. Historically in some villages, such as the Tewa and in Isleta, a women's Scalp Society provided a female counterpart to the male Warrior Society. The complex visual metaphors referencing scalps and scalping in the rock art may indicate that the scalp societies as such existed prehistorically, although this is not certain.

There are occasional individual supernaturals in Pueblo IV imagery whose historic counterparts have affiliations with specific societies in today's pueblos, and it is possible that these associations existed in similar form in prehistory. For example, Masau today is associated with the warrior group known as the Kwan (Agave) Society at Hopi. With this in mind, it is perhaps significant that an unusual notched horizontal bar pictured on a shield at a small Galisteo Basin site resembles the *mongkoho*, an emblem of the Kwan Society at Hopi.[37] The *mongkoho* is a carved stick carried by the society leader as an

emblem or badge of office. While contemporary *mongkohos* of the Agaves have a deep wide notch at only one end, the item in the rock art has such a notch at either end, but differences in time and place could account for this small discrepancy. Further, two large Masau masks are also pictured in this small cluster of petroglyphs that may have identified a society shrine.

In summary, the content of the rock art and kiva murals strongly suggests that various war societies with historic parallels, along with the kachina organization, were present from the fourteenth century through the fifteenth and later. Warrior societies would have functioned to consolidate war rituals and belief systems regarding Pueblo conflict, to sponsor public and private rituals, and to organize and prepare men for combat. These organizations would have been, like the kachina cult, integrative social structures promoting cooperation and the consolidation of the large villages and towns that characterized this period. Judging from the activities of warrior organizations in contemporary pueblos, membership in these warrior societies was probably not exclusive, and the focus of warfare embraced a broader cosmology that included a cult of the sun, the acquisition and activation of rain-bringing powers with an assurance of fertility, and the promotion of the growth of maize. From the lack of evidence in the art, it would seem that these organizations were not in place before the fourteenth century.

THE FOURTEENTH CENTURY AND BEYOND—THE ARCHAEOLOGICAL EVIDENCE

In spite of the rich body of war iconography from the fourteenth century on, as noted at the beginning of this chapter, the remaining, or more traditional, archaeological evidence for conflict and hostilities during Pueblo IV is hardly overwhelming. Commonly cited indirect indications of conflict during Pueblo IV are site aggregation and defensible architectural styles that incorporated features interpretable as security measures against attack. Trends that began in the thirteenth century continue into the fourteenth, with concentrated populations comprising much larger villages and even towns. To quote Plog and Solometo,[38] "Adams[39] regards the rapid aggregation of formerly dispersed populations in the large villages of the late thirteenth and fourteenth centuries as a peaceful solution to the potential for conflict between local groups and migrants from the Four Corners region. We contend, however, that the important aspects of the Southwestern social landscape . . . suggest that the threat of conflict continued on a significant scale throughout the fourteenth century."

These authors go on to describe defensive architectural features, emphasizing the enclosed plaza as a key element of defensible pueblos, a feature that Adams links with the public rituals of the kachina cult. While the use of the plaza as a focus for kachina and other ceremonies that socially unified the vil-

lage is an undeniable function of this enclosed space, rituals that unified tensions within a village have little to do with inter-village hostile relationships. Other defensive features include solid outer walls lacking apertures and limited access to central plazas through narrow entrances, architectural planning strategies that would have provided protection for the inhabitants. Lower rooms lacked doorways and were accessed only by hatches in the roof. Multistoried plaza pueblos located on low bluffs or even on the valley floors would have presented substantial resistance to the outsider. None of these features, however, constitutes direct evidence of hostile encounters.

Remains of burned villages and evidence of rapid departures may be more indicative of actual attacks, although even then other explanations are still possible. Unburied skeletal remains, individuals trapped in burned rooms, projectile points embedded in bones, and occasional evidence of scalping are considerably more substantial signs of conflict during this period, but again, this kind of evidence is not frequent. Evidence of scalping, consisting of horizontal cuts on ten crania from Nuvakwetaqa (Chavez Pass) and Grasshopper Pueblo in east-central Arizona, was found on individuals subsequently buried with grave goods.[40] It was not clear, however, whether these individuals were victims of war, later given formal burial by survivors, or victims of sacrifice.

Lacking copious evidence, it is likely that conflicts continued to be carried out on a small scale characterized by skirmishes and raids. Only rarely did an attack result in the destruction of an entire village, and there is no indication that warfare, regardless of those involved, was directed at territorial gain.

Warfare iconography in the kiva murals appears to reach a climax of complexity and popularity in the later 1300s and early 1400s. Crotty[41] contends that chronological evidence in the murals, taken as a group as well as per site, shows that war societies had an important role in Pueblo ceremonialism in the late 1300s and early 1400s, but that by the turn of the sixteenth century concern with warfare had considerably diminished. In the fourteenth and the first half of the fifteenth centuries, shields and shield bearers are featured prominently, while in murals ascribed to the later 1400s these elements decline.[42] The scarcity of war subjects in the Eastern Pueblo protohistoric kiva paintings from Kuaua and Las Humanas[43] appears to support these observations. In turn, Crotty[44] postulates that later war subject matter takes "a more subtle turn," incorporating animal symbolism and star beings. This later favoring of less explicit war-related motifs is said to have linkages to fertility themes, and Crotty postulates an era characterized by peacefulness. The open plaza or "street-oriented" layout in Western Pueblo settlement patterns after the mid-fifteenth century is cited as further archaeological evidence signaling that warfare had by this time declined.[45]

When all of the available data are taken into consideration, however, there is a lack of chronological consistency in the archaeological evidence and in the iconography as suggested by the kiva murals. Assuming a somewhat

general ideological congruity throughout all related graphic media, presumably this prevalence of war themes in the murals prior to the mid-fifteenth century should also be present in the less easily datable rock art. In the rock art at Cerro Indio, however, a Glaze A site probably abandoned early in the 1400s,[46] war-related themes, although not entirely absent, were not a preoccupation of the petroglyph makers. Instead, kachinas featuring cloud and rain symbolism are emphasized, a factor that suggests that thematic elements alone are not clear indicators of temporal placement of Rio Grande-style rock art between ca. A.D. 1325 and 1600.

On the other hand, the early emphasis on warfare themes in the murals concurs in part with the strong focus on war themes among the petroglyphs at Comanche Gap, which are believed to date anywhere from ca. 1325 or 1340 to as late as 1525. At this site, contrary to Crotty's proposed chronological distinctions among warriors and shield bearers and star motifs, one notes that stars are prevalent as shield designs, inseparable from the "hard core" war imagery. Star-bedecked shields here and elsewhere beg Crotty's assessment of this image as being a later, less explicit war motif. Further, as noted previously, war and fertility themes go hand in hand as a dual concept in Pueblo cosmology.

Neither does the traditional archaeological record in the Rio Grande valley offer an entirely concordant picture Pueblo-wide with regard to conflict chronology. For example, Robert Preucel[47] describes what he calls a peaceful profile on the Pueblo front on the Pajarito Plateau between A.D. 1325 and 1450, as indicated by the presence of many dispersed field houses, which suggests a non-threatening environment. He describes a reorganization during the 100 years following that results in an aggregated settlement pattern with fewer field houses, a period that ends with the abandonment of these large towns by A.D. 1550.

Although the settlement pattern on the Pajarito Plateau between A.D. 1450 and 1550 is more consistent with a more hostile milieu, this period temporally correlates with the "lull" in conflict as suggested by kiva murals and western pueblo settlement patterns. As Judith Habicht Mauche points out,[48] the arrival of bison hunters on the southern High Plains in the mid-fifteenth century may have led to conflict, as their presence restricted Eastern Pueblo exploitation of this region. The economic exchanges between Plains bison hunters and the horticultural Pueblos have been the subject of considerable discussion,[49] and the unstable nature of these relationships is also well-documented. Clearly more work is needed, and the data available in the art must be synthesized with evidence of conflict in specific subregional or more localized contexts. Perhaps generalizations with regard to patterns of Pueblo aggression in the centuries between A.D. 1325 and 1600 are not even feasible.

Regardless of the problems in fine-tuning the chronological patterns of hostilities in Pueblo IV, it is noteworthy that the amenability of the early Pueblo IV material to interpretation on the basis of the ethnographic record

indicates that there exists a continuity between the Pueblo warfare ideology and its related rituals that was sustained from the fourteenth century into historic times, and that any apparent decline in conflict in the past did not result in significant ideological loss.

As during the thirteenth century on the Colorado Plateau, the issue is raised as to the dynamics of conflict in the new geographic settings. Hostilities between Pueblo villages as well as between the Pueblos and outsiders probably took place. The hostilities in the mid-1400s between the Pueblos and Plains bison hunters has already been noted. Increased hostilities between Pueblo villages themselves, however, have been the focus of several studies.[50] It is postulated that the development of large aggregated villages and towns in a rather borderline farming environment with unreliable rainfall created a situation in which stress was prevalent. Social integration and intra-village cooperation, however, was expedited by the overarching institutions and societies that included the whole population or large segments thereof, while hostilities between autonomous villages seem to have been on the increase.

Tighter integration of the unprecedentedly large pueblos was promoted by village-wide sodalities such as the kachina cult and war societies, and evidence for both is present in the Pueblo IV rock art and kiva murals. Such organizations would have fostered intra-village cooperation and consolidation, offering a unified front to the outside world. War itself, along with its concomitant societies that drew their memberships from a broad spectrum of the village population, may have served as a factor in consolidating political power within each village.

Yet "a greater emphasis on ritual and cooperation within villages is often associated with social tension between village and regions. An emphasis on internal unity is a logical counterpart of the risk of threat from others."[51] Even lacking real economic threats, powerful village self-identities, which simultaneously create a strong sense of "other" with regard to neighboring towns, is often enough to generate competitive feelings and hostilities between pueblos that could have led to periodic aggression. The self-sufficiency, independence, and often disparaging attitudes expressed toward other villages that is characteristic among contemporary pueblos is indicative of a social environment that could have fostered hostile interactions in the past. Taking these factors into consideration, we do not have to search for environmental extremes to explain hostilities, although this certainly would have contributed toward aggressive behavior.

With the possible exception of the Cibola (Zuni) group,[52] which may have had an inter-village network, at the time of the conquest each Pueblo stood on its own. The consolidation of a pan-Pueblo effort to join forces at the time of the Pueblo Revolt is generally regarded as a unique response to historical circumstances,[53] although David R. Wilcox[54] has argued for the existence of protohistoric (A.D. 1450–1700) Pueblo confederations. He proposes

that these were organized along ethnic/linguistic lines linked by patterns of exchange, alliances, warfare, and "possibly tribute." His evidence for polities or confederations, based primarily on ambiguous historical references, as yet lacks confirmation on archaeological grounds and merits further investigation. If such alliances existed in the protohistoric, it is reasonable to consider the possibility that graphic imagery might have been used to state and confirm these identities. As yet, no such icons have been identified.

Warfare from the fourteenth century on is elucidated by patterns of conflict and fighting documented in the early historical records. Early documents support both factions as enemies: pueblo against pueblo as well as pillagers from the plains. George P. Hammond and Agapito Rey[55] reference war between Tiwa and Piro villages as well as hostilities between the Pueblos and the Plains Teyas, a bison-hunting Caddoan group on the High Plains said to have been responsible for the recently burned and abandoned villages in the Galisteo Basin encountered by Coronado. Later historical conflict between Plains and Pueblo groups was probably exacerbated by economic pressures levied by the Spanish.

Aside from latent inter-village tensions, inter-village raiding and skirmishes both prehistorically as well as historically were probably incited by a number of explicit factors. Historically many Pueblo battles were fought in self-defense—to protect villages, livestock, and crops from devastation by marauding outsiders, who included Navajo, Apaches, Utes, and, in the west, Chemehuevis. The Pueblo acquisition of slaves from nomadic groups may have been a factor in the motivation of hostilities,[56] but the significance of this enterprise remains obscure.[57] Although loot from the defeated, as listed in Zuni prayers, includes the enemy's flocks, clothing, and jewelry,[58] there are, not surprisingly, innumerable references to scalps as being highly sought among the profits of war. The acquisition of scalps seems to have been a major goal and possibly a traditional motivating force for conducting raids on neighbors, as made explicit in verbal texts referenced elsewhere in this volume.

Although Cordell[59] cautions against examining the ethnographic accounts made following the curtailment of traditional Pueblo warfare practices, these documents continue to be a valuable source of information in which values, traditional attitudes toward social conflict, and the goals of such encounters are expressed and preserved. Further, as this study demonstrates, ethnographic material and oral traditions are consistent with what is symbolized in multitudinous ways in Pueblo IV iconography, and they support the archaeological evidence for small-scale raiding as the predominant type of hostile encounter.

Verbal texts, like the historic sources, reference both revenge against other Pueblos as well as attacks on or by other ethnic groups. Motivations suggested for low-key conflict include retaliation for personal or group vendettas and other transgressions. Reasons for going on the warpath cited in historic Zuni

prayers are to avenge past wrongs, especially deaths. Similarly, the Pueblo stories of conflict and retribution involving racing and guard kachinas cited in Chapter IV bespeak of actual inter-pueblo strife, usually with only a few individuals participating. The case of Awatovi, in which the entire village was destroyed, appears to have been something of an exception, and historical/religious issues probably played a major role in its destruction by other Hopis. It is interesting, however, that in the tale told by Michael Lomatuya'ma et al,[60] moral decadence and sexual jealousy are stressed as key justifications for obliterating the village at the request of its leader, and the other Hopi towns, reluctant to stage this holocaust, were paid off in women and children as well as in fields.

Conflict with outsiders is constantly referenced in stories. There is a Santo Domingo tale that describes attackers from the east destroying many pueblos. The point of this account is how Santo Domingo alone among the Pueblos overcame the enemy using menstrual blood transformed into stinging bees.[61] In many stories, however, the Navajo and Utes are the enemy. Importantly, scalp-taking or decapitations are cited in these stories as the mark of true success, although Hopis often speak of Navajo scalps as "worthless."

Of considerable interest is a description of a late nineteenth-century Acoma reenactment of an attack on nearby Navajos.[62] This ritual drama took place in the late fall and was initiated by the few remaining members of the o.pi or Warrior Society, who wanted to hold one more scalp dance before they died. The "attack" on a hogan (built by the Acoma for the occasion, inside of which they placed their old scalps) resulted in the joyful, victorious return to the pueblo with the requisite scalps. The drama seems to have been enacted explicitly for the purpose of reinvigorating the old scalps, since they could not obtain new ones, and the whole event seems to have been lacking in any other symbolic significance, such as reaffirming their power over Navajo neighbors.

Historically, reports from Hopi are inconsistent—some stating that the Hopis never initiated conflicts but only fought in self-defense or to retaliate for some offense. This scenario is somewhat contradicted by Titiev's[63] statement that the Hopis regularly went on the warpath each fall after the harvest was over, and the return was celebrated by dancing with the scalps thereby procured. In this case it appears that warring activity was "scheduled" to fit the agricultural cycle, and the acquisition of new scalps may have been a prime motive to ensure rainfall for the following season's crop. It is significant that fall war dance celebrations were continued by the Hopi for years after the end of traditional warfare.[64]

WARFARE IDEOLOGY IN A BROADER CULTURAL CONTEXT

As considered earlier, the reestablishment of the Pueblo population in new regions early in the 1300s would have restructured hostile social relationships,

whether they were between warring Anasazi factions or between Pueblos and nomadic raiders. Also, the demographic shift would have relieved the problems of environmental degradation due to long-term farming on the Colorado Plateau. Nevertheless, warfare did not cease to be a factor in the lives of these ancestral Pueblos, but rather, as indicated by the art, it advanced a quantum leap in terms of the complexity of its symbolism and in its importance as a subject in iconographic renderings. All of this suggests that warfare itself intensified rather than abated after ca. 1325 on the new stage.

Many archaeologists treat warfare in the fourteenth century as a simple continuation of forces set in motion at the end of the thirteenth. The iconographic changes described here indicate that the situation is considerably more complicated. It has been proposed that the new iconography manifests, at least in part, an ideological response to the cultural crises that precipitated the Anasazi migration away from ancestral homelands on the Colorado Plateau at the end of the thirteenth century. In this context the art represents an aspect of cultural change that can be viewed as part of a revitalization movement following a major disruption that involved reorganization in the social, political, and religious arenas. Significant changes in Pueblo society following this major demographic shift are represented by the growth of significantly larger pueblos in the fourteenth century. The identification of socially integrative institutions that promoted or enabled their development has been the focus of a number of studies[65] and are part of the new order. Plog and Solometo[66] rightly acknowledge that environmental conditions and the resolution of social tensions within the large aggregated pueblos were mediated by social and religious meanings. Explanations for the appearance of the kachina society and the institutionalization of warfare and the need for integration in general in early Pueblo IV are traditionally sought within the regional and internal dynamics of Pueblo social organization. Inter-village tensions and warfare are commonly cited as a facet of Pueblo life at this time. These studies, focusing largely on the Southwest as a discretely defined cultural area (albeit one that may include parts of northern Chihuahua and Sonora in Mexico) and traditionally seeking explanation for change in "grassroots" cultural processes, have contributed significantly to an understanding of Pueblo culture change from the thirteenth century to the present.

It remains to be asked, however, whether the development of Pueblo IV art and the highly complex symbol structure and the institutions represented can be viewed solely as the result of an in situ regional development, or alternatively, whether new and broader areal ideological patterns in Pueblo thinking are apparent in the art after the thirteenth century. A strictly regional evolutionary sequence in art styles and ideology does not account for elements that occur after ca. 1325 in Pueblo contexts that have analogues in Mesoamerican ideographic systems. Some of these parallels have been touched on throughout the earlier discussions.

Of particular importance is the kachina complex, which shares multiple aspects with the Tlaloc cult of Mexico. Kachina ideology, which finds regional modes of expression, embodies the basic tenets of the Tlaloc complex with regard to ancestors, masks, and involved landscape symbolism.[67] Tlaloc, an ancient deity of the earth and rain, was also a vital part of a dualistic war cult in Mesoamerica in which war and fertility dominated as inextricably linked themes. In the Southwest, a linkage between kachinas and warriors, war and fertility is demonstrated repeatedly in the preceding pages, and is a relationship recently explored as well by Plog and Solometo.[68]

References have been made to parallel Mesoamerican supernaturals and specific concepts that elucidate those found in protohistoric Pueblo art, Mesoamerican analogues at times providing a foundation for understanding and amplifying the available Pueblo information. In summary, these include elements such as the connection between the movements of the sun and human death; the presence of the Hero Twins; the link between stars, Venus, other planets, and warfare; the connection between the sun and large feline predators, canines, eagle, and feline warriors; the Tlaloc-related kachinas; and Spider Grandmother and magic shields. The symbolism connecting the sun, shields, back shields, mirrors and spider webs, and felines and net designs all have Mesoamerican iconographic referents. A connection between warriors and women dying in childbirth are found both in the Southwest and in Mesoamerica. If any of these elements occur in the archaeological record of the Pueblos before the fourteenth century, their identity is extremely ambiguous, and even then their tentative presence is documentable only after A.D. 1250. The possible identification in the late thirteenth-century rock art on the Colorado Plateau of Tiikuywuuti, a Hopi personage manifesting characteristics with Mexican analogues, may be the most likely example of a war icon with Mesoamerican relationships from this period. Finally, underlying warfare in both areas is the fundamental duality that links war and fertility and maintains the cosmic balance via human involvement and sacrifice.

These analogues suggest that the pueblos after A.D. 1300 became participants in a wider ideological sphere centered in Mesoamerica. Much of what is pictured in Pueblo art after the thirteenth century seems to incorporate and even reconfigure aspects of an ancient New World/Mesoamerican reservoir of ideas. On a broad front, iconographic and symbolic parallels between Mesoamerica and the Pueblos of the Southwest have been explored by various scholars. As illustrated here, in the rich body of iconography of Pueblo art dating after ca. A.D. 1325 these parallels are particularly prevalent, and they continue in the oral literature up until the present time.[69] Southwest iconography that embodies themes with Mesoamerican analogues has been noted as early as Mimbres (i.e. A.D. 1000–1150)[70] and in the art of the Jornada Mogollon (A.D. 1200–1450).[71] These iconographies, however, for the most part lack the warfare themes so prevalent in Pueblo IV.

It is beyond the scope of this discussion to explore the mechanisms by which Mesoamerican-centered ideologies reached the Southwest. It is likely that certain values, concepts, and fundamental structural armatures[72] were shared by maize-growing farmers beyond the boundaries of Mesoamerica as such and modified by farming communities as they expanded northward along the Sierra Madre.[73] In spite of the ecological functionalism that dominated archaeological thinking during the 1970s and most of the 1980s, which supported an isolationist position, there is a general recognition that the Southwest was not a "closed system," that is, isolated unto itself. Ideological aspects of Pueblo cosmology related to or concordant with that of a greater ideographic sphere linked to Mesoamerica, but defined more generally by maize-growing farmers, cannot be summarily rejected.

The social issues characteristic of the Pueblo Southwest in the fourteenth century and the appearance of ideas with wider geographic implications may be viewed as parts of a complex cultural process. The appropriation of concepts from a broader world that expanded on the world view or cosmology prevailing in the northern Southwest prior to the fourteenth century became useful and meaningful, probably even facilitating Pueblo adaptive responses to new social and environmental conditions. It is hypothesized that cultural crisis, such as that indicated by the abandonment of the San Juan drainage by the end of the thirteenth century, resulted in a receptivity to ideological change and the development of new paradigms, such as the war complex discussed here.

CHAPTER VI

TODAY: CONTINUITY OF WAR RITUAL AND SYMBOLISM IN CONTEMPORARY PUEBLO SOCIETY

In spite of the fact that social conflict and its associated institutions have substantially and steadily diminished during the historic period, any reading of the ethnographies from the late nineteenth and early twentieth centuries quickly indicates that the ideology of warfare and its associated dimension of rain-bringing potential has been integral to Pueblo religious thought and social organization. As described in the foregoing pages, war ideology was intricately interwoven into the fabric of Pueblo cosmology, being more or less inseparable from many aspects of religion, ritual, social structure, and economic pursuits. Today various related religious rites, including restricted kiva and public seasonal rituals near the solstices, racing, and public ceremonies involving war-related kachinas, are still in place, although Pueblo warfare as such is a thing of the past.

Warrior associations ranked high historically, and at least until very recently, depending on the pueblo, have continued to carry out various important functions within the village. The control of enemies, including witches, has been a main concern of these societies in historic times. Weather control is another realm of their influence. Members of these societies function as guards and protectors in several realms—in ceremonies as well as of public morals and traditions. Furthermore, in addition to the Bow priesthood at Zuni (the Zuni Warrior association), as mentioned previously, Bunzel lists the Ant Society, Wood Society, the Great Fire Society with its Arrow Order, the Hunt, and Cactus societies as all being primarily war societies, and all are devoted to the Beast Gods.

Historically warfare has commanded such an important role in Pueblo social organization that the war priest, or chief, wielded authority equal to that of the cacique, or even shared his responsibilities in some villages. Adolph F. Bandelier referred to the war captain as the "warden" of the cacique.[1] At Cochiti, among other pueblos, the war priest was second only to the cacique, and the Bow Priesthood at Zuni was one of the most powerful. As mentioned earlier, in the Rio Grande Pueblos the War or Bow Priest was often regarded as a representative of the Sun.[2] In many pueblos, the war chief, who once led his warriors into combat, has now assumed primarily religious and civic

duties appropriate to his office, which include dealing with the outside world and protecting the village from hostile influences. At Acoma, the war chiefs, of which there were three in the first half of the twentieth century, play a major role in preserving the old traditions, organizing curing ceremonies, guarding the medicine men from witches, and making known the wishes of the cacique. White also notes, significantly, that another primary function of the war chiefs is to promote the rain supply.[3]

It has been noted that in most pueblos, other officers, such as the war captains, with military as well as peacetime duties, are sanctioned as the earthly counterparts of the War Twins of mythology. Even though their office is historical in origin,[4] having been imposed by the Spanish, their roles have received supernatural sanction, thus actively integrating them into the larger Pueblo cosmological domain. At Cochiti and elsewhere the war gods, Masewi and Oyoyewi, are still among the most important supernaturals, and the war captains bear their names in their official capacity in order to incorporate the prestige and authority of these deities.[5] There are indications that their power in the past was considerable, and bows and arrows are symbols of their office. In many pueblos today, war captains fulfill active nonmilitary roles that include religious and civic responsibilities such as maintaining kivas, serving as guards at dances, being in charge of ceremonial hunts, announcing religious events, and so forth. These officers and their helpers, along with the war chief, are responsible for village security, law, and order, protecting the villages from both inside and outside threats. Their roles include acting as internal authorities and protectors against social deviants, religious heresy, and potential or actual witches. In addition, they patrol Pueblo lands and keep out trespass stock and anyone else who is unwanted. At Zuni the Bow Priests, along with the priestly council, controlled both religious and civil matters until about 1692, when the office of governor was established to deal with outside affairs.[6]

Spider Grandmother provides a supernatural prototype for the recent role of female warriors. Parsons[7] describes a woman war chief from the northern Tewa Pueblo of San Juan, appointed by the male war chief, whose real-life assistants are known as the Blue Corn girls. She herself is known as Apienu, or Red Bow Youth, and the complex would seem to be a female counterpart of the male war chief and his assistants, the war captains, whose supernatural

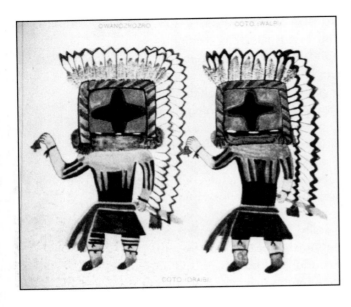

Fig. 6.1
A pair of Hopi star kachinas, or Coto, holding bells and yucca whips.[18]

analogues are the War Twins.

Among the post-thirteenth-century Pueblos, we have seen that the rock art of the southern Tewa features war-related iconography more heavily than that of any other group. The warlike or aggressive southern Tewa tradition implied by the art is continued into the present by their descendants, albeit in altered forms. The descendants of the Southern Tewa now live on First Mesa at Hopi where, according to oral traditions, they were invited to reside following the Pueblo revolts at the end of the 1600s. Following their dislocation from their own territory in the Galisteo Basin, their presence at Hopi was requested for the purpose of protecting the mesa trail to Walpi against marauding Utes and Paiutes.[8] Here they have maintained their warlike reputation, both ceremonially as well as in secular affairs. It was noted previously that they, among all the pueblos, have maintained the most intact ideology pertaining to stars and their symbolic dimension, as indicated in the rock art of previous centuries. Their songs and dances extol the virtues of warrior prowess, and Tewa magic is backed by self-reliance and aggression.[9] Furthermore, their propensity for dealing with the outside world is perpetuated by assuming roles distasteful to the Hopi, such as police officers, judges, and emissaries and interpreters to the whites.

In spite of the active roles of the war captains in most pueblos since the end of the nineteenth century, warrior societies as such have declined or become extinct.[10] As a consequence, during the last century ethnographers have found it increasingly difficult to obtain information on Pueblo war practices. Until around 1890, all able-bodied men at Hopi were expected to belong to the Momtcit Society,[11] membership in which, as discussed previously, did not involve taking a scalp. Working among the Tewa in the 1920s, Parsons[12] notes that all the war societies were extinct except for one at Santa Clara, which was still functioning in part and whose membership consisted of women. In the Tewa pueblos of Isleta, Zuni, and perhaps others, women's associations that paralleled the war society of the men have existed until recently, the women being in charge of the scalps. Scalp-taking was a requirement for war-society membership that became increasingly difficult to meet; in later years, to facilitate the continuation of war societies among certain Keres pueblos, the slaying of mountain lions and bears in lieu of scalping qualified for warrior-society membership.[13] By 1945 at Zia, there remained only one member of the Opi, and he did not know the rituals.[14] E. Adamson Hoebel relates that at that time Opi priests from elsewhere were called in to "cure" disturbed World War II veterans by initiating them into the Opi society. John J. Bodine[15] explains an abandoned kiva at Taos by noting that it may have been used primarily for ceremonial activities pertaining to war. In contrast, Joe S. Sando[16] remarked that every Jemez man belongs to either the Eagle

Fig. 6.2
Photo of a scalp pole in a Pueblo plaza.[19]

or Arrow society, both of which have traditional functions dealing with defense and warfare. Following Edward P. Dozier,[17] today public performances called "war dances" are sponsored by village associations. While preparatory aspects of these dances are considered sacred, the public dance is pure entertainment.

With regard to historic beliefs and practices, the Rio Grande Pueblo assimilation of the Spanish warrior saint, Santiago, necessitates some consideration, although his role as a warrior among the Pueblos seems to be ill-defined. A military religious order of Santiago, with origins in Europe in 1170, established this saint as the patron of all soldiers and horsemen, and Santiago entered the Southwest as a patron of the conquistadors. In the sixteenth century this Christian saint was flush with victory after having been an invincible militant who lent the Spanish supernatural assistance in their 700-year battle against the Moors. Stories and beliefs pertaining to these recent events in Europe were carried by the Spanish into the New World. Santiago was adopted by the Pueblos and transformed into one of a class of Pueblo spirits referred to as maiyanyi by the Keres.[18] Symbolized by his white horse, Santiago became very popular among the Indians, and is the saint most frequently impersonated. At best, Santiago's role as a warrior seems considerably, if not totally, diminished today among the Pueblos, where he is known primarily as a patron of agriculture and ranching. His association with horses is of major significance. The lather on horses raced hard during rooster pulls, a Santiago-related event, symbolizes clouds or rain, while the blood spilled fertilizes the earth.[19] Shades of war surround this contest.

It is unlikely that any significant amount of rock art pertaining to warfare has been made in the current century. Swastikas and a shield bearing a swastika design, lacking patina (desert varnish or discoloration) or any other indication of age, occur at a site with recent debris and historic graffiti by the Rio Grande along a road above the northern Tewa Pueblo of San Juan.[20] Although not singled out as historic by these authors, the context and the rarity of swastikas in Pueblo art suggests that these petroglyphs are the recent work of one individual, possibly connected with World War II, and not a general cultural statement. Nevertheless, the decision to place a power symbol such as a swastika on a shield appears to merge native Tewa practice with international sentiments.

More traditional war imagery has been documented from the walls of late-nineteenth-century rooms at Hopi. In contrast with the Pueblo IV murals, these paintings are simple isolated figures or symbols rendered without any regard for the conceptual or spatial whole. Stephen,[21] whose notes date from 1892, reports a painting of the Milky Way on the wall of the War Chief's house in Walpi. In 1887 the sun, a star (on a possible shield), a bobcat, a white wolf, a mountain lion exhaling a rainbow, a rainbow in its own right, and a bear had been painted on this wall. As described earlier, a wooden effigy of

crossed sticks representing the sky and/or possibly a four-pointed star was also hung from the ceiling of this room.

THE AHAYU:DA—THE LIVING ICONS

At the end of the twentieth century, Zuni war powers in the form of the Ahayu:da have penetrated the consciousness of the world at large. In today's world as in the past, Pueblo issues may not necessarily remain strictly locked within expected boundaries—whether they be ethnic, geographic, or cosmological categories. The theft of the Zuni War Gods beginning at the end of the nineteenth century, and their eventual return beginning in 1978, have become a focus of attention and interaction between the Zuni community, the War Gods, and the world at large.[22]

Ceremonially installed on a regular basis in their mesatop shrines overlooking Zuni by the Bow Priests at winter solstice, these icons, carved from cottonwood with stylized faces and pointed caps, represent the Ahayu:da, the Twins that were created by the Sun Father during the Zuni migrations. The images themselves are regarded as powerful animate beings.[23]

Between 50 and 75 centimeters high, these sculptures are painted upon arrival at their open shrines, and bundles of prayer sticks and other offerings, including netted shields, cluster around the base. Each year a new image replaces that of the previous solstice, and the older ones are retired and left as part of the open shrine to eventually disintegrate and return to the earth in the weathering process. The Bow Priests petition these Ahayu:da to use their potentially malevolent powers for protecting the Zuni world and for other beneficial purposes, such as bringing fertility and good things to all the people in the world.[24]

Left in their open mesatop shrines, they have become vulnerable to theft over the years. Removing them, however, unleashes their dangerous energy. "By the mid-1970s, several of the religious leaders concluded that the disturbing state of world affairs was caused in part by the Ahayu:da that had been stolen from the reservation, because these images were not in their shrines where their potentially destructive powers could be controlled."[25] Outside of their shrines, they pose a threat to world peace and the well-being of everybody. A major campaign was launched in 1978 to retrieve these escapees, an effort that is delineated in William L. Merrill et al.[26] At the time that article was written, 69 war gods had been returned to Zuni from museums, art galleries, public auctions, and private collectors in the United States, although a few more remained in other countries. Meanwhile a high-security shrine, still open to the sky, has been constructed to safeguard the images and world peace.

NOTES

TITLE PAGE
1. Lutonsky 1998.

ZUNI POEM
1. Bunzel 1932:676.

CHAPTER I
1. Hammond and Rey 1928; 1940; 1953.
2. Adams 1989; Cordell 1989; Haas 1990; Haas and Creamer 1993, 1996, 1997; Upham and Reed 1989; Wilcox and Haas 1994.
3. Haas and Creamer 1997:239.
4. 1989:149.
5. Matson and Cole 1997.
6. Cole 1984; 1985; Kidder and Guernsey 1919: Pl. 87a and b; Matson and Cole 1997.
7. Turner and Turner 1995.
8. Wilcox and Haas 1994:217–219.
9. 1989:149.
10. 1993.
11. 1989.
12. Wendorf and Reed 1955.
13. 1989:108.
14. 1990:46.
15. 1942:41 (n.5).
16. 1944:159.
17. 1896;1901.
18. 1901.
19. 1897.
20. 1936.
21. 1904.
22. 1903; 1905.
23. Riley 1995:166; Schroeder 1979.
24. Merrill, Ladd, and Ferguson 1993.

CHAPTER II
1. Dean 1969; Schaafsma 1966.
2. Morris and Burgh 1941.
3. Morris and Burgh 1941: 41 and figs. 30,g; 31,f.
4. Pl. 1, 24th Annual Report, Bureau of American Ethnology, 1907.
5. 1990:146.
6. Cole 1990:146.
7. Schaafsma 1971:57, Fig. 59.
8. 1978:194, Fig. 4.45 b; see also p. 235, Fig. 4.83.
9. 1990:143, Fig. 59.
10. Schaafsma 1980:Fig. 110.
11. 1990:147.
12. Cole 1990:171.
13. Castleton 1979:311, Fig. 9.8; Noxon and Marcus 1985: Fig. 127; Schaafsma 1971:53, Fig. 55.
14. Schaafsma 1971:53, Fig. 55.
15. Noxon and Marcus 1985: Fig. 137.
16. Cole 1990:170, Pl.69; Muench and Schaafsma 1995:64.
17. Cole 1990: pl:68.
18. 1941:329–235.
19. Castleton 1979: 315, Fig. 9.15, 329, Fig. 9.40; Noxon and Marcus 1985: Fig. 137; Schaafsma 1971:61.
20. Cole 1990:173–174.
21. 1996:98–114.
22. Sharrock 1966.
23. Coulam 1992:29.
24. Geib and Fairly 1992.
25. Coulam 1992:28–29.
26. Anderson 1971.
27. Riley 1950; Schulman 1950.
28. 1996.
29. Wright 1976:92.

30. Ambler and Sutton 1989.
31. Colton 1946; Michaelis 1981.
32. Malotki and Lomatuway'ma 1987.
33. Wallis and Titiev 1945:555.
34. 1994:141, Fig. 9.2.
35. McCreery and Malotki 1994:139.
36. McCreery and Malotki 1994:140.
37. 1939:964.
38. 1994:140.
39. Voth 1903:352–353.
40. Titiev 1944:160.
41. Pasztory 1983:302

CHAPTER III
1. Schaafsma 1980:252–268.
2. 1994:50–65.
3. McCreery and Malotki 1994:54–56.
4. LeBlanc 1997:243–245.
5. Hamilton 1982:1–6.
6. 1997:246–254.
7. Hibben 1975:65, Fig. 46.
8. Hibben 1975.
9. Smith 1952.
10. Kidder 1932:Figs. 138, 139, 145, 147 and p.180.
11. Hibben 1975; Smith 1952.
12. LA 70.
13. Schaafsma 1965.
14. Dutton 1963.
15. Brown 1979:270, Fig. 4; Crotty 1995:58 and 67.
16. Peckham 1981:17, 20, 23–24.
17. Crotty 1995.
18. Voll 1961; Hibben 1987.
19. 1975:54.
20. 1975:16, Table 3.
21. Hibben 1975 and slide files, Maxwell Museum of Anthropology.

22. 1975:70, Fig. 50.
23. Hibben 1975:90–92, Fig. 66.
24. Crotty 1995:162.
25. Bunzel 1932:528–534.
26. Hibben 1975:110, Fig. 79.
27. Hibben 1975; frontispiece and pp. 66–67, Figs. 47–48.
28. 1975:135.
29. Vivian 1994:83.
30. Smith 1952:315–318.
31. 1995:234.
32. Smith 1952:Fig. 51e.
33. Schaafsma 1965.
34. Schaafsma 1965:15, Figs. 2 and 6.
35. Dutton 1963:25, n.98.
36. 1963:20, 25.
37. 1963:23.
38. 1987:75.
39. C. Schaafsma 1995.
40. Dutton 1963:200–201.
41. Schaafsma 1992: Fig.2.
42. Dutton 1963:56, Fig. 93.
43. Dutton 1963:180,Pl. XXV.
44. 1990.
45. Smith 1971:12, 571.
46. Adams 1991; Schaafsma 1995.

NOTES, FIGURES
1. see also Schaafsma 1975:Fig. 46.
2. Schaafsma 1990:Figs. 8 and 9.
3. drawing after McCreery and Malotki 1994:51.
4. see Fig. 4.10
5. Stiny 1997.
6. Daggett and Henning 1974.
7. 1992.
8. Smith 1952:240–242.
9. Smith 1952:Fig. 47e and 91d.
10. 1952:caption, Fig. 49a.
11. compare, for example, Smith 1952:Fig. 77a.
12. 1952: p. 302.
13. Dutton 1963:108,Pl.IX, Fig. 54.
14. Crotty 1995: Table A.55.
15. Crotty 1995:Table A.55.
16. 1975:25.
17. Wright 1973:186.
18. Fewkes 1903:Pl. XXVIII.
19. Stevenson 1904, Pl. XXXI.

CHAPTER IV
1. Wobst 1978:306.
2. 1986:172.
3. Stevenson 1894:57; 1904: Pl. 22;

White 1935:31, 182; 1960:56.
4. Dumarest 1919:145; Lange 1990:235–236 from the unpublished manuscripts and field notes of Franz Boas.
5. Schaafsma 1992.
6. Bandelier 1892:116–22.
7. 1988:178–179.
8. Stephen 1936:131, Figs 83, 84.
9. C. Schaafsma 1994.
10. 1944:156.
11. 1903; 1905.
12. 1936.
13. 1901.
14. 1987:156.
15. Wright 1976:10.
16. Winship 1896:490.
17. Crotty 1995:235.
18. 1897:27
19. 1898:102
20. Parsons 1939:197.
21. Wallis and Titiev 1945:555.
22. Wright 1976:12.
23. Wright 1976:13, 92.
24. Wallis and Titiev 1945: Pls. 14, 16, 20; Wright 1976.
25. Parsons 1939:212, 240.
26. Stevenson 1904:24n.b.
27. Stevenson 1894:35.
28. Parsons 1939:212.
29. Parsons 1929:265.
30. 1900:998–999 and pls. 59, 60.
31. 1897:Pl. CIV.
32. 1973:124.
33. Smith 1952:240–242.
34. Smith 1952:Figs. 47a, 54b.
35. 1894:Fig. 14.
36. Cushing 1896:92; Stevenson 1894:44; White 1960:56.
37. Smith 1952:206–207.
38. Ellis 1951:200.
39. Parsons 1939:180.
40. Lomatuway'ma, Lomatuway'ma, Namingha and Malotki 1993:19–21; Malotki and Lomatuway'ma 1987:96; Parsons 1939:212.
41. Malotki and Lomatuway'ma 1987:96.
42. Lomatuway'ma et al. 1993.
43. Bunzel 1932:625.
44. 1982:345.
45. Malotki and Lomatuway'ma 1987:161; Parsons 1939:424-5.

46. Parsons 1939:200–201.
47. Parsons 1932:324.
48. 1939:962.
49. Ortiz 1968:108.
50. Fewkes 1897:268–272.
51. 1897:272.
52. Dorsey and Voth 1901:Pl. XXIX, p. 55; Fewkes 1897:268–272.
53. Dorsey and Voth 1901:22n. and 23, Pl.X.
54. Parsons 1939:532; White 1932b:53.
55. Schaafsma 1968:23.
56. 1917:46.
57. 1935:133–134 and Fig. 131.
58. Parsons 1926:60; 1929:266.
59. Parsons 1939:193.
60. Parsons 1939:919; Stephen 1936: Figs. 24, 25.
61. Titiev 1944:77–78.
62. Malotki and Lomatuway'ma 1987:164–166; Titiev 1944:77–79.
63. Townsend 1992:119.
64. Taube 1983:167, Fig. 17.
65. Taube 1983:Figs. 6–8.
66. 1912:pl.32.
67. Culin 1907:424.
68. Cushing 1896:321–447.
69. 1896:382.
70. Cushing 1896:382.
71. Parsons 1939:305.
72. 1983:130.
73. Taube 1983:130.
74. Taube 1983:112.
75. Parsons 1932:316.
76. Stevenson 1904:Pl.XXI.
77. Voth 1903:287.
78. Wright 1976.
79. Smith 1952:Fig. 72.
80. Muench and Schaafsma 1995:150–151.
81. 1903:334.
82. Dumarest 1919:151–157; White (1935:47).
83. White 1935:44–45.
84. Young 1992.
85. 1903.
86. Fewkes 1903:120.
87. Fewkes 1903:Pl. XXX.
88. Dorsey and Voth 1901:Pl. XXIX.
89. Fewkes 1903:120, Pl. XXIX; Titiev 1944:160.
90. Smith 1952:302–3.
91. Taube 1983:111.
92. 1932a:150–154.

Notes

93. Cushing 1896:381; Young 1992.
94. Boyd and Ferguson 1988: Fig. I–115.
95. Stephen 1936:96; Titiev 1944:151n.62.
96. Parsons 1939:178, 181.
97. Voth 1905:57.
98. 1905:56–58.
99. Brody 1991:Pl.39.
100. Titiev 1944:155.
101. 1996:129–130.
102. Thompson 1996:129.
103. Titiev 1944:159.
104. Malotki and Lomatuway'ma 1987:191–203.
105. McCreery and Malotki 1994:51.
106. Malotki and Lomatuway'ma 1987:159–163.
107. Titiev 1944;156.
108. Malotki and Lomatuway'ma 1987:3.
109. Malotki and Lomatuway'ma 1987:261.
110. Stevenson 1904:36–37.
111. 1932:846.
112. White 1932a:88–94.
113. White 1935:149, n. 31.
114. Wright 1977:76.
115. Wright 1977:76.
116. 1993:383–389.
117. White 1935:176–177.
118. Wright 1977:43.
119. Lange 1990:460–462.
120. Wright 1973:222.
121. Bunzel 1932:994.
122. for more information see Parsons 1939:519n.
123. Stevenson 1904:37.
124. Stevenson 1904:39; Wright 1977:24.
125. Wright 1985:75–77, Pl. 20h.
126. Wright 1985:77.
127. Bunzel 1932:1012; Wright 1973: 57, 100.
128. Wright 1973:100.
129. 1994.
130. 1939:759n.
131. Wright 1973:100.
132. Fewkes 1903:47
133. Colton 1959:57.
134. Kelley Hays–Gilpin, personal communication 1998.
135. Fewkes 1903: Pl. VI; Wright 1985:Pl. 24.

136. White 1932b:Fig. 9.
137. Edmund Ladd 1994, personal communication; Stevenson 1904:36–37.
138. Hays 1992; 1994:60–61.
139. Bunzel 1932:970.
140. Bunzel 1932:770, n.9.
141. 1979:193–197.
142. Wright 1973:111.
143. Cushing 1901:204–205.
144. Schaafsma, 1999.
145. Taube 1983:116–117.
146. 1957:V,163.
147. 1977:38–44.
148. Bunzel 1932:528.
149. Titiev 1944:157.
150. Young 1988:103.
151. Titiev 1944:155–156.
152. Bunzel 1932:528.
153. Parsons 1939:134.
154. Young 1988:122.
155. Young 1988:127–128.
156. Young 1988:128.
157. Titiev 1944:155.
158. Parsons 1939: 341, 936–7, 964.
159. Stephen 1936:97.
160. Stephen 1936:84.
161. 1983:130.
162. Schaafsma 1975:Fig. 71a, lower.
163. Ellis 1951:200.
164. Parsons 1939:899.
165. Ellis 1951.
166. Hibben 1975: frontispiece.
167. Smith 1952:Fig. 72b.
168. Hibben 1975:frontispiece.
169. Schaafsma 1980:184, Map 7.
170. Taube 1983:111.
171. Taube 1983:Fig. 12a.
172. 1903:334.
173. Dorsey and Voth 1902:Pl. XLII.
174. Fewkes 1919:67–68.
175. Parsons 1939:178.
176. Kelley 1964.
177. Titiev 1944:159.
178. Hibben 1975:Fig. 15.
179. Smith 1952:Fig. 77a.
180. Taube 1983:111.
181. Townsend 1992:119.
182. Pasztory 1983:82.
183. Bunzel 1932:531–532.
184. (Schaafsma, in press (b).
185. Hieb 1994:24.
186. Parsons 1939:182; 54n, 133.
187. Parsons 1939:937.

188. Parsons 1939:182.
189. Stephen 1936:85.
190. 1929:266; 1936:181.
191. 1992:5.
192. Young 1992:84–85.
193. Stevenson 1904:27.
194. Young 1992.
195. Reagan 1917:47.
196. Harrington 1916:49; Parsons 1939:181.
197. Parsons 1939:181.
198. Ellis 1951:182.
199. Colton 1959:55.
200. Wright 1973:42.
201. Fewkes 1903:119.
202. Parsons:1940:38.
203. Wright 1977:44; 1973:125.
204. Bunzel 1932:872.
205. Young 1992:85.
206. Parsons 1939:937.
207. Parsons 1939:181–182.
208. Parsons, 1939:299.
209. 1975:134.
210. Nicholson 1971:426.
211. Parsons 1926:23.
212. Voth 1905:65–71.
213. Parsons 1940:170.
214. Benedict 1935:97.
215. Parsons 1932:342.
216. Taube 1986:56–57; 74.
217. Navarrete 1997:61.
218. 1939:705, 708.
219. Smith 1952: Figs. 62a, 81b.
220. Stevenson 1904:39.
221. Hendricks and Wilson 1996:143, n. 16.
222. 1932:679.
223. Bunzel 1933: 133.
224. Bunzel 1932:676; 1933: 131–134.
225. Bunzel 1932:764.
226. Stephen 1936:97.
227. Stephen 1936:85.
228. Schaafsma, 1999 (a).
229. Wright, Gaede and Gaede 1988:Fig. 44.
230. Baird 1989; Carlson 1991; Nicholson 1971:426; Schele and Friedel 1990, etc.
231. Schele 1986.
232. Stevenson 1904:130–131.
233. Stevenson 1904:26; Young 1992:76.
234. 1916:49.
235. Harrington 1916:49.
236. 1917:46–47.

237. Carlson 1991:Fig. 8a–f.
238. Carlson 1991: Fig. 1f.
239. Bunzel 1932:487.
240. 1997:176.
241. White 1942b:132.
242. 1932:61.
243. 1904:205–207.
244. Tedlock 1979:501.
245. 1951:192.
246. Bunzel 1932:676.
247. Bunzel 1932:678.
248. 1983:123.
249. 1989.
250. 1991.
251. Carlson 1991:56.
252. Beaglehole and Beaglehole 1935:23.
253. Parsons 1939:208,350; Titiev 1944:160, n.35.
254. Pasztory 1983:58.

CHAPTER V
1. Adams 1989:105.
2. 1989:76.
3. Schaafsma 1980:117–119.
4. Matson and Cole 1997.
5. Schaafsma 1994:62.
6. Lewis–Williams 1997:827.
7. Matson and Cole 1997.
8. 1996:184.
9. 1995.
10. 1996:184.
11. 1996.
12. 1990:187.
13. 1989.
14. See also Turner, A. D. and R. C. Euler 1983.
15. Adovasio 1896:205; Marwitt 1986:171–172.
16. 1996:114.
17. 1994.
18. 1988:139–143.
19. Wallace 1956.
20. 1994.
21. Hibben 1975:Frontispiece.
22. 1936:84.
23. 1939:125.

24. Parsons 1932:258.
25. 1936:556.
26. Titiev 1944:156n.11; Voth 1903:334.
27. Parsons 1939:621.
28. Titiev 1944:156.
29. Titiev 1944:156–159.
30. Stephen 1936:83,n.4.
31. 1932:532.
32. 1904:444–485.
33. 1997:167.
34. 1991.
35. 1994.
36. 1997.
37. Voth 1901:Pl.LV.
38. 1997:168.
39. 1991; 1994.
40. Allen and Merbs 1985.
41. 1995:235.
42. Crotty 1995:14–145.
43. Peckham 1981.
44. 1995:237.
45. Adams 1991:103; Plog and Solometo 1997;176.
46. Marshall and Walt 1984.
47. 1988:234.
48. 1988:98.
49. Habicht Mauche 1988; Spielmann 1982; 1983.
50. Haas and Creamer 1997; Plog 1997.
51. Plog 1997:169.
52. Riley 1989.
53. Riley 1989:142.
54. 1981.
55. 1940; 1966.
56. Hammond and Rey 1940:219.
57. Riley 1989:142.
58. Bunzel 1932:669–972.
59. 1989:174.
60. 1993:275–409.
61. White 1935:179–182.
62. White 1932a:98–99.
63. 1944:162.
64. Frigout 1979:575.
65. see Adams 1991; 1994; Schaafsma and Schaafsma 1974.

66. 1997:167.
67. Schaafsma 1999.
68. 1997:174–176.
69. see especially Taube 1983; 1986.
70. Brody 1977a:206–209; 1977b; 1978; Thompson 1990.
71. Schaafsma 1999.
72. Hunt 1977.
73. Foster 1986; Pailes and Whitecotton 1995; Phillips 1991.

CHAPTER VI
1. White 1935:37, n. 9.
2. Ellis 1979:361.
3. White 1932a:45–46; 50; 116–122.
4. Dozier 1970:67.
5. Lange 1990:229.
6. Ladd 1979:489.
7. 1939:912.
8. Stanislawski 1979:600.
9. Dozier 1957:132.
10. Dozier 1970:Table 3, pp. 194–195.
11. Titiev 1944:156.
12. 1929:136.
13. Hoebel 1979:414–415; Strong 1979:401.
14. Hoebel 1979:414.
15. 1979:263.
16. 1979:425.
17. 1970:196.
18. White 1942a:559.
19. White 1947:233.
20. Boyd and Ferguson 1988:75, and Figs. 1–81, 1–82, 1–84.
21. 1936:87 notes 1 and 2, and Fig. 63.
22. Merrill et al. 1993.
23. Stevenson 1904:Pls. CXXXVII–CXXXIX.
24. Merrill et al. 1993:523.
25. Merrill et al. 1993:530.
26. 1993.

REFERENCES

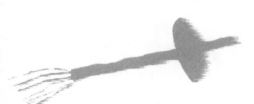

Adams, E. Charles. 1989. The Case for Conflict during the Late Prehistoric and Protohistoric Periods in the Western Pueblo Area of the American Southwest. In Cultures in Conflict: Current Archaeological Perspectives, edited by Diana Claire Tkaczuk and Brian C. Vivian, pp. 103–111. Proceedings of the Twentieth Annual Chacmool Conference, The Archaeological Association of the University of Calgary.

——. 1991. The Origin and Development of the Pueblo Katsina Cult. The University of Arizona Press, Tucson.

——. 1994. The Katsina Cult: A Western Pueblo Perspective. In Kachinas in the Pueblo World, edited by Polly Schaafsma, pp. 35–46, University of New Mexico Press, Albuquerque.

Adovasio, J. M. 1986. Prehistoric Basketry. Great Basin. Handbook of North American Indians, Vol. 11, pp. 194–205. Warren L. D'Azevedo, volume editor, Smithsonian Institution, Washington, D.C.

Ambler, J. Richard, and Mark Q. Sutton. 1989 The Anasazi Abandonment of the San Juan Drainage and the Numic Expansion. North American Archaeologist 10(1):39–53.

Allen, Wilma H., and Charles F. Merbs. 1985. Evidence for Prehistoric Scalping at Nuvakwewtaqa (Chavez Pass) and Grasshopper Ruin, Arizona. Arizona State University Anthropological Research 34, pp. 23–42.

Anderson, Keith. 1971. Excavations at Betatakin and Keet Seel. The Kiva 37:1–29.

Baird, Ellen T. 1989. Star and Wars at Cacaxtla. Mesoamerica After the Decline of Teotihuacan, A.D. 700–900. Edited by Richard A. Diehl and Janet Catherine Berlo, pp. 105–122. Dumbarton Oaks Research Library and Collection, Washington, D. C., 1989.

Baldwin, Stuart. 1992. Evidence for a Tompiro Morning Star Kachina. The Artifact 30(4):1–14. El Paso Archaeological Society, El Paso.

Bandelier, Adolph F. 1892. Final Report of Investigations among the Indians of the Southwestern United States, Carried on in the Years from 1880 to 1885, Vol. 2, Papers of the Archaeological Institute of America, American Series, Vols. 3 and 4, John Wilson and Son, Cambridge, Massachusetts.

Beaglehole, Ernest, and Pearl Beaglehole. 1935. Hopi of the Second Mesa. Memoirs of the American Anthropological Association 44.

Benedict, Ruth. 1934 Patterns of Culture. Mentor Books, New York.

——. 1935. Zuni Mythology, 2 vols. Columbia University Contributions to Anthropology 21. New York.

Bodine, John J. 1979. Taos Pueblo. Southwest, Handbook of North American Indians, Vol. 9, pp. 255–267. Alfonso Ortiz, volume editor, Smithsonian Institution, Washington, D. C.

Boyd, Douglas K., and Bobbie Ferguson. 1988. Tewa Rock Art in the Black Mesa Region. Cultural Resources Investigations Velarde Community Ditch Project, Rio Arriba County, New Mexico. U. S. Department of the Interior, Bureau of Reclamation, Southwest Region, Amarillo, Texas.

Brody, J. J. 1977a. Mimbres Painted Pottery. School of American Research and the University of New Mexico Press, Santa Fe and Albuquerque.

——. 1977b Sidetracked on the Trail of a Mexican Connection. American Indian Art 2(4):2–31.

——. 1978 Mimbres Painting and the Northern Frontier. In Across the Chichimec Sea: Papers in Honor of J. Charles Kelley, edited by Carroll L. Riley and Basil Hedrick. Southern Illinois University Press, Carbondale and Edwardsville.

——. 1991 Anasazi and Pueblo Painting. A School of American Research Book, University of New Mexico Press, Albuquerque.

Brown, Donald N.

——. 1979. Picuris Pueblo. Southwest, Handbook of North American Indians, Vol. 9, pp. 268–277. Alfonso Ortiz, volume editor, Smithsonian Institution, Washington, D. C.

Bunzel, Ruth L. 1932. Zuñi Ritual Poetry; Zuñi Katcinas: An Analytical Study. 47th Annual Report of the Bureau of American Ethnology, 1929–1930. Pp. 611–1086. Washington.

——. 1933 Zuni Texts. American Ethnological Society Publications 15, G. E. Stechert and Co. New York.

Burger, Richard L. 1988. Unity and Heterogeneity within the Chavin horizon. In Peruvian Prehistory, edited by Richard W. Keatinge, pp. 99–144. Cambridge University Press, Cambridge, New York, New Rochelle, Melbourne, Sydney.

Carlson, John B. 1991. Venus–regulated Warfare and Ritual Sacrifice in Mesoamerica: Teotihuacan and the Cacaxtla "Star Wars" Connection. Center for Archaeoastronomy Technical Publications No. 7. College Park, Maryland.

Castleton, Kenneth B. 1979. Petroglyphs and Pictographs of Utah (2): the South, Central, West, and Northwest. Utah Museum of Natural History, Salt Lake City.

Cohodas, Marvin. 1989. Mexican Warriors and Maya Victims: Warfare and Ethnic Opposition in the Classic Art of Mesoamerica. In Cultures in Conflict: Current Archaeological Perspectives, edited by Diana Claire Tkaczuk and Brian C. Vivian, pp. 19–33. Proceedings of the Twentieth Annual Chacmool Conference, The Archaeological Association of the University of Calgary.

Cole, Sally J. 1984. Analysis of a San Juan (Basketmaker) Style Painted Mask in Grand Gulch, Utah. Southwestern Lore 50(1):1–6

——. 1985. Additional Information on Basketmaker Masks or Faces in Southeastern Utah. Southwestern Lore 51(1):14–18.

——. 1990. Legacy on Stone: Rock Art of the Colorado Plateau and Four Corners Region. Johnson Books, Boulder.

Colton, Harold S..1946. "Fools' Names Like Fools' Faces—." Plateau 19:1–8.

——. 1959. Hopi Kachina Dolls with a Key to their Identification. Revised edition. University of New Mexico Press, Albuquerque.

Cordell, Linda. 1989. Warfare: Some Issues from the Prehistoric Southwest. In Cultures in Conflict: Current Archaeological Perspectives, edited by Diana Claire Tkaczuk

References

and Brian C.Vivian, pp. 173–178. Proceedings of the Twentieth Annual Chacmool Conference, The Archaeological Association of the University of Calgary.

Coulam, Nancy J. 1992. Radiocarbon Dating of the All American Man. Canyon Legacy 16:28–29. Moab.

Crotty, Helen Koefoed. 1995. Anasazi Mural Art of the Pueblo IV Period, A.D. 1300–1600: Influence, Selective Adaptation, and Cultural Diversity in the Prehistoric Southwest, 2 vols. Ph.D. dissertation, University of California at Los Angeles.

Crown, Patricia. 1994. Ceramics and Ideology: Salado Polychrome Pottery. University of New Mexico Press, Albuquerque.

Culin, Stewart.1907. Games of North American Indians. Twenty–fourth Annual Report of the Bureau of American Ethnology, 1902–1903. Washington, D. C.

Cushing, Frank H. 1896. Outlines of Zuni Creation Myths. Thirteenth Annual Report of the Bureau of American Ethnology, 1891–1892, pp. 321–447. Washington, D.C.

——. 1901. Zuni Folk Tales. G. P. Putnam's Sons, New York.

Daggett, Pierre M., and Dale R. Henning. 1974. The Jaguar in North America. American Antiquity 39:465–469.

Dean, Jeffrey S. 1969. Chronological Analysis of Tsegi Phase Sites in Northeastern Arizona. Papers of the Laboratory of Tree–Ring Research No. 3. University of Arizona, Tucson.

Dorsey, George A., and Henry R.Voth. 1901. The Oraibi Soyal Ceremony. The Field Museum of Natural History Publication 55, Anthropological Series 3(1):5–59. Chicago.

——. 1902. The Mishongnovi Ceremonies of the Snake and Antelope Fraternities. Field Columbia Museum, Publication 66, Anthropological Series 3(3). Chicago.

Dozier, Edward P. 1957. The Hopi and the Tewa. Scientific American 196:127ff.

——. 1970. The Pueblo Indians of North America. Holt, Rinehart and Winston, Inc. New York, Chicago, San Francisco, Atlanta, Dallas, Montreal, Toronto, London, Sydney.

Dumarest, Noel. 1919. Notes on Cochiti, New Mexico. Edited by Elsie Clews Parsons. Memoirs of the American Anthropological Association VI:139–236.

Dutton, Bertha P. 1963. Sun Father's Way. University of New Mexico Press, Albuquerque.

Ellis, Florence Hawley. 1951. Patterns of Aggression and the War Cult in Southwestern Pueblos. Southwestern Journal of Anthropology 7(2):177–201.

——. 1979. Isleta Pueblo. Southwest, Handbook of North American Indians, Vol. 9, pp. 351–365. Alfonso Ortiz, volume editor, Smithsonian Institution, Washington, D. C.

Ferguson, R. Brian. 1990. Explaining War. In The Anthropology of War, edited by Jonathan Haas, pp. 26–55. Cambridge University Press, New York.

Fewkes, Jesse Walter. 1897. Tusayan Katcinas. Fifteenth Annual Report of the Bureau of American Ethnology, pp. 245–313. Washington, D. C.

——. 1898. The Winter Solstice Ceremony at Walpi. American Anthropologist o.s. 11(3):65–87 and (4):101–115.

——. 1900. Tusayan Flute and Snake Ceremonies. Nineteenth Annual Report of the Bureau of American Ethnology, 1897–1898. pp. 957–1011, Washington, D. C.

——. 1903. Hopi Katcinas Drawn by Native Artists. Twenty–First Annual Report of the Bureau of American Ethnology, 1899–1900. Washington, D. C.

——. 1919. Designs on Prehistoric Hopi Pottery. 33rd Annual Report of the Bureau of American Ethnology, 1911–12, pp. 207–284. Washington. (Dover edition, 1973, New York).

Frigout, Arlette. 1979. Hopi Ceremonial Organization. Southwest. Handbook of North American Indians, Vol. 9, pp. 564–576. Alfonso Ortiz, volume editor, Smithsonian Institution, Washington, D. C.

Foster, Michael. 1986. The Mesoamerican Connection: A View from the South, pp. 55–69 In Ripples in the Chichimec Sea, edited by Frances Joan Mathien and Randall H. McGuire. Southern Illinois University Press, Carbondale and Edwardsville.

Geib, Phil R. 1996. Glen Canyon Revisited. University of Utah Anthropological Papers 119. Salt Lake City.

Geib, Phil R. and Helen Fairley

———. 1992. Radiocarbon Dating of Fremont Anthropomorphic Rock Art in Glen Canyon, South-Central Utah. Journal of Field Archaeology 19:155–68.

Grant, Campbell. 1978. Canyon de Chelly: Its People and Rock Art. The University of Arizona Press, Tucson.

Haas, Jonathan. 1990. Warfare and the Evolution of Tribal Polities in the Prehistoric Southwest. In The Anthropology of War, edited by Jonathan Haas, pp. 171–189. School of American Research Book, Cambridge University Press.

Haas, Jonathan, and Winifred Creamer. 1993. Stress and Warfare among the Kayenta Anasazi of the Thirteenth Century A. D. Fieldiana: anthropology:88

———. 1996. The Role of Warfare in the Pueblo III Period. Pp. 205–213 in The Prehistoric Pueblo World, A. D. 1150–1350, edited by Michael A. Adler. The University of Arizona Press, Tucson.

———. 1997. Warfare Among the Pueblos: Myth, History and Ethnography. Ethnohistory 44(2):235–261.

Habicht Mauche, Judith Ann. 1988. An Analysis of Southwestern-Style Utility Ware Ceramics from the Southern Plains in the Context of Protohistoric Plains–Pueblo Interaction. Ph.D. dissertation, Department of Anthropology, Harvard University, Cambridge.

Hamilton, T. M. 1982. Native American Bows, second edition, Missouri Archaeological Society Special Publication No. 5.

Hammond, George P., and Agapito Rey (eds.). 1928. Obregon's History of Sixteenth-Century Explorations in Western America, Entitled: Chronicle, Commentary, or Relation of the Ancient and Modern Discoveries in New Spain, New Mexico and Mexico, 1584. Wetzel, Los Angeles.

———. 1940. Narratives of the Coronado Expedition 1540–1542. University of New Mexico Press, Albuquerque.

———. 1953. Don Juan de Oñate: Colonizer of New Mexico, 1595–1628. University of New Mexico Press, Albuquerque.

———. 1966. The Rediscovery of New Mexico, 1580–1594. Coronado Cuarto Centennial Publications, No. 3, University of New Mexico Press, Albuquerque.

Harrington, John Peabody. 1916. The Ethnogeography of the Tewa Indians. Twenty–Ninth Annual Report of the Bureau of American Ethnology, 1907–1908, Washington, D. C.

Hays, Kelley Ann. 1992. Shalako Depictions on Prehistoric Hopi Pottery. In Archaeology, Art, and Anthropology: Papers in Honor of J. J. Brody. The Archaeological Society of New Mexico: 18, edited by Meliha S. Duran and David T.Kirkpatrick, pp. 73–84, Albuquerque.

———. 1994. Kachina Depictions on Prehistoric Pueblo Pottery. In Kachinas in the

References

Pueblo World, edited by Polly Schaafsma, pp. 47–62. University of New Mexico Press, Albuquerque.

Hendricks, Rick, and John P. Wilson. 1966. The Navajos in 1705: Roque Madrid's Campaign Journal. Edited, Annotated, and Translated by Rick Hendricks and John P. Wilson. University of New Mexico Press, Albuquerque.

Hibben, Frank C. 1975. Kiva Art of the Anasazi at Pottery Mound. KC Publications, Las Vegas, Nevada.

———. 1987. Report on the Salvage Operations at the Site of Pottery Mound, New Mexico During the Excavating Seasons of 1977–1986. Manuscript on File, Museum of Indian Arts and Culture/Laboratory of Anthropology, Museum of New Mexico, Santa Fe.

Hieb, Louis A. 1994. The Meaning of Katsina: Toward a Cultural Definition of "Person" in Hopi Religion. Kachinas in the Pueblo World, edited by Polly Schaafsma, pp. 23–34. University of New Mexico Press, Albuquerque.

Hill, W. W. 1982. An Ethnology of Santa Clara Pueblo, New Mexico. Edited and Annotated by Charles H. Lange. University of New Mexico Press, Albuquerque.

Hoebel, E. Adamson

———. 1979. Zia Pueblo. Southwest. Handbook of North American Indians, Vol. 9, pp. 407–417. Alfonso Ortiz, volume editor, Smithsonian Institution, Washington, D. C.

Hunt, Eva. 1977. The Transformation of the Hummingbird: Cultural Roots of a Zincantecan Mythical Poem. Cornell University Press, Ithaca, New York.

Kelley, David H. 1964. Knife-Wing and other Man-Eating Birds. 35th Congreso Internacional de Americanistas: Actas y Memorias 1, pp. 589–590. Mexico.

Kidder, A. V. 1932. The Artifacts of Pecos Papers of the Southwestern Expedition 6. Published for Phillips Academy by Yale University Press, New Haven.

Kidder, Alfred V., and Samuel J. Guernsey. 1919. Archaeological Explorations in Northeastern Arizona. Bureau of American Ethnology Bulletin 65. Washington, D. C.

Kohler, Timothy A., and Carla R. Van West. 1996. The Calculus of Self–Interest in the Development of Cooperation: Sociopolitical Development and Risk Among the Northern Anasazi. Evolving Complexity and Environmental Risk in the Prehistoric Southwest. edited by Joseph A. Tainter and Bonnie Bagley Tainter, pp. 169–196. A Proceedings volume in the Santa Fe Institute Studies in the Sciences of Complexity. Santa Fe.

Ladd, Edmund J. 1979. Zuni Social and Political Organization. Southwest. Handbook of North American Indians, Vol. 9, pp. 48–491. Alfonso Ortiz, volume editor, Smithsonian Institution, Washington, D. C.

Lange, Charles H. 1990. Cochiti: A New Mexico Pueblo, Past and Present. (Original edition, 1959). University of New Mexico Press, Albuquerque.

LeBlanc, Steven A. 1997. Modeling Warfare in Southwestern Prehistory. North American Archaeologist 18(3):235–276.

Lewis–Williams, J. D. 1986. Cognitive and Optical Illusions in San Rock Art Research. Current Anthropology 27(2):171–178.

———. 1997. Agency, Art and Altered Consciousness: a Motif in French (Quercy) Upper Paleolithic Parietal Art. Antiquity 71(274):810–830.

Lomatuway'ma, Michael, Lorena Lomatuway'ma, Sidney Namingha, and Ekkehart Malotki

———. 1993. Hopi Ruin Legends: Kiqotutuwotsi. Collected, translated, and edited by Ekkehart Malotki. Published for Northern Arizona University by the University

of Nebraska Press. Lincoln and Lincoln.

Lutonsky, Anthony F. 1998. Implements of Close Encounter: Shock Weapon Systems of the Pre-Historic Southwest. Paper presented in the symposium "Archaeology and Architecture of Tactical Sites," Meeting of the Arizona Archaeological Council, Flagstaff.

Malotki, Ekkehart, and Michael Lomatuway'ma. 1987. Maasaw: Profile of a Hopi God. American Tribal Religions, Vol. 11, Karl W. Luckert, General Editor. University of Nebraska Press, Lincoln and London.

Marshall, Michael P., and Henry J. Walt. 1984. Rio Abajo: Prehistory and History of a Rio Grande Province. New Mexico Historic Preservation Division, Santa Fe.

Marwitt, John P. 1986. Fremont Cultures. Great Basin. Handbook of North American Indians, Vol. 11, pp. 161–172. Warren L. D'Azevedo, volume editor, Smithsonian Institution, Washington, D. C.

Matson, R. G., and Sally J. Cole. 1997. Ethnicity and Conflict among the Basketmaker II of the U. S. Southwest. Proceedings of the 25th Chacmool Conference Forthcoming.

McCreery, Patricia, and Ekkehart Malotki. 1994. Tapamveni: the Rock Art Galleries of Petrified Forest and Beyond. Petrified Forest Museum Association, Petrified Forest, Arizona.

Merrill, William L., Edmund J. Ladd, and T. J. Ferguson. 1993. The Return of the Ahayu:da. Current Anthropology 34(5):523–567. The Wenner–Gren Foundation for Anthropological Research.

Michaelis, Helen. 1981. Willowsprings: A Hopi Petroglyph Site. Journal of New World Archaeology 4(2):2–23.

Morris, Earl H., and Robert F. Burgh. 1941. Anasazi Basketry, Basketmaker II through Pueblo III: A Study Based on Specimens from the San Juan River Country. Carnegie Institution of Washington, Publication 604, Washington, D. C.

Muench, David, and Polly Schaafsma. 1995. Images in Stone. Brown Trout Publishers, Inc., San Francisco.

Navarrete, Carlos. 1997. Los Mitos del Maíz entre los Mayas de las Tierras Altas. Arqueología Mexicana 5(25):56–61. Mexico, D. F.

Nicholson, Henry B. 1971. Religion in Pre–Hispanic Central Mexico. Archaeology of Northern Mesoamerica, Part 1, Gordon F. Ekholm and Ignacio Bernal, volume editors. Handbook of Middle American Indians, Vol. 10. University of Texas Press, Austin.

Noxon, John, and Deborah Marcus. 1985. Significant Rock Art Sites in the Needles District of Canyonlands National Park, Southeastern Utah. A National Park Service Report prepared under NPS purchase orders PX 1340–2–A099 and PX 1340–3–A334. Moab.

Ortiz, Alfonso. 1968. The Tewa World: Space, Time and Becoming in a Pueblo Society. The University of Chicago Press, Chicago and London.

Pailes, R. A., and Joseph W. Whitecotton. 1995. The Frontiers of Mesoamerica: Northern and Southern. In The Gran Chichimeca: Essays on the Archaeology and Ethnohistory of Northern Mesoamerica, edited by Jonathan E. Reyman, pp. 13–45. Avebury.

Parsons, Elsie Clews. 1926. Tewa Tales. Memoirs of the American Folk-Lore Society 19. New York.

———. 1929. The Social Organization of the Tewa of New Mexico. American

Anthropological Association Memoirs 36.

——. 1932. Isleta, New Mexico. Pp. 193–446 in 47th Annual Report of the Bureau of American Ethnology, 1929–1930. Washington.

——. 1936a. Early Relations Between Hopi and Keres. American Anthropologist 38:554–560.

——. 1936b. Taos Pueblo. General Series in Anthropology No. 2, Menasha.

——. 1939. Pueblo Indian Religion, 2 vols. University of Chicago Press, Chicago.

——. 1940. Taos Tales. American Folk-Lore Society. J. J. Augustin, N.Y.

Pasztory, Esther. 1983. Aztec Art. Harry N. Abrams, Inc. Publishers, New York.

Peckham, Barbara. 1981. Pueblo IV Murals at Mound 7. In Contributions to Gran Quivira Archaeology, Publications in Archaeology 17, Edited by Alden C. Hayes, pp. 15–38, National Park Service, Washington, D. C.

Phillips, David A., Jr. 1991. Mesoamerican–North Mexican Relationships: An Intellectual History. Paper presented at the symposium "Navigating the Chichimec Sea: Internal Developments and External Involvements in the Prehistory of Northern Mexico. 47th International Congress of Americanists, Tulane University, New Orleans.

Plog, Stephen. 1997. Ancient Peoples of the American Southwest. Thames and Hudson Ltd. London.

Plog, Stephen, and Julie Solometo. 1997. The Never-Changing and the Ever-Changing: the Evolution of Western Pueblo Ritual. Cambridge Archaeological Journal 7(2):161–182).

Preucel, Robert Washington. 1988. Settlement Succession on the Pajarito Plateau, New Mexico. The Kiva 53:3–33.

Reagan, Albert B. 1917. The Jemez Indians. El Palacio 4(2):25–72.

Riley, Carroll L. 1950. "Defensive" Structures in the Hovenweep Monument. El Palacio 57(11):339–344. Santa Fe.

——. 1989. Warfare in the Protohistoric Southwest: An Overview. In Cultures in Conflict: Current Archaeological Perspectives, edited by Diana Claire Tkaczuk and Brian C. Vivian, pp. 138–146. Proceedings of the Twentieth Annual Chacmool Conference, The Archaeological Association of the University of Calgary.

——. 1995. Rio del Norte: People of the Upper Rio Grande from Earliest Times to the Pueblo Revolt. University of Utah Press, Salt Lake City.

Rohn, Arthur. 1989. Warfare and Violence among the Southwestern Pueblos. In Cultures in Conflict: Current archaeological perspectives, edited by Diana Claire Tkaczuk and Brian C. Vivian. pp. 147–152. Proceedings of the Twentieth Annual Chacmool Conference, The Archaeological Association of the University of Calgary.

Sahagún, Bernardino de. 1950–82. Florentine Codex, General History of the Things of New Spain. (Arthur J. O. Anderson and Charles E. Dibble, trans.), 13 vols. The School of American Research and the University of Utah, Santa Fe.

Sando, Joe S. 1979. Jemez Pueblo. Southwest. Handbook of North American Indians, Vol. 9, pp. 418–429. Alfonso Ortiz, volume editor, Smithsonian Institution, Washington, D. C.

Schaafsma, Curtis F. 1994. Pueblo Ceremonialism from the Perspective of Spanish Documents. Kachinas in the Pueblo World, edited by Polly Schaafsma, pp. 121–138. University of New Mexico Press, Albuquerque.

——. 1995. Apaches de Navajo. Manuscript on file, Laboratory of

Anthropology/Museum of Indian Arts and Culture, Museum of New Mexico, Santa Fe.

Schaafsma, Polly. 1965. Kiva Murals from Pueblo del Encierro (LA 70). El Palacio 72(3):7–16.

———. 1966. A Survey of Tsegi Canyon Rock Art. Ms. on file, Laboratory of Anthropology, Santa Fe.

———. 1968. The Los Lunas Petroglyphs. El Palacio 75(2):13–24.

———. 1971. The Rock Art of Utah. Peabody Museum Papers no. 65, Harvard University, Cambridge. (Reprinted by the University of Utah Press, 1994).

———. 1975. Rock Art in the Cochiti Reservoir District, Museum of New Mexico Press Papers in Anthropology 16, Santa Fe.

———. 1980. Indian Rock Art of the Southwest. School of American Research and the University of New Mexico Press, Albuquerque.

———. 1990. The Pine Tree Site: A Galisteo Basin Pueblo IV Shrine. Pp. 239–258, in Clues to the Past: Papers in Honor of William M. Sundt. The Archaeological Society of New Mexico 16, edited by Meliha S. Duran and David T. Kirkpatrick, Albuquerque.

———. 1992. Imagery and Magic: Petroglyphs at Comanche Gap, Galisteo Basin, New Mexico. In Archaeology, Art, and Anthropology: Papers in Honor of J. J. Brody. The Archaeological Society of New Mexico No. 18, edited by Meliha S. Duran and David T. Kirkpatrick, pp. 157–74. Albuquerque Archaeological Society. Albuquerque.

———. 1994. Trance and Transformation in the Canyons: Shamanism and Early Rock Art on the Colorado Plateau. Pp. 45–72 in Shamanism and Rock Art in North America, edited by Solveig A. Turpin, The Rock Art Foundation, Inc., Special Publication 1, San Antonio, Texas.

———. 1999. Tlalocs, Kachinas, Sacred Bundles, and Related Symbolism in the Southwest and Mesoamerica. In The Casas Grandes World, edited by Curtis Schaafsma and Carroll Riley. University of Utah Press, Salt Lake City.

———. in press
(b)Feathered Stars and Scalps in Pueblo IV. Archaeoastronomy: Proceedings of the Fifth Oxford Conference in Santa Fe.

Schaafsma, Polly, and Curtis Schaafsma. 1974. Evidence for the Origins of the Pueblo Kachina Cult as Suggested by Southwestern Rock Art. American Antiquity 39)4):535–545.

Schele, Linda. 1986. The Tlaloc Complex in the Classic Period: War and the Interaction between the Lowland Maya and Teotihuacan. Paper presented at the symposium on The New Dynamics, Kimbell Art Museum, Fort Worth, Texas.

Schele, Linda, and David Freidel. 1990. A Forest of Kings: the Untold Story of the Ancient Maya. William Morrow and Company, Inc., New York.

Schulman, Albert. 1950. Pre–Columbian Towers in the Southwest. American Antiquity 15(4), part 1:288–297.

Schroeder, Albert H. 1979. Pueblos Abandoned in Historic Times. Southwest. Handbook of North American Indians, Vol. 9, pp. 236–254. Alfonso Ortiz, volume editor, Smithsonian Institution, Washington, D. C.

Sharrock, F.W. 1966. An Archaeological Survey of Canyonlands National Park. Anthropological Papers no. 83, Miscellaneous Papers No. 12. University of Utah, Salt Lake City.

References

Smith, Watson. 1952. Kiva Mural Decorations at Awatovi and Kawaika–a. Papers of the Peabody Museum of American Archaeology and Ethnology, 37. Harvard University, Cambridge.

——. 1971. Painted Ceramics of the Western Mound at Awatovi. Papers of the Peabody Museum of American Archaeology and Ethnology, 38. Harvard University, Cambridge.

Spielmann, Katherine A. 1982. Inter-societal Food Acquisition Among Egalitarian Societies: An Ecological Study of Plains/Pueblo Interaction in the American Southwest. Ph. D. dissertation. University of Michigan, University Microfilms, Ann Arbor.

——. 1983. Late Prehistoric Exchange between the Southwest and Southern Plains. Plains Anthropologist 28(102):257–272.

Stanislawski, Michael B. 1979. Hopi–Tewa. Southwest. Handbook of North American Indians, Vol. 9, pp. 587–602. Alfonso Ortiz, volume editor, Smithsonian Institution, Washington, D. C.

Stephen, Alexander M. 1936. Hopi Journal of Alexander M. Stephen. Elsie C. Parsons, editor. 2 vols. Columbia University Contributions to Anthropology, 23, New York.

Stevenson, Matilda Coxe. 1894. The Sia. Eleventh Annual Report of the Bureau of Ethnology, 1889–90. Smithsonian Institution, Washington, D. C.

——. 1904. The Zuñi Indians: Their Mythology, Esoteric Fraternities, and Ceremonies. Twenty–Third Annual Report of the Bureau of American Ethnology, 1901–1902, Washington, D. C.

Steward, Julian. 1941. Archeological Reconnaissance of Southern Utah. Bureau of American Ethnology, Bulletin 128. Washington, D. C.

Stiny, Andrew. 1997. The Track of the Jaguar. The New Mexican, January 2, Santa Fe.

Stirling, Matthew W. 1942. Origin Myth of Acoma and Other Records. Bureau of American Ethnology, Bulletin 135. Washington, D. C.

Strong, Pauline Turner. 1979. Santa Ana. Southwest. Handbook of North American Indians, Vol. 9, pp. 398–406. Alfonso Ortiz, volume editor, Smithsonian Institution, Washington, D. C.

Taube, Karl A. 1983. The Teotihuacan Spider Woman. Journal of Latin American Lore 9(2):107–189, UCLA, Los Angeles.

——. 1986. The Teotihuacan Cave of Origin. Res: Anthropology and Aesthetics 12, pp. 51–82.

Tedlock, Dennis. 1979. Zuni Religion and World View. Southwest. The Handbook of North American Indians, Vol. 9, pp. 499–508. Alfonso Ortiz, volume editor, Smithsonian Institution, Washington, D. C.

Thompson, J. E. S. 1975. The Rise and Fall of Maya Civilization. University of Oklahoma Press, Norman.

Thompson, Marc. 1990. Codes from the Underworld: Mimbres Iconography Revealed. Paper presented at the Sixth Biannual Mogollon Conference. Western New Mexico University, Silver City.

——. 1996. The Correlation of Maya Lithic and Glyphic Data. Lithic Technology 21(2):120–133.

Titiev, Mischa. 1944. Old Oraibi: a study of the Hopi Indians of Third Mesa. Papers of the Peabody Museum of American Archaeology and Ethnology, Harvard University 22(1). Cambridge.

Townsend, Richard F., General Editor. 1992. The Ancient Americas: Art from Sacred

Landscapes. The Art Institute of Chicago.

Turner, A. C., and R. C. Euler. 1983. A Brief History of the San Juan Paiute Indians of Northern Arizona. Journal of California and Great Basin Anthropology 5:199–207.

Turner, Christy G., II, and Jacqueline A. Turner. 1995. Cannibalism in the Prehistoric Southwest: Occurrence, Taphonomy, Explanation, and Suggestions for Standardized World Definition. Anthropological Science 103(1):1–22.

Tyler, Hamilton A. 1979. Pueblo Birds and Myths. University of Oklahoma Press, Norman.

Upham, Steadman, and Paul F. Reed. 1989. Inferring the Structure of Anasazi Warfare. In Cultures in Conflict: Current archaeological perspectives, edited by Diana Claire Tkaczuk and Brian C. Vivian. pp. 153–162. Proceedings of the Twentieth Annual Chacmool Conference, The Archaeological Association of the University of Calgary.

Vierra, Bradley J. 1987. A Tale of Two Cities. Secrets of a City: Papers on Albuquerque Area Archaeology in Honor of Richard A. Bice, edited by Anne V. Poore and John Montgomery, pp. 70–86, The Archaeological Society of New Mexico:13, Albuquerque.

Vivian, Patricia. 1994. Anthropomorphic Figures in the Pottery Mound Murals. In Kachinas in the Pueblo World, edited by Polly Schaafsma, pp. 81–92. University of New Mexico Press.

Voll, Charles. 1961. The Glaze Paint Ceramics of Pottery Mound. Master's Thesis, Department of Anthropology, University of New Mexico.

Voth, Henry R. 1901. The Oraibi Powamu Ceremony. Field Museum of Natural History, Anthropological Series 3(2):61–158.

——. 1903. The Oraibi Summer Snake Society. Field Columbian Museum, Anthropological Series 3(4). Chicago.

——. 1905. Traditions of the Hopi. Field Museum of Natural History Publication 96, Anthropological Series 8, Chicago.

——. 1912. The Oraibi Marau Ceremony. Field Museum of Natural History, Anthropological Series 11(1):1–88.

Wallace, A. 1956. Revitalization Movements. American Anthropologist 58:264–81.

Wallis, Wilson D., and Mischa Titiev. 1945. Hopi Notes from Chimopavy. Papers of the Michigan Academy of Science, Arts, and Letters 30, pp. 523–555. University of Michigan Press, Ann Arbor.

Wendorf, Fred, and Erik K. Reed. 1955. An Alternative Reconstruction of the Northern Rio Grande Prehistory. El Palacio 62(5–6):131–173.

White, Leslie A. 1932a. The Acoma Indians. Forty–Seventh Annual Report of the Bureau of American Ethnology, 1929–1930, pp. 17–192. Washington, D.C.

——.1932b. The Pueblo of San Felipe. Memoirs of the American Anthropological Association 38. Menasha.

——.1935. The Pueblo of Santo Domingo, New Mexico. Memoirs of the American Anthropological Association 43. Menasha.

——.1942a. The Impersonation of Saints Among the Pueblos. Papers of the Michigan Academy of Science, Arts, and Letters, Vol. 27, 1941, pp. 559–564.

——. 1942b. The Pueblo of Santa Ana, New Mexico. Memoirs of the American Anthropological Association 43. Menasha.

—— 1947. Notes on the Ethnozoology of the Keresan Pueblo Indians. Papers of the

Michigan Academy of Science, Arts, and Letters, vol. 31, 1945, pp.223–243.

———. 1960. The World of the Keresan Pueblos. In Culture in History: Essays in Honor of Paul Radin, edited by Stanley Diamond, pp. 53–64. Published for Brandeis University by Columbia University Press, New York

Wilcox, David R. 1981. Changing Perspectives on the Protohistoric Pueblos, A. D. 1450–1700. The Protohistoric Period in the North American Southwest, A. D. 1450–1700. pp. 378–409, Anthropological Research Papers, No. 24, Arizona State University, Tempe.

Wilcox, David R., and Jonathan Haas. 1994. The Scream of the Butterfly: Competition and Conflict in the Prehistoric Southwest. In Themes in Southwest Prehistory, edited by George J.Gumerman, pp. 211–238. School of American Research Press, Santa Fe.

Winship, George Parker. 1896. The Coronado Expedition, 1540–1542. 14th Annual Report of the Bureau of American Ethnology, Smithsonian Institution, Washington, D. C.

Wobst, H. Martin. 1978. The Archaeo-Ethnology of Hunter-Gatherers or the Tyranny of the Ethnographic Record in Archaeology. American Antiquity 43(2):303–309.

Wormington, H. M. 1955. A Reappraisal of the Fremont Culture. Proceedings of the Denver Museum of Natural History, no. 1.

Wright, Barton

———. 1973. Kachinas: A Hopi Artists's Documentary. Northland Publishing with the Heard Museum. Flagstaff.

———. 1976. Pueblo Shields: From the Fred Harvey Fine Arts Collection. Heard Museum, Phoenix.

———. 1977. Hopi Kachinas: the Complete Guide to Collecting Kachina Dolls. Northland Press, Flagstaff.

———. 1985. Kachinas of the Zuni. Northland Press in cooperation with the Southwest Museum. Flagstaff.

Wright, Barton, Marnie Gaede, and Marc Gaede. 1988. The Hopi Photographs: Kate Cory: 1905–1912. University of New Mexico Press (originally published 1986, Chaco Press; reprinted 1988 by arrangement).

Young, M. Jane 1988. Signs from the Ancestors: Zuni Cultural Symbolism and Perceptions of Rock Art. University of New Mexico Press, Albuquerque.

———. 1992. Morning Star, Evening Star: Zuni Traditional Stories. In Earth and Sky: Visions of the Cosmos in Native American Folklore, Ray A. Williamson and Claire R. Farrer, editors, pp. 75–109. University of New Mexico Press, Albuquerque.

Index

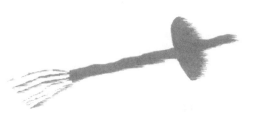

Index

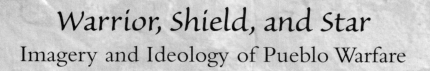

Warrior, Shield, and Star
Imagery and Ideology of Pueblo Warfare

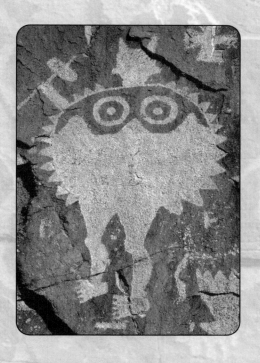

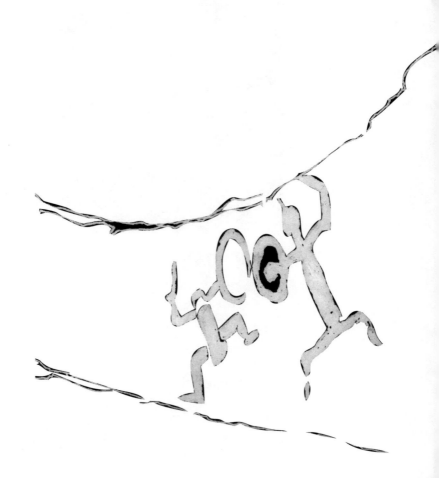